PHOTOGRAPHY FOR VISUAL COMMUNICATORS

PHOTOGRAPHY

FOR VISUAL COMMUNICATORS

WESTON D. KEMP

Rochester Institute of Technology
Rochester, New York

Designed by
TOM MUIR WILSON

Rochester Institute of Technology
Rochester, New York

PRENTICE-HALL, INC.
Englewood Cliffs, New Jersey

Library of Congress Cataloging in Publication Data

Kemp, Weston D
 Photography for visual communicators.

 Bibliography: p.
 1. Photography. I. Title
TR145.K4 770'.28 73-4645
ISBN 0-13-665356-1

*Drawings
by
LYNNE AUSTIN BENTLEY*

*Instructional photographs
by
JOSEPH POLANIN
JOHN MASSEY
C. TYLER QUILLEN*

Current printing (last digit):
10 9 8 7 6 5 4 3 2

Printed in the United States of America

PRENTICE-HALL INTERNATIONAL, INC., *LONDON*
PRENTICE-HALL OF AUSTRALIA, PTY., LTD., *SYDNEY*
PRENTICE-HALL OF CANADA, LTD., *TORONTO*
PRENTICE-HALL OF INDIA PRIVATE LIMITED, *NEW DELHI*
PRENTICE-HALL OF JAPAN, INC., *TOKYO*

Photo source key:

G.E.H. — International Museum of Photography
 at George Eastman House, Rochester, N.Y.
L.C. — Library of Congress, Washington, D.C.
L.G. — Light Gallery. New York, N.Y.
R.P.S. — Royal Photographic Society, London

CONTENTS

ACKNOWLEDGMENTS

First of all, a very special acknowledgment to the designer of this book, Professor Tom Muir Wilson, friend and colleague, whose excellent taste and far-ranging contacts made possible the unique and relevant collection of fine photographs.

I particularly extend appreciation to the photographer/artists represented for their generous cooperation essential to the publication of this work.

Ralph Hattersley's review work and thoughtful Foreword was both helpful and sustaining. Our thanks to Tom Barrow at the Eastman House and Harold Jones at Light Gallery for extensive aid in securing photographs.

This is an opportunity to express gratitude to Dr. Lothar Engelmann and Professor William Shoemaker in the College of Graphic Arts and Photography at R.I.T. for warm encouragement and ready support. The faculty and staff merit a special note of thanks for their interest and readiness to help. A special thanks to Professors Leslie Stroebel and David Engdahl.

Especially appreciated was the editorial assistance of Marlene Ledbetter who was responsible for transcribing dictation into the written word. Her constant attention to style, grammatical construction, and presentation of material, was invaluable. The assistance of Elizabeth Smith in acquiring and cataloging photographs brought order to an often complex task.

For their interest and appreciation for the guiding concepts of this project, I am indebted to Dennis Curtin, Hank Kennedy, Marvin Warshaw and Leon J. Liguori at Prentice-Hall. Their support and enthusiasm contributed to the joys of this project.

WESTON D. KEMP

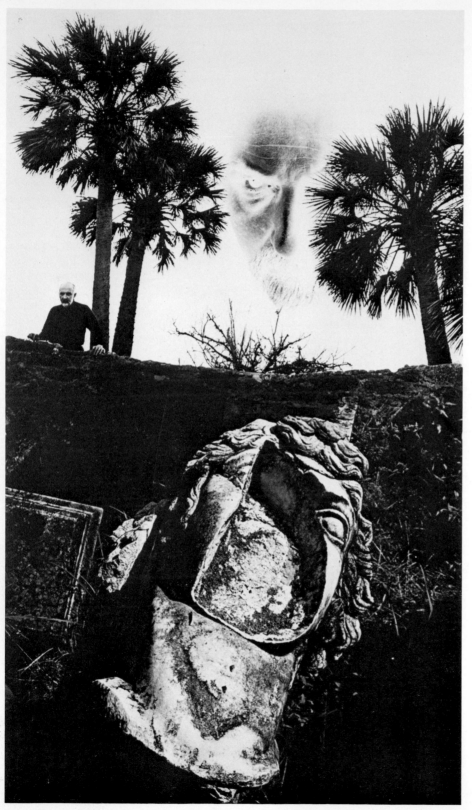

Jerry Uelsmann
"*Ralph Hattersley.*" 1969. Photomontage.

FOREWORD

I have known Wes Kemp and Tom Wilson for many years and have long admired them as artists and teachers. I wasn't in the least surprised when they told me of their plans to produce a high-quality textbook for photography, a teaching and learning tool that has been long-awaited in this field.

The basic problem is that there is no logical beginning point for the study of photography. This is also true of the study of law. In both fields the student is supposed to say a prayer, then jump right in, hoping he will learn to swim before drowning overtakes him. The difficulty is that everything depends on everything else; an understanding of what one is studying today depends on a knowledge of something else that he may not encounter for another week or month. Furthermore, both are described in the specialized jargon of photography, which he has never before encountered. Thus getting oneself oriented in photography in the beginning is like sitting in the middle of a huge, three-dimensional jigsaw puzzle and trying to assemble it from all eight corners at once without being able to see the color of the pieces.

Since he has long been familiar with this chaos, Wes Kemp could be forgiven if he had turned to horticulture instead of writing in such an uncompromising area. As a friend and fellow teacher of photography I am very glad that he did not. The result is a handsome volume that will help greatly in reducing the chaos that ordinarily confronts the people who try to find a way of getting themselves productively involved in photography.

The reader must understand that this book is not designed to be read at one sitting and that one time through it is by no means enough. Though Weston Kemp has threaded his way very deftly through a very complex subject he could only go so far in simplifying things. Beyond that point photography would begin to lose its vitality, and the ideas and instructions would begin to look like simple recipes. Thus through necessity he had to introduce a few concepts in early chapters whose understanding must be based on information in later ones. For the writer-teacher there is absolutely no way around this problem. For the reader it's not so hard: Read the text a couple of times, then use it as a reference work by bouncing back and forth from place to place.

The reader should also understand that the pictures in the book were selected with great care and that it took Kemp and Wilson months to gather them. They represent many of the main streams in photographic expression and are done by photographers famous in these areas. Studying them carefully can be an educa-

tion in itself. I will now say a few things that Kemp and Wilson probably had in mind but couldn't say without sounding self-inflationary. They concern the tremendous importance of photography in the Western World.

The term photography includes still photography, cinema, and television (which also includes videotape). Seen in this larger context it is easy to understand that photography completely dominates the mass media of communication. The omnipresent TV set should make this fact unmistakable. The effects of it are less easily seen. One of them is that a completed visual language has developed without anyone being very aware of it. Another is that this photographic language form has mainly replaced the written form in the so-called TV Generation.

Where photography differs from earlier pictographic languages is in its inclusion of literally everything that affects an emulsion or electronically sensitized surface as both a symbol and a letter of the alphabet. One would expect that the result of such an infinitely complex language would be chaos, but it hasn't worked out that way. A reasonable prediction, considering that everything has been all right up to now, is that this new language will greatly broaden the scope of human mentation.

One thing about language that few people are aware of is that it limits mentation, or thinking, very severely. They may realize that one can think things in Greek that are impossible to think in French, or that mathematical thought is easier for a Navaho than an Englishman, but they don't put things together to see that any known language is a conditioning system.

We have yet to learn how to turn photography into a conditioning system, though many have tried and are still trying. Thus insofar as it is a language it is largely free of the programming influences that limit the thinking of those who use it.

Though many young folk have been cut off from the printed word by the effects of television, they have by no means been barred from the spoken word. Indeed their speech has reached a level of subtlety and sophistication undreamed of by educators a generation or two ago. I have observed it mainly in photography courses, where they talk about (read) pictures. In such a context it is obvious that their minds are ranging far more broadly than their parents' were able to range. This is to say that the visual language has opened up vistas that more restrictive language forms would bar them from.

Though I've mainly discussed photography in the form of television, the crux of present and future developments in photography as a language form is the still photograph. Still photographs are steadily growing in importance as a final form of communication; and one can truthfully say that they represent moving images in a highly compressed form. Fairly frequently one sees, say, a group

of six or eight still photographs that says as much as an entire motion picture. Such a group is usually called a sequence, and thousands of students and teachers are laboring to develop this form of visual communication.

Except for people in colleges and art schools, few have heard of these developments—mainly because there are at present no easy ways of commercializing them. These will develop in due time (and will revolutionize the visual media), but for the present the splendid work of our students is being ignored, which may be for the best. When the time is right the young folk will confront the public with a linguistic revolution as a fait accompli. At that time no person will be allowed to consider himself fully literate unless he has a substantial understanding of the visual language of photography.

There is more to it than this, however. I have said that a visual language such as photography can broaden the scope of thinking, but I didn't say how much. It is my considered opinion that when we have perfected this language we will open the doors to telepathy, which is also a form of communication by images. On the unconscious level, for example in dreams, we are already telepathic and always have been. I suspect that the reason we haven't had conscious access to our telepathic powers is that we couldn't cope with the imagery, that it would overwhelm us. What we have needed is a language form that would help us to see the meaning of these telepathic images. The development of such a form is now well under way in photography. It will prepare us to deal meaningfully with the fantastic complexity and subtle nuances of telepathic communication.

Those who haven't had close contact with photography students in the colleges and art schools might see this telepathy concept as preposterous. However, those who work with them and see how much they perceive in images shouldn't be in the least surprised. Photography students aren't at all surprised by the telepathy idea, incidentally, for it fits in beautifully with what they are already doing.

We can now see some of the unstated reasons for the title of this book: *Photography For Visual Communicators*. Kemp and Wilson are not merely trying to show the reader how to have fun with a camera, though he will indeed have fun. By showing the reader the fundamentals of photography they are opening a door leading to the use of photography as a magnificent and eloquent language. If I am correct in my prophecy they may even be showing him the door to the future.

Ralph M. Hattersley

Visual communicators who use photography constantly question the medium. They constantly seek to discover and comprehend exactly what is being photographed and what is being revealed. They have a continuing concern for what happens when the subject in front of the lens is transformed into a photographic image on paper or film. This concern extends to a consideration of what actually happens, what takes place, when the photographic print is viewed by themselves and by their audiences.

It is necessary to reexamine constantly what it is you are trying to say with your camera . . . to constantly question the rationale for photographing an event, a person, or an emotion.

If your photographic vision is to improve, perhaps the questions that you need to ask yourself again and again are, "What was there about what I photographed that made it important, that made it worthwhile? What did I see? What did I feel?"

Part of the solution lies in personal honesty, in knowing what you really feel about something as opposed to what you think you should feel about it. This is an endless learning process. Answers come only with more photographing and with gaining new insights from the photographs.

When you look at something your visual impression of it is the combination of what you've heard about it, what you feel about it, and how you care about it. Your brain assembles not only the visual data being fed to it by your eyes, but all the other data about similar things that have been stored in your memory banks. It's not surprising, then, that the image generated by the camera may be very unlike the image in your brain. The photograph will contain few if any clues about the nonvisual perceptions which were bouncing around in your head at the time you made the photograph and which contributed to your total reaction to what you were photographing. If you are going to communicate successfully your impressions of the subject to others, every visible feature, every tone, every line, every shape in the print must be right lest the viewer confuse and misinterpret your message.

Seeing photographs is a learned process. Truly seeing photographs is an art. To begin with, you have to give the photograph a chance. It should be well lighted and viewed in a place that's free from noise and other distractions. It should be looked at from different distances to get a long view of the photograph and a close look at textures, details, and tones. You must be willing to give the photograph your total attention.

A photograph is usually small, physically insignificant. You should help it to communicate with you. You have to sensitize your eyes and your brain, open your head to give the photograph a chance to get in and an opportunity to speak. Relax. Look. Allow the picture to take over all your thoughts. Move into a state of total awareness of the photograph. Let your responses to the image flow naturally. Let your brain become sensitized to appreciate the texture of a patch of skin or the glare of polished metal. Let your eyes wander over the image and taste the tones, the shapes, and the flow of the lines.

What you get from a photograph is a combination of what the photographer put into it and what you bring to it. Looking at photographs you don't like is a valid visual exercise. Don't limit your appreciation of photography by dealing only with images that already appeal to you. Try to discover what it is that blocks you from enjoying some photographs. Try to avoid the trap of dismissing a photograph because of your own ignorance.

Whenever possible, examine original photographs. You may have seen scores of reproductions of the work of W. Eugene Smith, but the original prints are truly not the same photographs.

Perhaps the greatest reward in seeing a good photograph is that it may broaden and refine your own vision.

W.D.K.

PHOTOGRAPHY 1

the light-sensitive language

1

Of all the languages in the world, none is more universal and believable than the language of photographic pictures—images made on a light-sensitive surface.

The influence of photography in our lives is of unbelievable magnitude. Photography is involved directly or indirectly in nearly all we experience: teaching, explaining, entertaining, revealing the unseen, expressing our feelings and desires, and, occasionally, deceiving us.

People today are completely familiar with photography and accept this communication medium. Everyone seems to have at least one camera. People everywhere are making straight or contrived photographs ... beautiful pictures and brutal pictures ... truthful photographs and photographs that lie.

Photography is both an art and a valuable research tool. Our moon is less a mystery to us because of photography. We marvel at it's quality of light—a light never diffused or degraded by passing through a polluted atmosphere.

Photography has shown us astronauts awkwardly moving about on an alien surface, driving through vistas of incredible beauty and desolation. Because of photography we know more about our moon and our universe.

THE EVOLUTION OF PHOTOGRAPHY

Photography is so commonplace—millions of people shoot still or motion pictures—that it seems strange when we consider that photography is one of the newest languages in this world. For all intents and purposes, photography was introduced in 1839. And there are people alive today who remember seeing the first Kodak, the camera which made photography practical for everyone.

At the turn of the century it was a novelty to see reproductions of photographs in newspapers and magazines. Color photography—in very rudimentary form—appeared about 1910. The first sound-on-film recordings—the "talkies"—came out of the motion picture industry in the 1920s. Television, which has made the whole world picture-conscious, was still new to most people as recently as 1950. Color television has become practical and widely accepted only in the last few years.

People were intensely fascinated by photography from the very first. Although we consider photography as having first appeared in 1839, it really evolved through a long and frustrating process. The camera existed long before there was any real use for it as a recording device. No one knows when the first camera was constructed, but we do know that Aristotle observed the images of a solar eclipse formed by light passing through small gaps in tree foliage—in effect, a pinhole image.

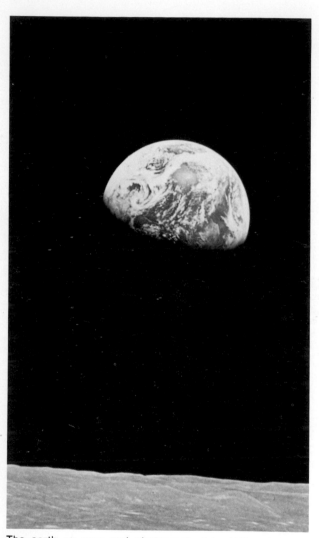

The earth as seen and photographed by U.S. astronauts orbiting the moon. The cratered lunar surface is visible in the foreground.

16

Camera Obscura

The first camera probably was constructed by tenth-century Arab scholars. Roger Bacon referred to the *camera obscura* in the 1200s, possibly learning about it from Arab writings. In its earliest form, the *camera obscura* (meaning "dark chamber") was a darkened room with a very small hole in one wall. Leonardo da Vinci described one in detail in about 1490, stating that the image was viewed through the back of a screen of paper which had to be very thin. Leonardo also specified that the hole should be made in a piece of very thin sheet iron.

Giovanni Battista della Porta described the *camera obscura* in 1558: a conical hole was installed in the wall of a darkened room and the image could be seen on a white screen. It appeared upside down and reversed from left to right, and its size was proportional to the distance from the hole to the viewing screen. All these observations are equally valid for the cameras used today.

The *camera obscura* image was used primarily as a guide for drawing by artists who wanted to have more exact perspective in their drawings or paintings. Della Porta recommended that the *camera obscura* image be used for just such a purpose, and invented a method for producing a right-side-up image using lenses and curved mirrors. He astounded viewers with the images of elaborate theatrical productions staged outside.

Incorporating lenses into the *camera obscura* was a significant step. The image was brighter and sharper, since a lens permits the entrance of more light than a simple hole and focuses the light rays to finer points.

More and more people became interested in these "cameras," and in about 1575 the first movable ones appeared. At first they were wooden huts or tents completely enclosing the viewer and viewing screen. Later more elaborate models, such as sedan chairs, were constructed.

From that point on the evolution of the camera was rapid. Smaller models were designed to be completely portable. A reflex camera in which the image was reflected onto a top-mounted viewing screen was built in 1675. A ball-and-socket mount, much like modern tripod heads, appeared in 1680. And a telephoto lens was first used in 1685. The camera, in effect, was invented before photography.

Discovery of Light-Sensitive Chemicals

The first important photographic discovery was made in 1727 by Johann Heinrich Schulze, a professor at the University of Altdorf.

A German chemist, Schulze noticed that certain materials were sensitive to light. These chemicals turned black when exposed to

Camera Obscura.

light. Schulze began experimenting. He mixed powdered chalk with a solution of nitric acid and found that the mixture turned dark violet in sunlight. He discovered that the discoloration was due to a contaminant in the acid—silver. He eventually proved that silver nitrate and silver carbonate were sensitive to light.

Schulze made numerous stencil prints on the sensitive contents of his bottles, but apparently never applied the solution to paper or made any attempt to record natural images. He was never able to fix these images caused by light. Whenever the whole bottle was exposed to light, the entire contents eventually turned black.

In 1777, a Swedish chemist, Karl Wilhelm Scheele, made some interesting discoveries while investigating the properties of silver chloride. He established that the blackening effects of silver salt were due to light. He also proved that the black material was metallic silver and found that ammonia, which was known to dissolve silver chloride, did not affect the blackened, or metallic silver. Unfortunately, Scheele failed to realize the importance of his discovery. Had he become aware of its significance, he could very well have been the inventor of photography.

Now the essential processes were known: silver chloride could be reduced to black metallic silver by exposure to light. Ammonia could serve to preserve the image by dissolving the silver chloride remaining in the solution without harming the metallic silver image. The camera existed and the photographic process was known; all that was lacking was someone who could put the two together.

Scheele's discoveries were only noted in passing. The fantastic possibility of using light to produce real images had simply not occurred to anyone yet.

Thomas Wedgwood was the youngest son of the famous potter Josiah Wedgwood. In addition to being an outstanding craftsman and artist, he was a brilliant and respected member of the scientific community. Wedgwood was familiar with the *camera obscura* because his father had used it as an aid in drawing some scenes for his pottery work. The Wedgwood family also owned the notebooks of William Lewis, who in 1763 had described Schulze's and his own experiments with silver compounds.

This unusual set of circumstances prompted Wedgwood to begin experimenting on his own in about 1795. He tried soaking paper in light-sensitive chemicals, then laid lace on the paper, exposed it to light, and formed a facsimile image. But he was not able to make the image permanent. Wedgwood was on the right path, however, for his experiments later proved useful. One technique involved the negative-positive relationship. Because no light passed through the opaque lace the portion of the paper covered by the lace remained white and the exposed areas turned black. This produced an image which was a reversal of the original material—a negative.

Unfortunately, Wedgwood also gave up his research in making pictures with the *camera obscura* and missed the distinction of becoming the inventor of photography. His experiments were published in 1802 with this comment by a friend: "Nothing but a method of preventing the unshaded parts of the delineation from being colored by exposure to the day is wanting to render the process as useful as it is elegant."

Experimenters for the next thirty years were frustrated by the same problem.

In 1826, Joseph Nicéphore Niepce, a French inventor, succeeded where Schulze and Wedgwood had failed. Niepce succeeded in making his images permanent and became the first photographer. He discovered that certain chemicals—those found in varnish, for example—became insoluble when exposed to light. He placed a thin tin plate covered with this light-sensitive varnish in a *camera obscura*. He then put the exposed plate in a weak acid which allowed the unexposed areas on the place to be etched. This plate was etched or incised deeper by hand, inked, and printed. The process yielded the first photomechanical reproduction.

The world's first permanent camera image shows the view from Niepce's second-floor window and is little more than an impression. It is a bituminous image on pewter, showing only masses of light. The exposure is supposed to have taken about eight hours.

Niepce had limited success. His images were reversed from nature —they were negatives. But he realized that total reversal was an inherent part of the silver process and tried, unsuccessfully, to produce a positive print by reprinting one of his negatives. Ill health and lack of money led Niepce into a partnership with Louis Daguerre.

Daguerreotype Process Announced in 1839

In 1835, working alone, Daguerre discovered that treatment with mercury vapor would produce a visible image on an iodized silver plate which had been briefly exposed to light. He found he could stabilize this image with a strong salt solution. Details of this process were announced to the public in August of 1839. Although the French government announced that the process was public property, this was not entirely true. Daguerre had secretly patented it in England just a few days before the formal French announcement.

Enthusiastic experimenters in France and elsewhere became deeply involved in this new technique for making pictures. The *daguerreotype* was made from a sheet of copper, one side silver-plated. The silver surface was buffed until it looked like a mirror, and certain chemicals were applied to make the plate light-sensitive. The plate was then placed in a camera and exposed.

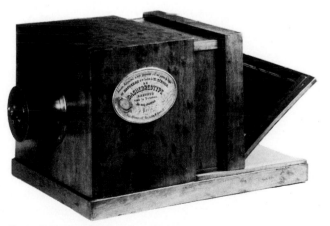

Early French daguerreotype camera.

After exposure, the plate was developed with fumes from hot mercury, which produced a visible image. This image was made permanent by soaking the plate in hypo and rinsing it with water.

A daguerreotype is difficult to look at because of its mirrorlike surface. From certain angles, the image appears as a negative. You can also see your own reflection in a daguerreotype. Its surface is very delicate and is usually covered with glass.

There was an immediate and enthusiastic demand for daguerreotype photographs, even though they were expensive. The process required long exposure (about thirty seconds), making it difficult to photograph young children. Neck clamps were used to keep the subject's head still, making movement less likely. Each daguerreotype is unique; the material exposed in the camera became the finished photograph. It was difficult to duplicate a daguerreotype.

Fox Talbot Announces Calotype Process

While Niepce and Daguerre were conducting their experiments, a respected member of the Royal Society of London, William Henry Fox Talbot, was doing similar work. Fox Talbot was not aware of the early work of Niepce and Daguerre, but on hearing of Daguerre's success, he made his bid for fame.

Fox Talbot was a brilliant, well-educated man. He first thought of trying to capture *camera obscura* images while in Italy drawing landscapes. He later wrote in his famous picture book, *The Pencil of Nature*, that this experience led him to reflect on the beauty of the pictures produced by the lens of the camera. It was at this time that the idea occurred to him that it might be possible to capture—and hold—these images on paper. He returned to England in 1834 and began experimenting. He had heard that silver nitrate was light-sensitive and made his first experiments with silver nitrate–coated paper. It proved unsatisfactory and he tried silver chloride.

In 1835, Fox Talbot succeeded in taking pictures with a very small camera fitted with a microscope lens. The pictures were about an inch square; he was unable to make larger ones because of optical problems. Spurred by the success of Niepce and Daguerre, Fox Talbot went to the famous scientist Sir John Frederick Herschel. Herschel immediately began experiments with photography. In less than two weeks, he found that he could produce photographs using silver salts and fix these photographs with a chemical he had discovered twenty years before—hyposulfite of soda, today's "hypo." Herschel gave Fox Talbot permission to announce the use of hypo with his own process.

Fox Talbot improved his original paper-negative process, a process wherein the paper negative from the camera was used to make an unlimited number of paper positives through the technique of contact printing. He found that he could increase the

sensitivity of the paper, shortening the exposure time, by developing the paper in gallic acid in silver nitrate solution. He called the product of this new process the *calotype*. It was later referred to also as the talbottype.

The calotype process could not compete with the daguerreotype in terms of fine detail and beauty of tonal scale, but it did permit making any number of copies. Fox Talbot tightly controlled and patented the use of his new process. It didn't flourish. Perhaps the most significant work in calotype was done in Scotland, where the patents did not apply, by Robert Adamson and David Octavius Hill. Working together, they produced a series of portraits which are famous to this day.

Fox Talbot appropriately gets credit for inventing the photographic process as we know it today, but he slowed down the evolution of photography. Because of his patents, Fox Talbot controlled the use of photography in England until 1855.

Collodion Process

A later photographic invention which proved to be a milestone was given freely to the public by another Englishman, Frederick Scott Archer. In 1851, he introduced a successful method called the *collodion* or wet-plate process. It consisted of coating a piece of glass with collodion, a chemical compound which dried to form a skinlike film which adhered to the glass. This coated plate was immersed in light-sensitive chemicals and exposed in the camera while still wet. The plate had to be developed immediately because the image in the chemicals lasted only a short time.

For the wet-plate landscape photographer this meant that he needed to take with him in the field a colossal amount of equipment, including a dark tent; a box of glass plates; chemicals for sensitizing, developing, and fixing; dishes; measures; cameras; lenses; a tripod; and often a supply of water. A wet-plate collodion photographer working in the field needed large amounts of water and five separate solutions: an iodized collodion solution which was poured evenly over the glass plate, a silver nitrate solution in which the collodion plate was sensitized in a dipping bath, a solution of ferrous sulfate in acetic acid in which the exposed plate was developed, a weak silver solution to darken the image, and varnish to protect the surface of the negative from injury.

Roger Fenton, who photographed scenes of the Crimean War, used a horse-drawn wagon as his darkroom. Fox Talbot seriously considered replacing the clear glass of the family carriage with red glass and using it as a portable darkroom.

Ambrotypes and Other Early Processes

The *ambrotype*, a variation of the collodion process, was par-

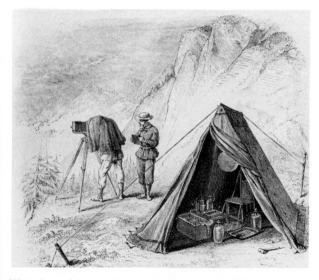
Wet-plate photography on location in the 1800's.

ticularly popular in the United States. It answered the great demand for inexpensive portraits. The ambrotype was simply a piece of glass coated with a collodion emulsion and purposely underexposed. This underexposed image was very pale. It had the appearance of an underexposed negative when viewed against white. When viewed against black, the image appeared to be a properly exposed positive. These photographs were usually encased in pressed paper or leather frames similar to the daguerreotype presentations. The ambrotype was easier to produce and cheaper, and eventually replaced the daguerreotype.

A variation of the same process produced a positive image on a thin sheet of varnished iron. The images were inferior to a true ambrotype, but they were even cheaper, easier, and faster to product. These photographs, popularly called *tintypes*, were produced in great quantity by itinerant photographers.

Another variation of the collodion process was the *carte de visite*. It used the basic idea of the collodion process in which a negative was produced on a glass plate. However, cameras with multiple lenses (usually six or eight) were used to produce one negative. This resulting negative containing multiple images was then contact-printed. The photographs were cut apart and mounted individually on 2½ x4-inch cards. The *carte de visite* eliminated the two major handicaps of previous processes: expense and quantity of reproductions. *Cartes de visite* were enormously popular, often used as calling cards. They were collected and exchanged like baseball trading cards. *Cartes de visite* of famous people were sold by the thousands.

Early Documentary Photography

Documentary photography of the world's people and places got under way in the 1850s. Since then photographers have been present wherever there are significant events or great attractions to be documented.

A New York photographer, Matthew Brady, realized the power with which photography could document the Civil War. He requested permission from President Lincoln to photograph the battlefields. Lincoln consented, but provided no financial backing. Brady was a reasonably wealthy man. He assembled a staff of several men, outfitted them with cameras and materials to make wet-plate photographs, and began photographic documentation of the Civil War.

Today his photographs are famous. They were taken and processed under incredibly difficult and dangerous conditions. Brady spent great sums of money and got almost nothing in return. There was little market for his pictures after the war ended; no one wanted to be reminded of it. The photographs were stored and eventually auctioned off. Fortunately, a great number of· them were purchased by the government. Eventually Brady received a

An Ambrotype, showing negative image when viewed against white and positive image when placed on black, causing only light reflected from silver image to be visible to viewer.

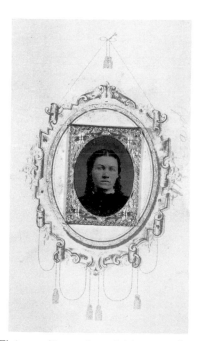

A Tintype with ornate metal frame and matte.

government grant of twenty-five thousand dollars, but he died a poor man in 1896.

An outstanding explorer-photographer was Timothy O'Sullivan, who at one time had assisted Matthew Brady. O'Sullivan was involved in western survey work in 1873. He made photographs which show the contrasts between the squalid mining-boom towns and the magnificent, unspoiled wilderness areas which were opening up.

Collotype

Serious investigations with the physical and chemical aspects of photography continued. Good glass-plate negatives could be made, but no completely satisfactory printing process was available until Alphonse Louis Poitevin, a French scientist, developed the *collotype* process.

The collotype process used gelatin sensitive to light. When exposed to light, areas of the gelatin hardened, making it less absorbent to water and capable of holding a coating of ink. The collotype plate was used for printing: the exposed portions holding water printed dark, while the unexposed portions holding water printed light in tone. When properly done, the process could produce a print with a complete range of tones. Collotype is still one of the finest printing processes known.

Nineteenth-Century Photographic Illustrators

While many scientists were concerned with the chemical and physical aspects of photography, there were other people who were concerned with the esthetic and artistic possibilities of the medium. Oscar G. Rejlander, a Swedish-born English portrait painter, became interested in photography as an aid to painting. He soon became excited about the medium for its own sake. He is primarily known for an allegorical composition he completed in 1857 called **Two Ways of Life**. One side of the photograph represents dissipation, the other symbolizes industry.

Rejlander made several prints of his photograph—which was no mean feat, since it had been taken in thirty separate pieces which he joined together by multiple-printing techniques. The finished image is sixteen by thirty-one inches and was done on two sheets of paper joined together.

Another English painter, Henry Peach Robinson, was influenced by Rejlander. He set out to produce pictures with real emotional appeal, the best known a photograph called **Fading Away**. Robinson is also remembered for the large volume of work he produced.

One of the first great portrait photographers was a woman, Julia Margaret Cameron. She was a forty-eight-year-old mother of six

when she became excited by photography in 1863. Her portraits have a unique charm which has been appreciated ever since. Many of her photographs have technical flaws and many are out of focus, but all of her portraits have style and originality. She photographed famous personalities, including Robert Browning, Alfred Lord Tennyson, and Charles Darwin, and made illustrations influenced by the literature of the time. She was not immune to the syrupy romanticism of the era; many of her illustrations for Tennyson's **Idylls of the King** are foolish. But she did bring a strength to portraiture which is admired to this day.

The Long Popular Tintype Process

In 1856, Hannibal L. Smith, a professor of chemistry at Kenyon College, patented the tintype. The tintype delivered a finished picture even faster than the ambrotype. This speed came about through the use of rapid-processing solutions. Like the ambrotype, the tintype was a collodion wet-plate negative on a dark background which resulted in a positive image. But instead of a glass plate backed with dark cloth, Smith used a metal sheet, usually iron enameled black or chocolate brown, to support the collodian.

The inexpensive tintypes quickly became a fad. Ambitious photographers turned up everywhere, taking pictures of families in parks, newlyweds at wedding receptions, and children sitting on ponies. Hundreds of thousands of young soldiers—self-conscious in their new uniforms—posed for the tintype camera before going off to the Civil War. The results were often crude, but a talented photographer could produce striking portraits with the tintype process. Many photographers remembered the special multilens cameras used to make *cartes de visite* which could produce several pictures at once and put them to use again making tintypes.

Although it was eventually replaced by roll film and the simple box camera, the tintype has never completely disappeared from photography. Even today you may have your tintype photograph made in many countries of South America, in front of the Leaning Tower of Pisa in Italy, near the Eiffel Tower in Paris, and in many other cities of the world.

The Dry Plate

The frustrating inconveniences of the wet-plate process prompted eager experiments to discover a dry substitute. Collodio-bromide dry plates were placed on sale in 1867 in England. These plates were extremely slow, requiring exposures of thirty seconds or more.

In 1878 Charles Harper Bennett devised the technique of "ripening" the emulsion by storing the coated plates at ninety degrees (Fahrenheit) for several days. This resulted in a significantly faster film, permitting short exposures. Several manufacturers began

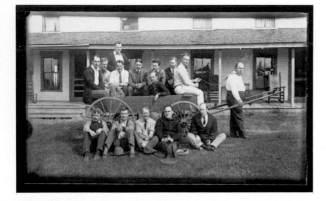
A Dry-plate snapshot. (c. 1900)

producing gelatin dry plates, which did away with the need for a portable darkroom in which to coat plates and to process them immediately after exposure.

The introduction of the dry plate allowed "Sunday photographers" to leave their exposed plates with someone else for developing and printing—giving birth to the photofinishing industry.

Roll Film

In 1889, George Eastman, an obscure manufacturer of dry plates in Rochester, New York, devised a method by which an emulsion could be applied to a flexible support. At first he used a paper support. He later changed to *nitrocellulose*, a new material possessing all the qualities of glass but with the additional advantages of lightness and flexibility. This flexible, transparent plastic could be rolled, permitting many photographs on a single piece of film.

Eastman designed a small camera in which he could place a roll of film. The camera was little more than a box with a lens and shutter release and a film-advance mechanism. The camera, loaded with a hundred-exposure roll of film, sold for about twenty-five dollars. Eastman invented the name "Kodak" for it quite arbitrarily. He was looking for a name easy to remember, one not likely to be mispronounced in any language, and one that could be registered in the patent office without confusion. The name "Kodak" and the slogan which accompanied it—"You press the button, we do the rest"—soon became household words. The slogan told it all.

When the hundred pictures were taken, the owner mailed the camera back to the company. For a fee of ten dollars, the film was removed and processed, prints were made, and the camera was reloaded and returned to its owner, ready for the next hundred pictures.

The Kodak made photography popular, and this popularity resulted in the formation of large corporations such as Eastman Kodak Company. It was within these corporations that further significant technical research was carried out. Improvements in materials, processes, and cameras followed rapidly. The snapshot era had arrived.

By 1910 a large variety of cameras were available. Action pictures were made possible by higher-speed films. Fast and well-corrected lenses were being produced. New and valuable uses for photography were being encountered rapidly.

COLOR PHOTOGRAPHY

Joseph Niepce, the Frenchman who became the first man to actually take a photograph with the camera, wasn't satisfied. He

"If it were possible for any one person or group of people to go through a photographic finishing plant's work at the end of a day, you could probably pull out the most extraordinary photographic exhibition we've ever seen. On almost any subject. The trouble is to find the things. And very frequently, the photographer who's made them doesn't recognize them and scraps it. If he knew how good the picture was, or how important it was, not only wouldn't he scrap it, but he would use it as a guidepost to himself in the future."

EDWARD STEICHEN

looked for a way to produce a color photograph. Louis Daguerre, the first man to create a really practical commercial form of black-and-white photography, wasn't satisfied. He too recognized the need to produce color photographs.

One hundred years later, "Man" and "God" made color photography simple enough for anyone to use. In the early 1930s, two young musicians working in Eastman Kodak's research laboratories, succeeded in producing a workable system of taking pictures in color. They were Leopold Mannes and Leo Godowsky, Jr., nicknamed Man and God by fellow scientists at Kodak. This triumph of "Man" and "God" was an appropriate climax to a century-old search.

Although a method of photographing in color that was both simple and effective was not developed until 1935, fairly good color pictures could be made as early as 1868, if one wanted to take the trouble. The first man to produce color photographs successfully was one of the greatest physicists of all times, James Clark Maxwell. It was Maxwell who formulated the mathematical equations for magnetism, electricity, and light and who conceived the idea of electromagnetic waves, laying the basis for radio and television.

In 1861, Maxwell presented the hypothesis that the eye is sensitive to only three colors in the visible spectrum: red, green, and blue. To demonstrate this hypothesis, Maxwell made three black-and-white photographs of a colorful ribbon. One negative was made with a red filter in front of the camera lens, the second with a blue filter, and the third with a green filter. Lantern slides were made from each of the negatives, producing positive transparencies. All three slides were black and white, but each had tones that represented the amount of one of the three colors in the ribbon.

To produce a color image of the ribbon, Maxwell placed each slide in a projector fitted with the color filter appropriate to the slide: red for the slide made with a red filter on the lens, blue for the one made with a blue filter, and green for the one made with a green filter. The light passing through the lens of the projector was filtered so that the red slide cast a red image, and so on. When these three projected images were thrown on a screen, precisely superimposed, the colors combined in the additive method of mixing color to reproduce a single image of the ribbon in its original hues. This experiment is often repeated by students of photography.

Not long after Maxwell demonstrated the additive color process, two young Frenchmen came up with another system which was to prove more significant. Although they worked independently of each other and Maxwell, they presented their ideas and results almost simultaneously. Charles Cros revealed in 1869 his work on a *subtractive* color process. At the same time, Louis Deaucoux du Hauran described several alternative methods of making color photographs.

Cros and du Hauran, independently, had developed a process now referred to as the subtractive color process, which has become the basis of all practical present-day systems of color photography.

In the subtractive process colors are created by combining dye images. Like the additive method, it employs three negatives representing red, green, and blue in the subject. In the subtractive process the images are transformed by a complex series of steps into cyan, magenta, and yellow dye images. The dye images are superimposed to provide a single picture with the color already in it.

Du Hauran produced many color photographs this way. A few have survived and they exhibit astonishingly good renditions of color, but du Hauran's subtractive process never was made practical.

The first practical color photographs employed Maxwell's *additive* process. The most successful were the autochrome plates invented by Auguste and Louis Lumière. They used color dots. The autochrome plates fit into standard cameras and were developed in a fairly simple manner.

During the 1920s photographers such as Edward Steichen, Alfred Stieglitz, and Louis Lumière produced hundreds of beautiful color photographs. The **National Geographic** printed color photographs made in Egypt, India, and other places by its correspondents. The autochrome process never gained acceptance by the public in general, but a limited number of professional photographers were able to work with it.

Kodachrome—First Popular Process

It wasn't until the 1930s that Mannes and Godowsky at Kodak were able to produce a workable system of color photography using the subtractive process. By 1933, they had come up with a color film for home movies which used only two primary colors. The results were fair. Mannes and Godowsky were determined to perfect a three-color process before the two-color film was made available to the public. They were successful. On April 15, 1935, Eastman Kodak placed on sale a film called *Kodachrome*, the result of the work of these two young musicians. The year after its introduction in amateur movie-camera size, it was put on the market in 35-mm rolls for still cameras. This new Kodachrome produced a positive transparency.

Mannes, Godowsky, and the Kodak research staff continued to work on several variations of the three-color process. Ektachrome, the film with color couplers in the emulsion so that it can be developed in any well-equipped darkroom, and Kodacolor, the negative color film from which contact prints and color enlargements can be made, were the results of their work.

Before Kodak succeeded with its Ektachrome, the German photographic firm Agfa found a way to include couplers in the emul-

"I wish there were a thing that I could put in my eye, just blink, twist my ear and pull it (a photograph) out of my mouth."

ART KANE

sion of film. Agfa began marketing its own *Agfacolor*, beating Kodak to the punch. The closely guarded technical details of the method for making Agfacolor were uncovered by U.S. troops when they liberated the photography plant in Germany near the close of World War II. The formulas were distributed to film manufacturers around the world. The original Agfacolor has thus become the basis for a variety of color processes.

Their work completed, Mannes and Godowsky left Kodak. Mannes returned full time to his first love, music, and eventually took over management of his father's school in New York City. Godowsky occasionally performed as a professional violinist and continued to take an active part in color photography and research in color television.

Lippmann Color Process

The subtractive and additive methods of color photography attempt to reproduce all colors by mixing varying proportions of a few primary colors. This never quite works. The only known method of reproducing all colors exactly as they are in nature turned out to be impractical. This method, demonstrated in 1891 by physics professor Gabriel Lippmann, won him the Nobel Prize in 1908.

Lippmann's process makes use of the phenomenon of light interference: the interaction of light waves that produces that brilliant array of colors seen in oil slicks or soap bubbles. The Lippmann process requires a fine-grain emulsion of a bath of mercury. Reflections from the mercury surface create the interference in the emulsion that records the colors in black and white. Interference in viewing recreates the colors, which are unsurpassed in reproducing reality. Because of the complexity of the method, Lippmann's achievements remain a scientific curiosity.

Color Photographs in a Minute

Perhaps the most outstanding development within color photography occurred in late 1962, when Edwin H. Land's Polaroid Corporation revealed the Polaroid color process, yielding a color print that develops in a minute. The chemistry on which the processing of Polacolor is based is extremely complex. It is a subtractive-type color film in which dyes form the three primary colors.

The remarkable thing about Polacolor is that all the chemicals must be included in a roll of film small enough to fit inside a relatively small camera. Contained within a cross section of the film, no greater than half the thickness of a human hair, are the six color layers required to create the negative image, three layers of emulsion, layers that contain specially designed molecules of developer and dye, four other layers that form positive images, and a layer containing a pod of alkaline chemical which triggers

"Thinking should be done beforehand and afterwards, never while actually taking a photograph."

HENRI CARTIER-BRESSON

28

the processing. Polacolor employs a *dye-diffusion* technique for getting the colors from the negative to the positive paper.

POLAROID LAND PHOTOGRAPHY

In the 1930s a young student scientist at Harvard, Edwin H. Land, discovered a way to make synthetic polarizing materials. He left school to begin manufacturing polarizing filters. The advent of World War II found his organization preeminently equipped to manufacture antiglare goggles and gunsights and to carry out research on infrared sensing devices. Toward the end of the war, Land hit upon the "picture in a minute" idea. He assembled a small staff of researchers to assist him in the investigation of the problem.

The first Polaroid Land camera was marketed in 1948. The print film was slow, not sensitive to red, and gave a *sepia* or reddish-brown image. Within a few years, a film giving good black-and-white images replaced the old sepia-print film. This development was followed by the introduction of a black-and-white transparency material. A system permitting the use of Polaroid Land film in 4x5 press cameras was announced in 1957. The world's fastest film, type 107 or type 47 with a speed of ASA 3000, was marketed in 1959. The ten-second-development films were introduced in 1960 —yielding, literally, pictures in an instant.

A unique positive/negative film, type 55, was introduced in 1961. Polacolor, giving color pictures in fifty seconds, reached the market in 1963, after years of perfecting in the Polaroid laboratories. In the same year a new and revolutionary system of photography was introduced: an automatic camera which used a simple film-pack system in place of the familiar double roll. This camera had a highly sophisticated electronic shutter.

One of Polaroid's latest developments is a vest-pocket-sized compact camera, producing color photographs which develop before your eyes outside the camera. It is quite reasonable to expect that one day in the not-so-distant future, Polaroid will come up with a camera producing color slides in an instant.

The Polaroid SX-70 Land Camera.
This latest advance from Polaroid is a single-lens reflex producing color photographs which are immediately ejected from the camera and develop in the light in five to 10 minutes. Unique optical and chemical wizardry are incorporated in a unit which folds to vest-pocket size. The camera was called "Project Aladdin" during secret development and research stages.

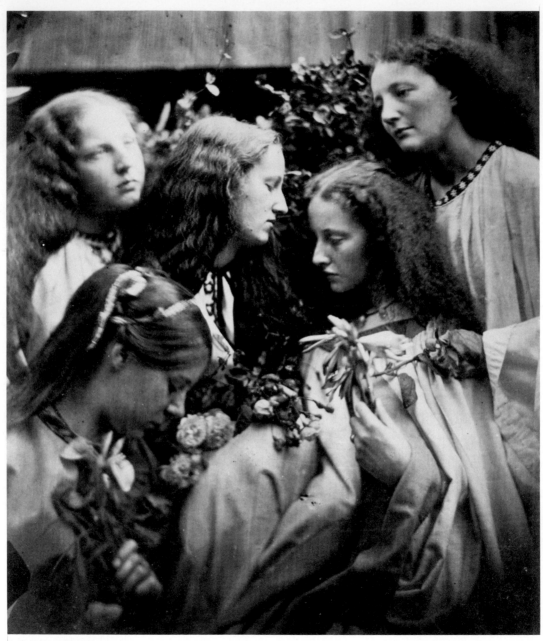

Julia Margaret Cameron.
"*Rosebud Garden of Girls*, 1868." (RPS)

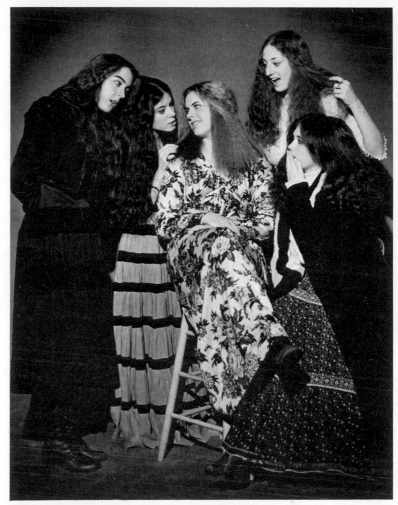

Anthony Armato.
From "*Theatrical Series*." 1971.

These photographs, made more than 100 years apart, bear
an astonishing similarity to one another. The photograph
opposite, "*Rosebud Garden of Girls, 1868*," was made by
Julia Margaret Cameron using the slow and awkward wet-
plate process. The photograph above was directed and
photographed in New York by Anthony Armato in 1971.
Armato had never seen the Cameron photograph.

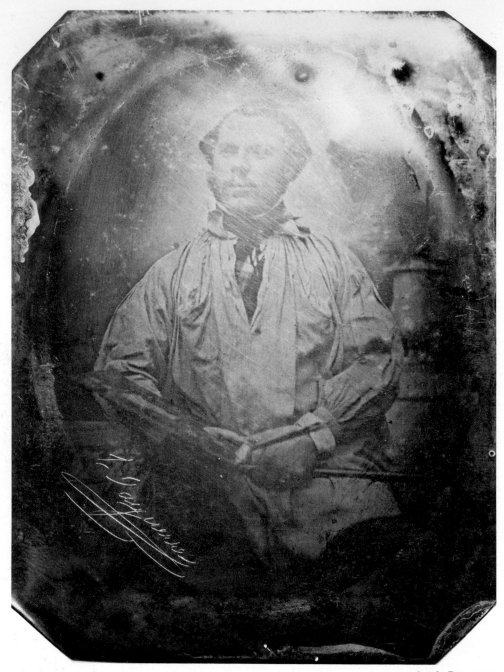

Louis Daguerre
"Portrait of a Painter." c. 1840.
The only signed example of the photographer's work.
(G.E.H.)

David Octavius Hill and Robert Adamson
"D.O. Hill." c. 1843/45.
From a photogravure 1905. (G.E.H.)

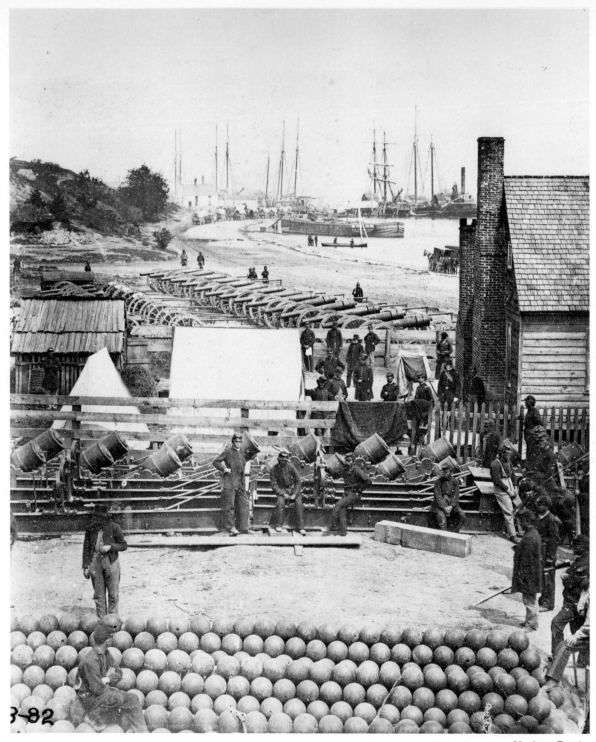

Mathew Brady
"The James River at Yorktown, Virginia. 1864." (L.C.)

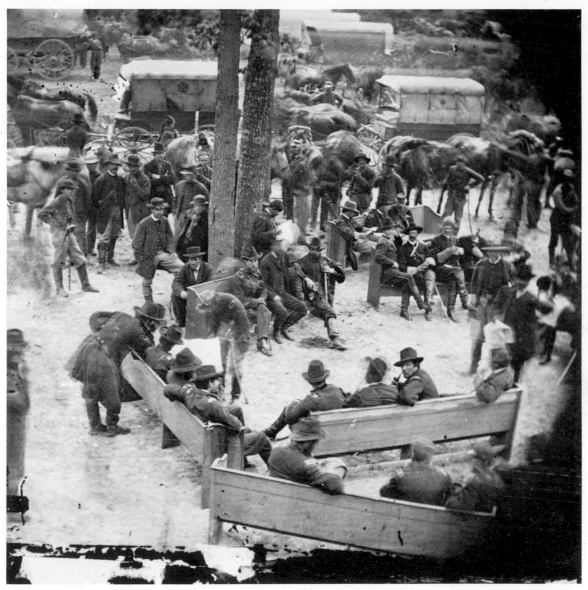

Timothy H. O'Sullivan
"General Grant and officers." 1864. (L.C.)

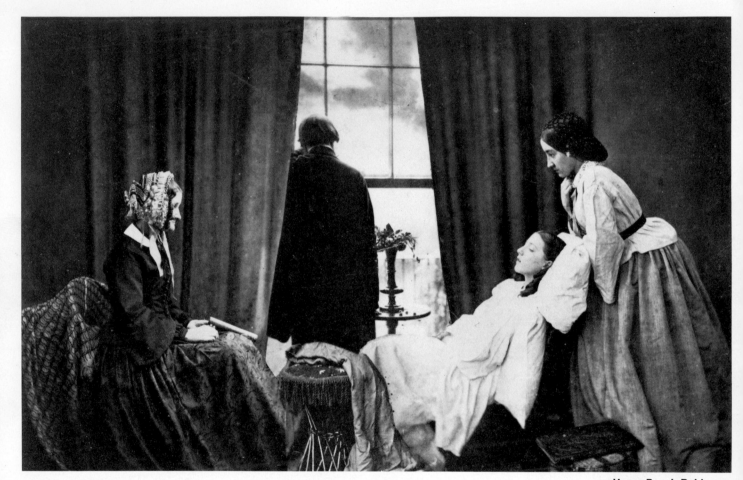

Henry Peach Robinson
"Fading Away." 1858. (R.P.S.)

Oscar G. Rejlander
"The Two Ways of Life." 1857. (second version on bottom)
Composite picture made from more than thirty negatives.
(R.P.S.)

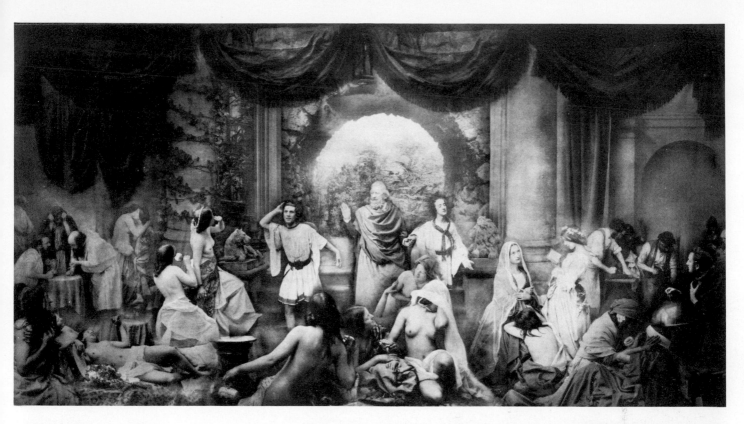

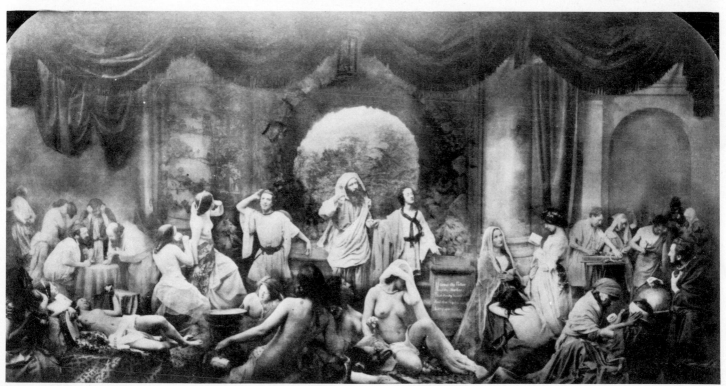

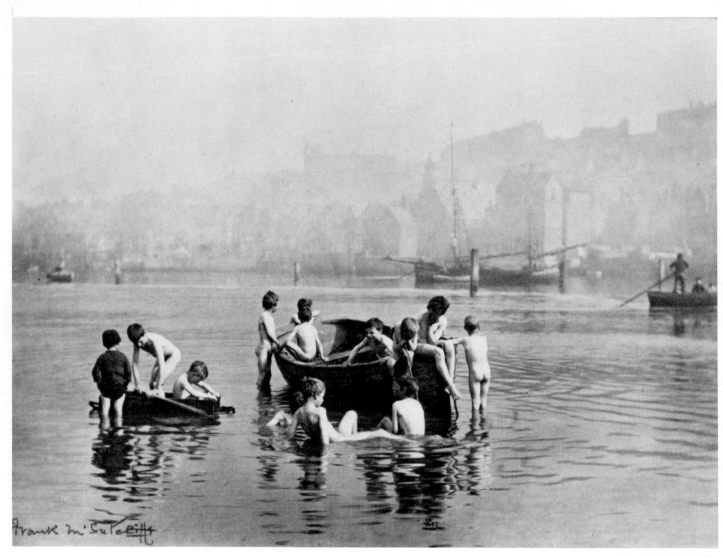

Frank M. Sutcliffe
"*Water Rats.*" 1885. (R.P.S.)

Weston Kemp
"*Joanne.*" 1962. Photographed with experimental
Polaroid material.

C. Tyler Quillen
"Photogram." 1971.

PHOTOGRAMS 2

camera-less photography

2

Gil Smith, Photogram.

In the 1830s, Fox Talbot placed a piece of lace on his sensitized paper and produced his first photographic image—a photogram. A *photogram* is the simplest and easiest photographic image to produce. It is made by placing any object on a sheet of photographic paper and exposing the paper to light for a few seconds. Since photographic paper darkens where exposed to light, the photogram will be a negative image.

Semitransparent objects, translucent objects, and opaque objects can be used to produce your photograms. Try such things as grass, beads, broken glass, crumpled cellophane, plastic wrap, drops of water, streaks of honey, rise, marbles—the possibilities for variety are limited only by your imagination.

Exciting photogram images can be produced by clever modulation of the light hitting the photographic paper. Some of the most effective photograms are produced by moving a small penlight at a distance of two to three feet from the paper during the exposure time to produce changing shadow patterns.

Your first photograms may be awkward and corny, but they should be useful as stepping-stones to more serious experimentation with the process.

The Photogram as a Serious Visual Medium

The first man to explore and exploit the full range of possibilities in photograms—distorted images, multiple exposures, reverse tones, and other variations—was an American, Man Ray. Ray was an irrepressible experimenter. One day he placed a piece of un-exposed photographic paper in a tray of developer. On the paper he placed a glass funnel, a graduate, and a thermometer. He then turned on the light. "Before my eyes, an image began to form, not quite a simple silhouette of the objects as in a straight photograph but distorted and refracted by the glass."

Excited by the visual possibilities of this technique, Ray experimented with strewing every sort of object on the printing paper—bottles, scratched glass, beads, hairpins, wire, anything that would modulate light. Opaque objects produced images with sharp contours; translucent ones added a variety of textures and tones. Sometimes he used a stationary light for the exposure; at other times he used a moving flashlight. The photograms of Man Ray have served as a model and inspiration for much of the work subsequently done with this technique.

A Hungarian, Laszlo Moholy-Nagy, produced a large collection of photograms while at the Bauhaus in Germany. Moholy-Nagy felt that the photogram was the purest form of photography. He explored all the effects of light striking a light-sensitive material. He said, "Cameraless pictures are . . . direct light diagrams recording the action of lights over a period of time, that is the motion of light in space." He felt that the photogram had no real relationship to subject matter. Its only content was the elements of its design, the play of light in space. His photograms simply utilized light and film to make beauty.

"The photogram opens up perspectives of a hitherto wholly unknown metamorphosis governed by optical laws peculiar to itself."

LASZLO MOHOLY-NAGY

To make a photogram, follow these steps:

1. In total darkness or under a suitable safelight, place an object on a sheet of photographic printing paper such as Kodabromide or Polycontrast.

2. Expose the paper to light for a few seconds, using an enlarger, a flashlight, or an ordinary lightbulb.

3. Place the exposed paper in a standard developer, such as D-72 or Dektol diluted 1:2 with water, for about a minute-and-a-half. An image of the object's shadow will appear as a light tone against a dark background.

4. Transfer the photographic paper to a stop bath, a weak acid solution.

5. Place the paper in a fix or hypo solution for about five minutes. The fixer washes out the unexposed silver halides in the paper emulsion to make the image permanent.

6. Wash the photogram in running water for one hour to remove any remaining chemicals.

7. Dry the photogram in a blotter roll or on a heated-drum dryer.

Typical collection of materials used to produce photograms.

Objects arranged on piece of enlarging paper and exposed.

Exposed paper is placed in developer for 1½ minutes with continuous agitation.

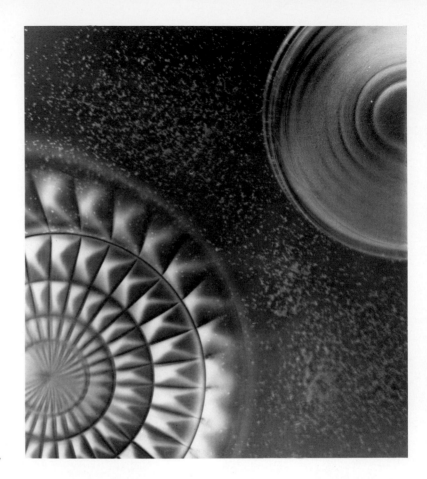

Joseph Polanin, Photogram,

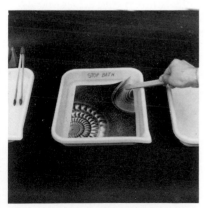

Photogram is transferred to stopbath for 20 seconds.

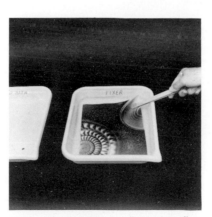

Place photogram in fixer for five minutes with occasional agitation.

Wash photograms in tray for one hour before drying.

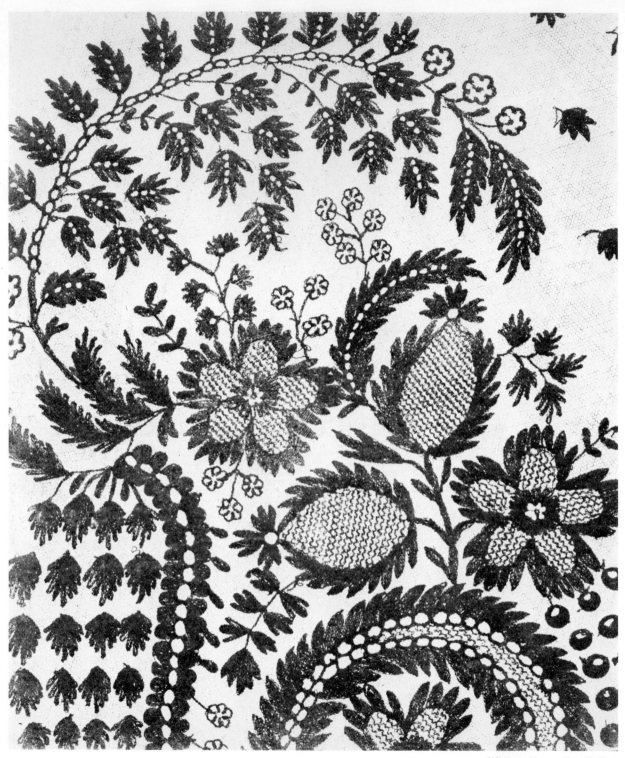

William Henry Fox Talbot
"Lace." c. 1839. Photogram. (G.E.H.)

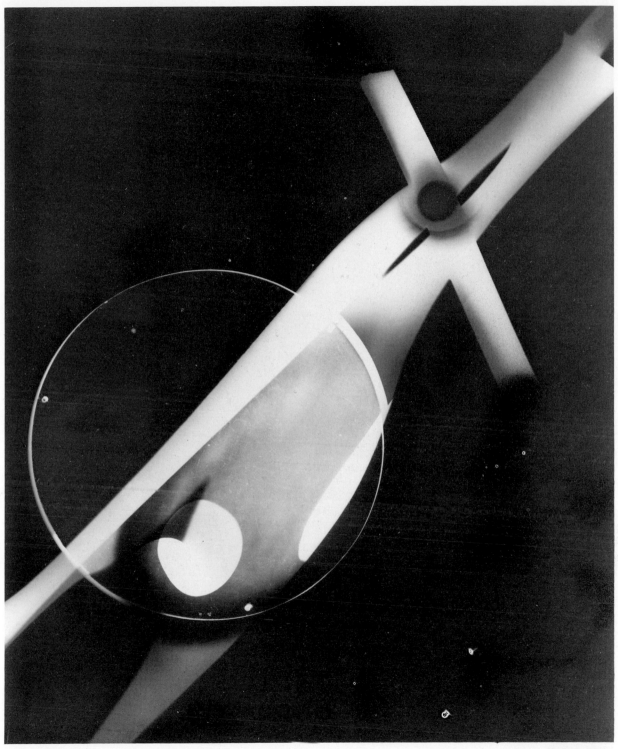

Lazlo Moholy-Nagy
"Photogram." 1924. (G.E.H.)

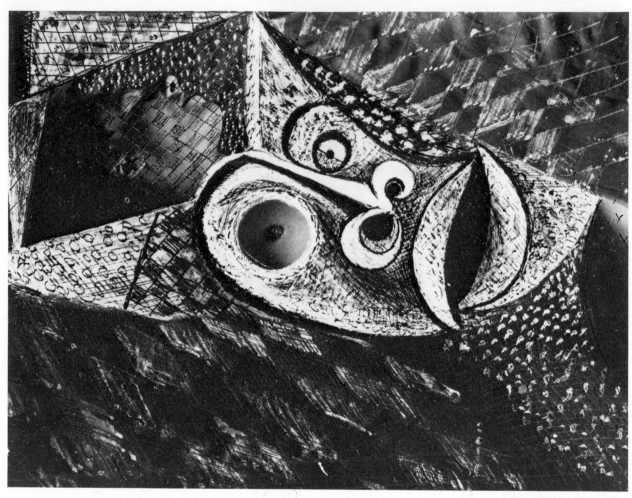

Brassai (Gyula Halasz)
"Tentation de Saint Antoine " from Transmutations. 1969.
Cliché-verre. (G.E.H.)

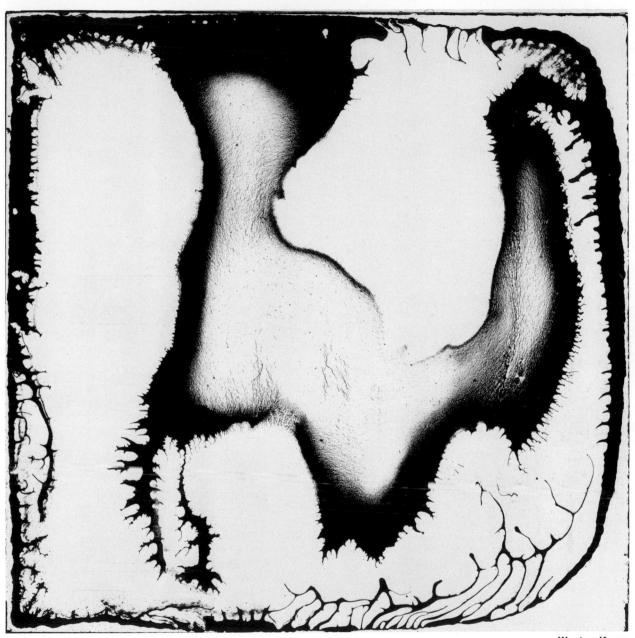

Weston Kemp
"Capillary Activity." 1972. Photogram.

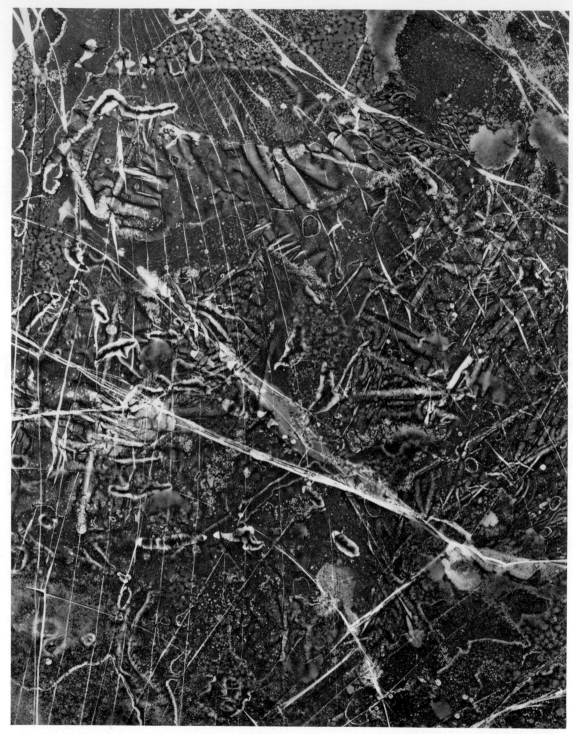

Tom Muir Wilson
"Honey and Salt." 1960. Photogram.

Francis Bruguiere
"The Light That Never Was on Land or Sea." 1926.
Light Abstraction. (G.F.H.)

CONTEMPORARY CAMERAS 3

simply "superboxes"

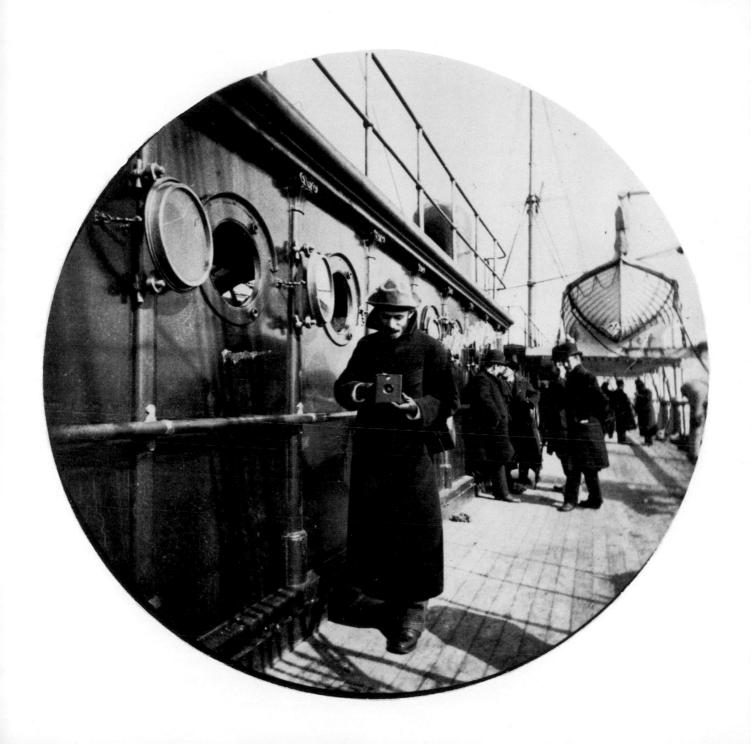

3

There is a bewildering array of cameras in all shapes and sizes available in today's photographic marketplace. They range in price from twenty-five dollars to more than a thousand dollars. All are essentially "superboxes." Each has a lens, a shutter, a viewing and focusing system, and a film-holding or film-transport mechanism.

For all practical purposes, cameras can be put in one of the following categories:

- 35-mm rangefinder cameras
- 35-mm single-lens reflex cameras
- Roll-film cameras (available in 2¼x2¼, 2¼x2¾, or 2¼x3¼ image size, and as either rangefinder, single-lens reflex, or twin-lens reflex models)
- Press cameras (usually 2¼x3¼, 3¼x4¼, or 4x5 image size)
- View cameras (usually 4x5, 5x7, or 8x10 image size)
- Special-purpose cameras

35-mm Rangefinder Camera

The 35-mm rangefinder camera is small, compact, and quiet. The rangefinder consists of two mirrors, or prisms, placed about two-and-a-half inches apart. When you look through the rangefinder window (in some cameras the rangefinder window and the viewfinder window are combined), you will see a double image if the lens is not focused on your subject. By rotating the focusing mount on the lens, the two images are made to converge, at which point the lens will be in focus.

A quality rangefinder system is very accurate. For some photographers, particularly those involved in photojournalism, the rangefinder camera has distinct advantages over a single-lens reflex camera. Many photographers feel that it is a faster camera to operate with the rangefinder and viewfinder combined in one window. Focusing and composing the picture is both simple and fast. The bright image seen in the optical viewfinder is particularly useful when working in poor light conditions. Most 35-mm rangefinder cameras have provisions for interchangeable lenses, permitting the use of wide-angle and telephoto lenses. A rangefinder camera is usually lower in price than a single-lens reflex.

The rangefinder does have disadvantages which have made it less popular than the single-lens reflex. The viewfinder doesn't frame your subject from exactly the same point as the lens of the camera. This introduces an error called *parallax*, which simply means that the camera lens does not record exactly what you see through the viewfinder. The rangefinder has no provision for visually previewing the depth of field obtained with a given aperture. This is a particular disadvantage if you are attempting to use depth of field creatively, when it is important that you know what is and is not in focus at a particular *f*-stop.

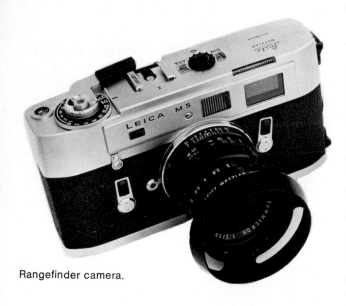
Rangefinder camera.

Rangefinder cameras are not limited to the 35-mm format. Cameras taking 120 or 220 roll film are on the market. Press cameras designed for sheet film also have rangefinder focusing systems.

Single-Lens Reflex Camera

The basic design of the single-lens reflex camera has been around for more than a hundred years. Single-lens reflex *camera obscuras* were used before 1800, but only in the last two decades has the modern single-lens reflex enjoyed popularity and success.

Most contemporary single-lens reflexes have focal-plane shutters. The camera lens is used for both viewing and taking the photograph. The camera is designed with a movable mirror behind the lens. When viewing and composing a picture, the mirror is inclined in such a way as to reflect the image up to a ground glass screen. When the shutter release is pressed to take the picture the mirror swings upward, sealing light from the ground glass opening, and the focal-plane shutter curtain travels across the film surface to make an exposure. The mirror then returns to its position behind the lens, restoring the viewfinder image. The action of the mirror makes the single-lens reflex somewhat noisier than the rangefinder.

The single-lens reflex gives a parallax-free image. Because you actually view your subject through the taking lens, the single-lens reflex is perfect for closeups and extreme telephoto situations. You can easily stop the lens down and preview the depth of field at any time. Most single-lens reflexes have provisions for interchangeable lenses.

The 35-mm single-lens reflex is probably the best general-purpose camera, although it is a little heavier, a little bulkier, and a little more expensive than the rangefindor camera. Excellent and reliable 35-mm single-lens reflex cameras are made by Minolta, Canon, Nikon, Leica, and Pentax.

Roll-Film Cameras

The first roll-film camera was the Kodak, introduced in 1889 by George Eastman. Not a versatile camera; it was intended to be used only on bright, sunny days. It became the camera for family events—weddings, picnics, parties, reunions. This camera introduced photography to the general public.

Roll-film single-lens reflex cameras operate similarly to the 35-mm single-lens reflex. Some feature a separate, removable film-magazine system. A magazine holding a partially exposed roll of film can be removed and replaced with a magazine holding a different type of film. This gives the photographer more versatility—the ability to switch from black-and-white to color, for example.

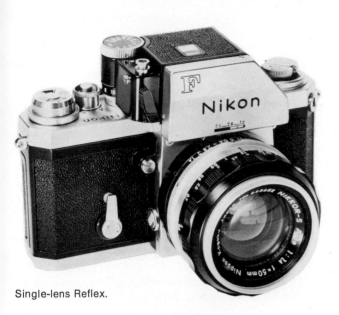

Single-lens Reflex.

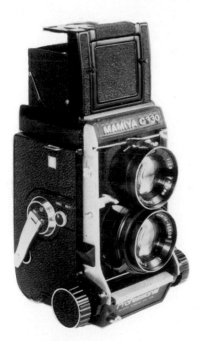

Twin-lens Reflex rollfilm camera.

The 2¼ x 2¼ single-lens reflex roll-film camera is particularly popular with advertising and fashion photographers. Though bulkier and heavier than the 35-mm single-lens reflex, it offers the same advantages, plus the additional advantage of larger negative size.

Currently, several manufacturers produce single-lens reflex roll-film cameras such as Hasselblad, Bronica, Rolleiflex, Graflex, and Pentax. They are very expensive, some costing more than a thousand dollars.

A second type of roll-film camera is the *twin-lens* reflex. The twin-lens reflex has two lenses, one above the other. The top lens is for focusing and composition, the bottom one for exposing the film. The two lenses are mounted to enable them to be moved back and forth together. As the image on the ground glass comes into focus, the lens for exposing the film is simultaneously focused. It is as quiet or quieter than the rangefinder camera since no moving mirror or focal-plane shutter is used. A between-the-lens shutter, which is quieter than a focal-plane shutter, is most often used with twin-lens reflexes. Another advantage of the twin-lens reflex is that the image can be seen at all times on the ground glass; it never blacks out during exposure.

A twin-lens reflex does not offer the variety of lenses common to the single-lens reflex. A few models do have a limited range of interchangeable lenses.

Good twin-lens reflex cameras include Rolleiflex, Mamiya, and Yashica.

Press and View Cameras

The press camera is usually found in the 4x5 format. Until recently it was very popular with newspaper photographers, but most newspapers are now replacing their press cameras with twin-lens reflexes and 35-mm cameras. The press camera is heavy, but it can be used as a hand camera. It is a compromise camera, having some of the features of a view camera and some of the features of a rangefinder.

Today's view cameras are highly refined versions of the first cameras made. They are large cameras which use sheet film. The film is loaded into holders, which are inserted in the back of the camera in front of the ground glass. Many feel that the view camera is photography's most versatile instrument. A view camera permits the film and lens to be deliberately unaligned. This capability permits making pictures which are impossible to produce with any other kind of camera. The view camera is used extensively in product photography, formal portraits, architecture, closeups, situations requiring great depth of field, and for large images of highest quality. View cameras can be adapted for almost any lens or shutter.

View Camera.

Focusing with a view camera is accomplished by viewing the ground glass with the shutter open. A black cloth is used to block out light so that you can see the ground glass image. The view camera has a variety of adjustments to enable the photographer to control perspective and depth of field.

View cameras must be used on a tripod and are slow and awkward to use. They are not suitable for action photography, candid portraits, or other situations where you need to work fast and be very mobile.

Special-Purpose Cameras

Special-purpose cameras include underwater cameras such as the Nikonos; power-driven cameras such as motorized Nikon or the larger-format Hulcher, used to photograph such events as a space shot or to capture picture sequences at a football game; and subminiature cameras such as the Minox, long popularly associated with espionage.

In selecting a camera for yourself, it's important to consider your particular needs. Look at the advertising, but keep in mind that every manufacturer feels his camera is the best and the ideal one for you. Especially in the early stages of your photographic education, avoid getting a camera that requires more knowledge and skill than you have. Like any other tool, a camera is worthless unless it fits your needs and requirements.

Your first fine camera doesn't necessarily have to be a new one. With careful shopping you should be able to find a camera in like-new condition for about half-price. Check with the camera dealers in your area. A good used Nikon, Canon, or Pentax still has many years of fine photography in it.

Check out used equipment very carefully for signs of careless handling. There should be no scratches on the lens, and the various controls should operate freely. Reject any camera with a lens that shows signs of having been dropped or abused. Most reputable camera dealers will allow you to shoot a roll of film with any camera you are seriously considering buying. Check the negatives carefully for scratches. Check prints and negatives for sharpness. If the pictures look good and you're satisfied with the operation of the camera, it's probably a good buy if the price is right.

Nikonos II underwater camera.

LENSES

The prime function of a lens is to project a sharp and accurate image onto the film. It is the most important part of your camera. You won't get good pictures unless you are using a good lens—and the right lens. Good lenses are not cheap, but they are essential to making good pictures.

Even if you have a good lens, you still may not have the right one. There are three basic types of lenses—normal, long, and short—to answer different photographic needs. Most cameras are equipped with a *normal* lens, so called because the size and perspective of its images seems the most lifelike to the human eye. The long (*telephoto*) lens magnifies distant objects, allowing a large image without your moving up close to the subject. The short (*wide-angle*) lens gives a wide view and a smaller image than your eye sees. The kinds of pictures you want to take will determine the kinds of lenses you need.

As you experiment and gain confidence in photography, you will probably feel handicapped by having only a normal lens for your camera. If you're getting into nature photography, for example, you'll soon be frustrated with your inability to get sharp and distinct photographs of wildlife. If you're at large gatherings, you may want closeups of faces in the crowd. In sports photography you may want to get closeups of dramatic plays at midfield. A telephoto lens will help you solve these problems. If you've been working with a 50-mm lens on a 35-mm camera, a 400-mm lens will magnify your images by eight times. Thus, a subject which is forty feet away will appear to be only five feet away.

The telephoto lens will compress perspective and eliminate the feeling of space between objects in the scene. You can use this optical effect as a creative tool. A long lens, because of its great focal length, produces almost no depth of field, even at small apertures. This allows you to make photographs with a background entirely out of focus.

A telephoto lens magnifies the image size. It will also magnify any camera movement of which you may be guilty. Long telephoto lenses often require the use of a tripod for sharp pictures. Most photographers cannot hold a 400-mm lens and get sharp pictures when shooting with shutter speeds slower than 1/250 second.

A wide-angle lens accomplishes the opposite of the telephoto lens. It is the answer when you want to get more of a subject onto a piece of film than is possible with a normal lens. This becomes extremely important if you're physically prevented—as by the walls of a room—from getting as far back as is necessary to make the picture with a normal lens.

A wide-angle lens allows you to use size distortion creatively. You can make parts of a person or object appear unnaturally large to emphasize your visual statement. Another advantage of the wide-

angle lens is its enormous depth of field. A 25-mm lens focused at ten feet with an aperture of f/16 will give an image with everything in focus from two feet to infinity.

Because of its unusual rendition of perspective and proportion, a wide-angle lens does not lend itself to portraiture. Nonetheless, very effective photographs—caricatures really—have been made of faces using a wide-angle lens.

Lenses are made of glass and are fragile. They must be protected from scratches. Scratches will reduce the effective sharpness of any lens. Many photographers keep a protective skylight filter on their lenses. These lightly-tinted filters take the punishment, get the dirt and occasional scratches, and protect the easily damaged lens surface. It is much cheaper to replace skylight filters occasionally than to replace fine and expensive lenses.

The lens must be kept clean. Dirt, dust, and fingerprints reduce its sharpness. Clean a lens with great care to avoid scratching the surface. Use a camel's-hair brush to gently brush away dirt and dust. Use inexpensive lens tissue to carefully and gently remove fingerprints. Stubborn dirt or fingerprints can be removed safely with Kodak Lens Cleaner. Use only lens tissues specified for photographic lenses. A shirttail or clean handkerchief should be used only when nothing better is available.

A 300mm telephoto lens and construction diagram.

A 16mm extreme wide-angle lens and diagram.

28mm, 15 feet.

50mm, 15 feet.

28mm, 15 feet.

28mm, 9 feet.

105mm, 15 feet.

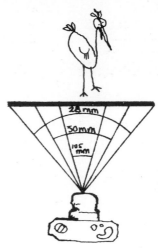

These photographs, each taken at 15 feet from the girl, demonstrate that different focal length lenses change image size but not perspective. The diagram shows the reduced angles of view as larger images of the subject are recorded on the film. The photographs were made with 28, 50, and 105 mm lenses.

28mm, 3 feet.

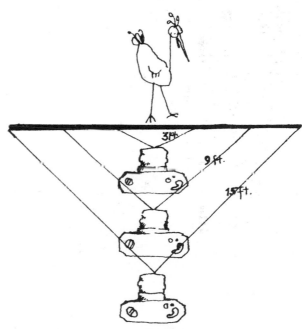

These photographs demonstrate how changing the distance from the subject affects both image size and perspective. A 28mm lens was used for each photo. The first photograph was exposed at 15 feet, the second at 9 feet, and the third at 3 feet. Moving closer has the effect of enlarging foreground images more than background ones giving the three different perspectives. The diagram shows how the angle of view remains the same for each photograph. The angle of view depends on the lens being used, not the distance from the subject.

Shutters

The shutter controls the flow of light from the lens to the film by the amount of time it remains open. Shutters are commonly calibrated to open for 1 second, 1/2 second, 1/4 second, 1/8 second, 1/15 second, 1/30 second, 1/60 second, 1/125 second, and so on—all the way down to 1/2000 second in some models.

Each change in the shutter setting changes the exposure by half or double the previous setting, giving the photographer an orderly choice of speeds. Most shutters have provisions for time exposures, allowing them to remain open for minutes or even hours. Some shutters feature an optional self-timer, delaying operation for a few seconds to allow the photographer to get into the picture himself.

The leaf shutter consists of a number of small, over-lapping metal blades activated by a spring. When the shutter release is pushed, these blades open and shut for the preset length of time.

The focal-plane shutter is usually positioned directly in front of the film in the rear of the camera. It has a mechanism which brings a spring-driven curtain containing a narrow slit across the film at high speed. The speed of the curtain and the width of the slit can be adjusted for the desired exposure. The major criticism of the focal-plane shutter is that it is slightly noisier than a leaf shutter. Another disadvantage is that when using flash, particularly electronic flash, the focal-plane shutter can be synchronized with the flash only at low speeds. Leaf shutters allow synchronization at speeds as fast as 1/500 second.

Photographed at a slow shutter speed of 1/30 second, a fast moving motorcycle nearly vanishes in a blur.

A fast shutter speed of 1/500 second was required to freeze the speeding cycle.

A focal-plane shutter is located just in front of the film at the back of the camera. These drawings show how the slit in the shutter curtain passes across the film exposing different portions as it moves. Because the slit moves at a fixed speed, all portions of the film receive equal exposure.

The leaf shutter is usually located in the lens and consists of many small, overlapping, spring-powered, metal blades. When the shutter is released, these blades open for a preset time, then close. The amount of light passing through the lens is controlled by how long the shutter is adjusted to open and by the size of the lens aperture.

"Panning" the camera with the action permits the use of a slow shutter speed to retain detail in the speeding cycle The blurred background contributes to the feeling of motion.

Because the cycle was moving directly towards the camera, little blur is apparent in a photograph made at the same shutter speed as the photo at far left.

Diaphragm (Aperture or f-stop)

The aperture works like the pupil of your eye. It may be enlarged to allow more light to enter, or contracted to reduce the light passing through. This is done with a ring of thin, overlapping metal leaves called the *diaphragm*, located inside the lens. By turning a control on the lens, the leaves can be rotated back out of the way so that all the light reaching the surface of the lens passes through. Turning in the opposite direction closes the aperture down, making a smaller and smaller opening until the smallest possible opening is obtained.

The size of the aperture is measured on a scale of numbers called f-stops. Commonly used f-stop numbers are f/1.4, 2, 2.8, 4, 5.6, 8, 11, 16, 22, and 32. In this series f/1.4 is the largest opening and admits the most light. Each successive f-stop reduces the light passing through the lens by one-half: a lens set at f/11 admits half as much light as one set at f/8. Few lenses use the whole scale of apertures. A standard lens for a 35-mm camera might go from f/2 through f/16.

You can control the amount of light which hits the film by changing the shutter speed or the f-stop.

At a large f-stop setting the depth of field at 7 feet is great enough only to include the front figure in the zone of sharp focus.

64

With the lens closed down to its smallest aperture, f/16, the entire scene becomes sharp with the lens still set for a focus of 7 feet. The depth of field and distance scales on a lens can be used as a guide for determining zone of sharp focus at any given distance and f-stop.

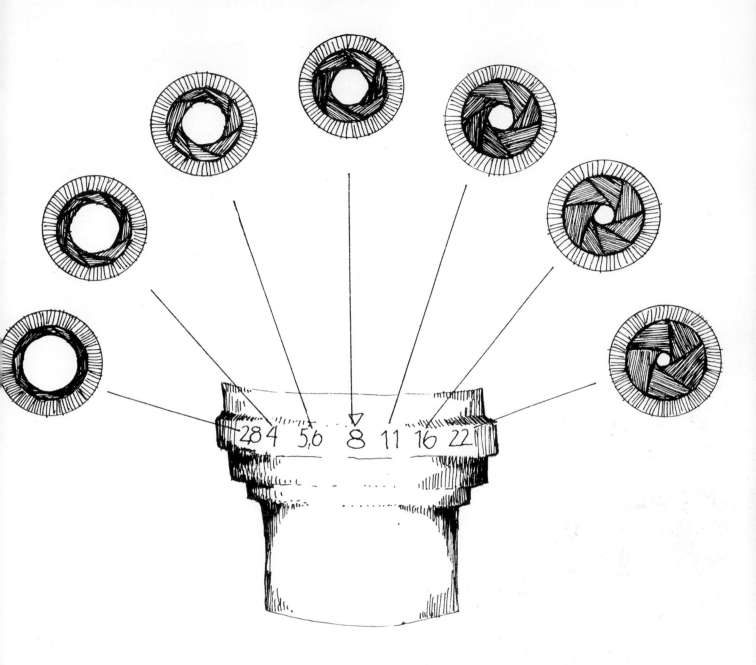

A lens aperture works like the pupil of an eye. A ring of thin, overlapping, metal leaves called a diaphragm forms variable sized holes through which light must pass to reach the film. The sizes of the holes are indicated by "f-stops" marked on the lens. In the lens illustrated here, they go from f/2.8 to f/22. An f-stop is selected by turning the movable ring until the desired setting is opposite an arrow or mark. Each successively larger f-stop passes twice as much light as the previous one and vice versa.

OTHER CAMERA FEATURES

Film Chamber and Film-Advance Mechanism

Every camera has provisions for accepting a sheet or roll of film in the focal plane. Roll film will either be contained in a *cassette* or *cartridge* to protect it from light, or on a spindle covered with opaque paper. This film is usually packaged in rolls to make twelve, sixteen, twenty, twenty-four, or thirty-six exposures. View cameras accept either sheet film in holders or roll film in special adapters. Thirty-five-millimeter cameras take a cassette containing a length of film with a short length of film ("leader") protruding from the cassette. The cassette is placed in the camera, and the film leader is placed across the focal plane and attached to a take-up spool. When all the film on the roll has been exposed, it is rewound into the original cassette and removed from the camera.

Roll films, in 120- or 620-size, employ a length of paper to protect the film from light. The paper leader is pulled across the focal plane and attached to an identical film spool. When all the film is exposed, the camera is opened and the film, now on the take-up spool, is removed from the camera. The original film spool is transferred to the take-up side of the chamber.

Use of sheet film is discussed in Chapter 12.

Instamatic-type film cartridge.

Sheet film holder.

Rollfilm, paper backing, and spool.

35mm film cassette and leader.

Focusing Mechanisms

An extremely important feature in any adjustable camera is the focusing control. Nearly all successful photographs must be sharply focused. Adjustable cameras have one of two main focusing systems: a viewing screen or a rangefinder.

The viewing-screen system is used in single-lens reflex, twin-lens reflex, and view cameras. In this system, light passing through a lens falls on a piece of glass that is etched or ground, giving it an opalescent look. The photographer views this glass from the side away from the lens to see the optical image. If the image is not sharp, he can focus it by manipulating the focusing control.

The rangefinder focusing system is a faster focusing system because it is only necessary to line up a double image or two parts of a split image in the viewfinder. The rangefinder is usually coupled with a focusing mechanism on the lens so that the lens and rangefinder focus simultaneously. The rangefinder system is particularly useful in low-light conditions because it gives a brighter image in the viewfinder. This system absorbs less light than a through-the-lens focusing control utilizing a ground glass.

In a reflex camera the optical image formed by the lens is reflected from a mirror upwards onto a ground-glass screen. Both the ground-glass on top of the camera and the film in the back of the camera are the same distance from the lens, the camera will be perfectly focused when the image of the subject on the ground-glass is adjusted for maximum clarity and sharpness. This is accomplished by manipulating the focusing ring on the lens or the focusing knob on the camera body.

A twin-lens reflex is focusing by moving the coupled lenses while observing the groundglass image.

A rangefinder camera is focused by superimposing two images of the same subject seen from different angles. When the lens is "out of focus," a split image of the subject will be seen through the viewfinder. This occurs because part of the image is reflected from a movable prism on the right side of the focusing system. When the lens is "in focus" the two images overlap and appear as one. This is because the movable prism has been adjusted to the correct angle for the distance from camera to subject by a mechanical linkage to the lens.

View cameras are focused by observing the ground-glass image and adjusting the focusing knob for a sharply defined image. Viewing and focusing the image often requires the use of a "focusing cloth"; a large opaque cloth used to shield light from the ground glass.

Frits J. Rotgans
"Aletsch Glacier." Switzerland, 1969. With custom-made
wide view camera from photographer's design.

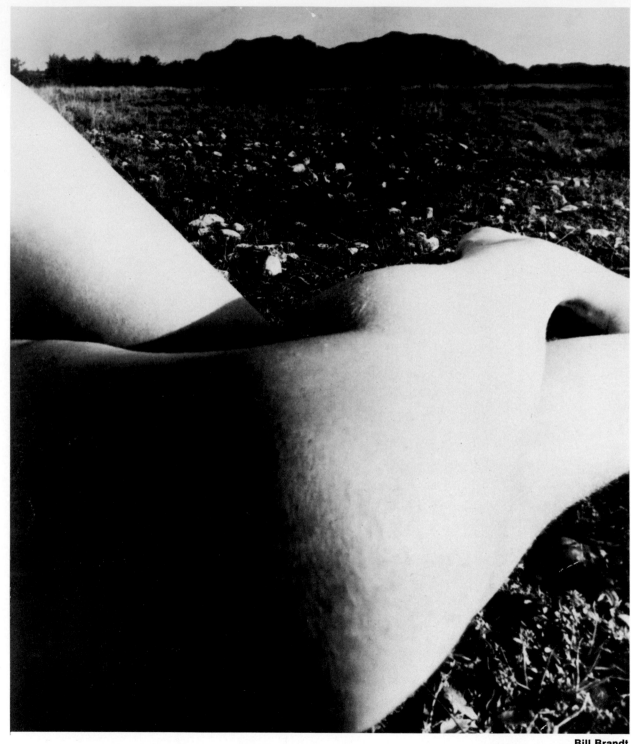

Bill Brandt
"Untitled." 1957. From *"Perspective of Nudes."* (G.E.H.)

William A. Garnett
"Four-sided Sand Dune." 1954.
Aerial view over Death Valley.

John Massey
"Glassblower." 1972.
Photographed with Fisheye Lens.

Ernest H. Brooks II
"Underwater Flare." 1971. Hasselblad in underwater
housing used to document oil spill near
Santa Barbara Islands.

Erich Salomon
"Spectators Gallery at League of Nations." 1928.
Early candid photograph made with Ermanox camera.
(G.E.H.)

Glenn Showalter
"Solar Eclipse." 1972.
Photographed with telephoto lens.

PHOTOGRAPHIC FILM 4

to catch and hold the optical image

4

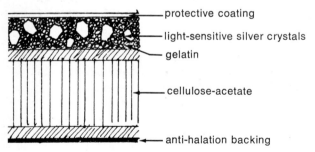

protective coating
light-sensitive silver crystals
gelatin
cellulose-acetate
anti-halation backing

Black and white film consists of several layers, as shown here. A thin protective coating shields the emulsion layer from abrasions. The emulsion layer, where the image is formed, consists of a mixture of refined gelatin and light-sensitive silver halide crystals coated on a flexible cellulose-acetate film base. The film base is backed with an anti-halation coating which prevents light passing through the film from reflecting back to the emulsion causing halos around the highlights in the image.

The films and papers used in photography are coated with light sensitive silver salts—usually a silver halide such as silver bromide, silver iodide, or silver chloride. These salts undergo physical and chemical changes when exposed to even very small quantities of light. Nothing has been found to equal silver for sensitivity to light and image quality, although much research has been and is being done in this field.

As soon as one decides to use a camera, he comes up against an extended array of technical and esthetic choices. Which film will he use? How will the scene be lighted? What *f*-stop and shutter speed will produce the photograph he sees in his mind? Even experienced photographers continually consider alternatives and seek answers to these questions.

The reason it all seems so complex is that everything is interrelated. Illumination affects exposure; the choice of film affects the tones of the photograph; and so on. The confusion disappears and the complexities begin to fall into place when the basic facts about film and light are understood. This chapter deals with the types of film available and how they are used, the characteristics of films, exposure considerations, the operation and use of light meters, film-processing techniques, a survey of contemporary film developers, and the care and handling of film after processing.

Contemporary photographic film operates on the same basic principle as the films used by the early masters of photography. The light coming through the lens is recorded on microscopic crystals of a silver halide. These crystals are carried in a transparent gelatin, and the combination of the crystals and the gelatin is called an *emulsion*. The emulsion is thinly spread on a plastic support.

Today's films are vastly more effective at registering light than the old, slow wet or dry plates used by such photographers as Roger Fenton or Julia Margaret Cameron. Several factors in manufacturing affect a film's sensitivity and other characteristics. The kind of gelatin in which the silver halide is suspended is one factor. Even the diet of the cattle from which the gelatin is made affects the speed of the film. The size of the silver halide crystals also affects film speed. An emulsion containing large crystals needs less light to form an image than an emulsion with small crystals. But it's not as simple as that, for the bigger the crystals, the poorer the image. A very sensitive, but coarse halide crystal emulsion produces a grainy picture.

TYPES OF FILM AVAILABLE

Fortunately, manufacturers offer a choice. You can select a very sensitive, very-high-speed, but grainy film, or a very-fine-grained but slow film, or a compromise between the two. You can't have the best of both worlds, but some films come close to it. One of the best compromises is Tri-X, a film made by Eastman Kodak

Tri-X has a speed of ASA 400—which is quite fast—and yet it is remarkably free from grain.

Manufacturers describe a film by its sensitivity, or speed, which is indicated by its ASA rating, a numerical system formulated by the United States of America Standards Institute (formerly the American Standards Association). A high ASA number means that you can get your picture with less illumination—or, alternatively, you can use a higher shutter speed to stop action. Most films are designated "slow," "medium," or "fast." A slow film would be in the ASA 20–50 range; medium film in the ASA 100–200 range; fast film in the ASA 400–1250 range.

Manufacturers use another code to describe the physical characteristics of a film. Film for 35-mm cameras is usually designated 135 film. Films for cameras using roll film are numbered 120, 220, 620, 127, 616, and so on. Sheet film is usually designated by the actual size of the film in inches: 2¼x3¼, 4x5, 8x10, and so on.

There have been many recent advances in film technology. Films have been made faster; graininess has been reduced; and films have been made sensitive to the whole visible spectrum. Today's films contain dyes that prevent halos from forming around highlights in a photograph. Other substances are introduced in manufacturing to prevent the film from curling excessively.

Film Speed: What it Means

One of the founding principles of photography is that increasing the amount of light that reaches the film causes a proportional increase in the silver density of the negative. But this is not always true. The density of an image does not always increase proportionally with the total exposure of the film, and this has a distinct effect on the way a picture turns out.

Every type of film has a *characteristic curve*. This curve shows how silver density increases as the amount of light reaching the film becomes greater. The graph to the left is an example of a characteristic curve for a medium-speed film. Notice that the bottom part of the curve rises very slowly, while the middle part of the curve rises at an even rate, indicating that increasing the light in this exposure region will cause a directly proportional increase in silver density. Notice also that the top part of the curve levels off. This is the highlight area in a picture. If the camera is set so that much of the exposure falls in this part of the curve, there will be a loss of fine detail. The same is true if a film is underexposed; detail will be lost because the film will fail to record differences between light and dark at low light levels.

"It is important to see what is invisible to others, perhaps the look of hope or the look of sadness. Also, it is always the instantaneous reaction to oneself that produces a photograph."

ROBERT FRANK

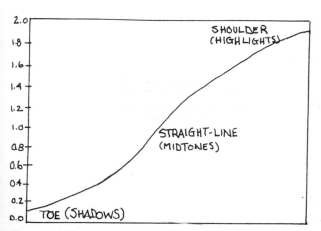

Characteristic curve for a medium speed film.

Slow film, 32 ASA.

Medium-speed film, 125 ASA.

Ultra-fast film, 1250 ASA.

Sharpness and Graininess

An excessively grainy photograph turns off most people. There is a loss of detail. Contrast and sharpness seem inadequate. Unless it is made grainy for a certain effect, the picture seems to lack craftsmanship. Graininess is particularly obvious when a photograph is blown up to a large-size print. A grainy image gives gray shades which are not smooth tones but rather speckled. This mottling usually obscures fine detail.

The faster the film, the grainier it is. The relationship between film speed and graininess is demonstrated in these photographs which were taken with slow (ASA 32) film, medium-speed (ASA 125) film, and very fast (ASA 1250) film. You can see that each increase in speed brings with it a penalty in graininess. The moral: if you want maximum sharpness and minimum graininess, select the slowest film that the lighting conditions and the action will permit.

Most Polaroid films are an exception to this rule. Even the extraordinarily fast ASA 3000 Polaroid Land film is remarkable both for its great speed and for the fact that this speed is achieved without sacrificing grain quality. Although ordinary films generally suffer in grain as they increase in speed, the Polaroid films do not. Polaroid Land photography employs a diffusion-transfer process in which the silver from the negative physically travels across a very narrow gap to the positive paper print. This gap is so small that there is little random clumping of silver which would cause graininess and loss of detail.

Polaroid photography is particularly useful to professionals who use this instant-picture film to check lighting and composition. Occasionally it will be used as an instant exposure guide. In cases where it is difficult or impossible to measure the brightness of a subject, the professional will use Polaroid film coupled with neutral-density filters to arrive at a basic exposure for whatever conventional photographic material he is using.

An advertising photographer working with an agency's art director at his shoulder may use Polaroid to get immediate approval of a setup. As soon as the Polaroid picture is approved in terms of action, composition, and design, the professional will photograph with his conventional material, which will be used to produce the advertising illustration.

USING LIGHT METERS

In black-and-white photography there is a time-honored rule: "Expose for the shadows, develop for the highlights." The light meter is the most useful tool for determining correct exposure. It is a small electronic device which measures the amount of light falling on or being reflected from a subject. A good light meter is as important as a good camera for producing good photographs.

There's nothing magical about a light meter. It can't think; it can only measure. Effective use of the light meter requires considered judgment on the part of the photographer. If the meter is not pointed at the most important area of the picture, the reading indicated on the meter may not be the correct one. The photographer must decide which areas in the pictures are most important and adjust his exposure accordingly. If the scene is extremely contrasty and the meter is unduly influenced by the bright areas, the reading may result in a picture which is underexposed.

When working with a meter it is essential that the scene be studied carefully. On occasion a variety of meter readings must be taken, and these readings must be interpreted to get the exposure which will yield the kind of negative producing a satisfactory print—one with a full range of tones, pure blacks to pure whites with many distinct tones of gray between the extremes, and detail in nearly all these tones.

There are many varieties of light meters: clip-on types which attach to the camera, meters built into the camera itself, self-contained units held in the hand, and units with optical systems with which you look through an aperture and read very small areas in the scene.

The electronic light meters made today operate on one of two light-sensing systems. The less expensive ones use selenium cells which convert light into electrical energy and cause a needle to move across a dial. The stronger the light, the stronger the current and the more the needle moves. These type meters have no batteries and are not always sufficiently sensitive for low-light conditions.

The other type of meter contains a battery which provides a flow of current through a light-sensitive cadmium sulfide (CdS) cell. The resistance of this cell varies with the amount of light hitting it. This variation in current moves a pointer across a dial, indicating the amount of light hitting the cell.

Reflected or Incident Light Metering

You have an option of how you measure the light. You can measure the light being reflected from a subject, or you can measure the light falling on a subject. A meter that measures the light coming from the subject is a *reflected-light* meter. A meter measuring the light falling on the subject is an *incident-light* meter.

A reflected-light meter is pointed at the subject or at that part of the subject you want to measure, and read. An incident-light meter (which has a wider angle of view) is taken to the subject, held in the hand, and pointed toward the camera position. The meter reading tells you how much light is falling on the scene. The reflected-light meter is used more often in still photography, the incident-light meter more often in motion picture photography.

This drawing shows the construction of a typical light meter. Light is measured when it passes through an opening and falls on a cadmium-sulfide cell which regulates the flow of electricity from the battery to an indicating gage. The amount of light striking the cell influences the amount of current reaching the gage and moving it's needle. This needle setting is used to calculate correct exposure. The appropriate ASA number for the film being used is first dialed into place on the scale. The outer dial is adjusted to the setting indicated by the needle and one of the resulting shutter speed/aperture combination is selected for use on the camera. For this example, exposures would be f/5.6 at 1/250 or f/8 at 1/125 second or any other combination displayed on the scale.

Each type of meter has advantages under certain circumstances. Consequently many meters are made to take both reflected and incident readings. When the sensing cell is opened to direct light it serves as a reflected-light meter. A hemispherical diffuser is placed over the sensing cell to obtain incident-light readings.

A reflected-light meter is particularly useful in measuring the brightness range In a scene. First make a reading of the darkest area in the scene—the area having the deepest shadows. Make a note of this reading and then take a reading of the brightest object or portion of the scene. To determine camera exposure when using this metering system, calculate the reading which is halfway between these two readings and use it to set your lens and shutter.

The brightness range (the difference between the meter reading in the shadow area and the reading in the highlight area) will be a factor in determining how much development to give the film. If the scene is extremely contrasty, you will probably reduce development time to retain detail in the highlights. If the scene is flat and dull with very little brightness differences, it is likely you will need to increase development to get a more contrasty negative, resulting in a more brilliant print. Remember that a light meter doesn't really determine exposure; it only measures light intensity. How this information determines exposure depends on how you want to reproduce on film the scene you are photographing, a scene which may include many colors and many degrees of brightness, all of them to be transformed into a variety of grays. How do you want the bright side of a house to appear? Do you want it to be white, or soft gray with texture? Should the clouds be brilliant white? What tone of gray should a person's face be? The exposure meter doesn't answer these questions automatically.

A famous California photographer, Ansel Adams, has developed a simple approach to calculating exposure. He calls it the *zone system*. Adams's system is based on the fact that most scenes (for purposes of photography) can be reduced to ten basic exposure zones or shades of gray.

These zones can be related to brightness areas in the actual scene to aid in arriving at an exposure. The zones are numbered from 0—the deepest black, resulting from no exposure on the negative —to IX, the whitest possible tone in the photographic print. After zone I each lighter zone represents a doubling of the exposure from the previous zone, or, an increase of one *f*-stop. The average tone in the average scene is a medium gray, zone V, and in an average print it should appear as a zone-V gray.

A light meter will give you information, but it won't think for you. A meter sees things only in terms of quantity of light. For example, suppose you are using a reflected-light meter to measure the luminance of a sunlit clean white door. Your meter will indicate an exposure for this situation; it will be an incorrect exposure.

Prove this. Make a photograph using the exposure indicated. It will be badly underexposed. The white door will be recorded as a middle gray. Now find a jet-black door. Measure the luminance with your meter and make another photograph, again using the exposure indicated by the meter. Again the photograph records this black door as a middle gray.

Why? Why does a meter reading cause both bright white and jet-black objects to be recorded in a middle-gray tone? **Most reflected-light meters are designed to indicate, for any light intensity they measure, exposures which will reproduce as zone V.**

Now consider why you may want to increase exposure by an additional stop of light when measuring the light from a Caucasian person's face. A photograph made with the exposure indicated by the meter would result in a middle-gray rendering of the skin, and we usually want the skin to be recorded as one step or tone lighter than a middle gray. To get something a step lighter, give a stop more exposure.

Reflected-light meters are pointed at a subject to measure the light coming from a scene. The sensing-window admits light in a limited angle and measures light from only a small area at close range.

An incident-light meter should be positioned near the subject and pointed to the camera position to measure the light falling on the subject. This meter's light sensing system covers about 180° which allows it to measure all the light falling on the subject from the direction of the camera position.

Top row—left to right:
1. Over exposed and overdeveloped.
2. Overexposed and normal development.
3. Overexposed and underdeveloped.

Center row—left to right:
1. Normal exposure and overdeveloped.
2. Normal exposure and normal development.
3. Normal exposure and underdeveloped.

Bottom row—left to right:
1. Underexposed and overdeveloped.
2. Underexposed and normal development.
3. Underexposed and underdeveloped.

EXPOSURE AND DEVELOPMENT "RING-AROUND"

If you'll be content with "ordinary" images, simply follow the manufacturer's directions that come with most photographic materials. But, if you're genuinely concerned with consistently producing images of optimum quality, invest a little time and film in doing a controlled exposure and development "ring-around" with your favorite film. Only by evaluating controlled variations can you really become familiar with your materials and use them creatively. Only you can determine what constitutes the "best" negative for your purposes and interests.

Doing a "ring-around" will give you control over shadow detail, highlight detail, negative contrast, and ultimate print quality. If you are trying out a new developer, going through a "ring-around" will efficiently provide you with useful data for evaluation.

After exposing and processing the negatives in the "ring-around," make the best possible print from each test negative, using no dodging or burning-in. Make these test prints with the paper you normally use. Arrange the test prints on a well-lighted surface in the same order as shown by the "ring-around" plan. Select the print which, in your opinion, is superior to all others. There may be several acceptable prints in the group, so be extra critical in making your selection.

This "ring-around" permits you to set standard exposure (your own ASA speed) and normal development criteria for this film/developer combination.

2 Stops more exposure with 25% more development	2 Stops more exposure with normal development	2 Stops more exposure with 25% less development
1 Stop more exposure with 25% more development	1 Stop more exposure with normal development	1 Stop more exposure with 25% less development
Normal exposure with 25% more development	Normal exposure with normal development*	Normal exposure with 25% less development
1 Stop less exposure with 25% more development	1 Stop less exposure with normal development	1 Stop less exposure with 25% less development
2 Stops less exposure with 25% more development	2 Stops less exposure with normal development	2 Stops less exposure with 25% less development

*manufacturers suggestions

FILM PROCESSING

When your film is removed from the camera it contains a *latent image* formed by the action of light on the silver halides in the emulsion. This latent image will become visible when the developer reduces the exposed silver halides to black particles of silver. These particles of metallic silver clump together during development to form the photographic image.

There are three basic types of film developers: fine-grain (compensating) developers such as Microdol, Microdol-X, and TEC; all-purpose developers such as Kodak D-76, UFG, and FG-7; and high-energy developers such as Acufine or Diafine. D-76 is one of the best all-purpose developers. It can be used full strength or diluted 1:1 for finer-grain results. D-76 is suitable for developing most contemporary films.

Time-Temperature Controls Development

The time that your film remains in the developer is a variable. It depends on the type of film you are using and the temperature of the developer. The temperature of the developer is critical. It should be measured with a good-quality thermometer. The specific developing time at that temperature for your particular type of film can be determined from the time-temperature chart which comes with the developer.

Most developers will function effectively within a temperature range of 60 to 75 degrees Fahrenheit. The temperature of the other solutions in the processing line should be the same as that of the developer, plus or minus one degree. Subjecting your film to drastic changes in temperature during the processing sequence may cause excessive grain and, in extreme cases, reticulation. Reticulation is the physical cracking, wrinkling, or distorting of film emulsion.

It is very important for the film to be properly agitated while in each of the processing chemicals. Proper agitation in the developer is particularly critical. Agitate the film vigorously but gently for the first thirty seconds and for five seconds every thirty seconds thereafter. The initial agitation removes any air bubbles present on the film. Avoid excess agitation; it can cause streaks or mottling.

A water rinse removes excess developer from the film surface before it is placed into the hypo. Although some instruction sheets suggest the use of an acid stop bath in place of the water rinse, most photographers prefer simple tap water to rinse off excess developer.

The hypo (fix) halts all development. It dissolves the unexposed silver halides remaining in the emulsion. This is necessary to insure the permanence of your negative image. Hypo usually contains a hardening agent which toughens the emulsion, making it

less susceptible to scratches and abrasions. Many photographers use a hypo neutralizer to reduce washing time. After being rinsed well in water, negatives are transferred to hypo neutralizer, agitated for a few minutes, and then washed.

The wetting agent reduces the surface tension of water, allowing most of the surface water to run off the film. This is important because it permits negatives to dry without permanent water marks. Wetting agents such as Kodak Photoflo are highly concentrated and should be diluted according to the manufacturer's instructions.

Many darkroom technicians prefer to use a high-quality, clean, photographic sponge instead of a wetting agent to remove excess moisture from negatives before drying them. They feel this method gives cleaner negatives, with fewer dust or dirt problems. The sponge should be thoroughly soaked in clean water and squeezed out before being applied to the film. Each side must be carefully sponged before the film is put in the drying cabinet or hung on the drying line.

Nearly all of today's films are sensitive to light and must be developed in total darkness. Open the rolls or cartridges containing film only in a lighttight room.

There are four basic types of film: roll film, most commonly available in 120, 620, and 127 sizes; 35-mm film in cassettes containing twenty- or thirty-six-exposure rolls; sheet film in various sizes; and drop-in cartridges such as are used in the Instamatic cameras. Each type of film has its own unique characteristics.

Thirty-five-millimeter film, film from the Instamatic cartridges, and roll film can be developed using reels and developing tanks. A separate reel is needed for each film size. Nikor and Kindermann reels and tanks are made of stainless steel. These units are more expensive than the plastic ones available, but they are superior in many ways. There is no need for the reel to be perfectly dry before using it again, and the tanks will hold several reels for processing at one time. Stainless steel developing tanks and reels are a wise long-term investment.

For processing roll film, assemble the following equipment:

- Chemicals: developer, hypo, hypo neutralizer (if you decide to use it), and wetting agent
- Containers: plastic bottles (best for chemicals)
- A film-processing tank and reels (Nikor or Kindermann recommended)
- A good-quality thermometer
- A timer, preferably one with fluorescent numerals
- A handtowel
- A viscous photographic-quality sponge
- Film clips—either metal clips or clothespins

A collection of equipment used in rollfilm processing.

ROLL-FILM PROCESSING PROCEDURE

Then perform the folllowing steps:

1. In total darkness, carefully load the film onto the developing reel. It's a good idea to practice first with old film. If improperly loaded, areas of the film may stick together or be bent and ruined.

2. Put the reels in the tanks, placing lighttight covers in place over the tanks. Turn on the room lights.

3. Check the temperature of your chemicals. Be sure all chemicals are within one degree of each other and within the range 68–75°F. Warm or cool the solutions if necessary.

4. Consult the appropriate chart for the proper developing time for the film you are using.

5. Pour the developer into the developing tank. Agitate briskly for the first 30 seconds and 5 seconds every 30 seconds thereafter.

6. At the end of the appropriate developing time, pour the developer back into its container.

7. Fill the developing tank with water immediately, agitate, and pour the water out.

8. Fill the tank with hypo, agitating periodically (5 seconds every 60 seconds is suggested). The total time in the hypo depends on the hypo and the film being processed. Instructions with your film or hypo will give the optimum time.

9. Pour the hypo back into its container.

10. Wash the film in running water for 20 minutes. It's a good idea to empty the tank periodically during the wash, permitting a fresh supply of water to bathe the film and rinse off any traces of chemicals used in the film processing.

11. Soak the film in the wetting agent for about 30 seconds.

Developer is poured in developing tank and brought to specified temperature before extinguishing lights to load reel.

After removal of film from cassette *in the dark*, the leader is clipped off.

In the dark, the film is next loaded on the reel, with care to avoid kinking.

12. Remove the film from the processing reel to dry. The film should dry in a dust-free area. Attach film clips to the top and bottom to prevent curling. Use a sponge to remove any excess moisture on the film surface.

Sheet-film processing procedures are presented in Chapter 12.

The Care and Handling of Negatives

A negative is delicate, fragile, easily bent or scratched. Treat your negatives with great care and respect; they are essential to the production of your final photographs. A scratch on the negative will appear as a black mark on the photographic print. Handle negatives only by the edges. Fingerprints on negatives are difficult to remove. If you have a negative with a fingerprint, you can try using Carbona on a wad of cotton to gently rub it away. If your negatives are handled with care, you won't have this problem.

As soon as your negatives are dry, cut them into strips about six inches long. Do not cut off each individual negative because that would slow you down in the contact- and projection-printing phases of printmaking. Carefully place the strips of negatives in glassine envelopes or the plastic sheets which will hold the negatives from an entire roll of film. The latter are especially convenient because the negatives can be contact printed through the plastic.

This is the time to assign a file number to each roll of film. The number will be used later to key your contact sheet and to help you in selecting those negatives from which you wish to make enlargements.

Store your negatives in a clean, dry place.

The reel is placed in tank, covered, and agitated during processing sequence.

After developing and fixing, film is washed for 20 minutes in rapidly flowing water.

Film may be hung on a clip and sponged dry to remove excess surface moisture. An alternative is to soak film in wetting agent before hanging for drying.

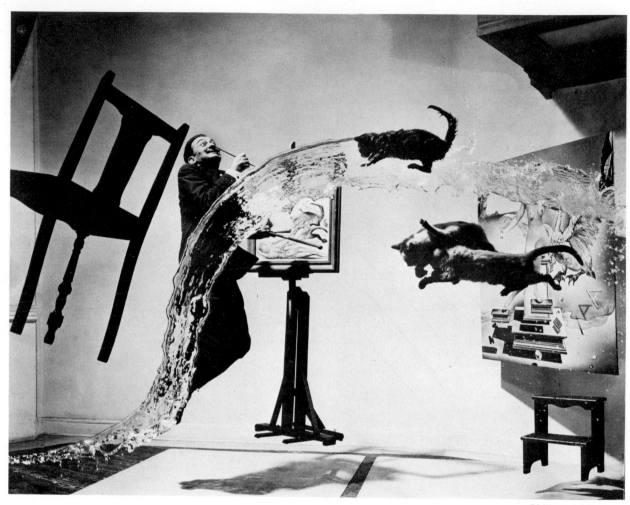

Philippe Halsmann
"Dali Atomicus." ©

Bradley T. Hindson
"Breakfast." 1968.

Owen Butler
"Untitled." 1972.

Minor White
"Cobblestone House; Avon, N.Y." 1958.
Photographed with 4x5 Infrared film and red filter.

5

Contact printing is the simplest method of producing photographic images on paper. It is the oldest method of making photographic prints, and the method used today when maximum quality in photographic printing is desired. Since the contact print is the same size as the negative, large-format cameras are used when the contact print is to be the final result.

Photographers noted for the beautiful photographs they have produced by the contact-printing method include Edward Weston, Frederick Evans, Ansel Adams, and Timothy O'Sullivan.

Contact printing is much like making photograms. Negatives are substituted for the objects used in making the photogram images. All other steps are the same.

A contact print is produced by putting the photographic image in contact with photographic paper, emulsion to emulsion. The negative side of this "sandwich" is exposed to light. After exposure the photographic paper is processed in developer, rinsed in a stop bath, and fixed in a hypo solution. It is then washed and dried. Photographers also produce contact proof sheets as an editing aid and as a file record of all the negatives on a roll or "take." Contact proof sheets are meant to be handled and pored over. Many photographers use grease pencils (china markers) to indicate which frames they will enlarge. The markings can be erased later with a tissue.

It's a good idea to assign a number to each contact proof sheet and to the roll of film from which it was made. This number helps in selecting the negatives to be printed after editing the contacts. An easy numbering system uses the date on which the negatives were exposed. For example, the first roll exposed on the third day of November 1973 would be numbered 3-11-73-1.

CONTACT-PRINTING PREPARATIONS AND PROCEDURES

Orderliness is vital to efficient photographic printing. The first step is to set up things conveniently.

1. Prepare the solutions. After mixing the developer, the stop bath, and the fixer, set up a line of four trays in the sink. Fill the first tray with properly diluted developer, the second with stop bath (usually 28% acetic acid diluted to a proportion of 1½ ounces to 32 ounces of water), the third with hypo, and the fourth with water.
2. Assemble the negatives. Remove them from their protective storage envelopes, handling them by the edges. (If you are using the transparent negative pages it is not necessary to remove the negatives.)
3. Dust the negatives with a Staticmaster brush or an antistatic cloth. Any dirt or dust on the negatives will cause white spots on the photographic prints.
4. Identify the emulsion side of the negatives. Film curls toward

A contact proof sheet is useful for selecting frames to be enlarged. The negatives, in a file page, are placed on a light box to better evaluate quality.

the emulsion, which is duller than the base side of the negative. The emulsion side of the negative must be in contact with the emulsion side of the paper during printing.

5. Clean the contact frame. Most contact-printing frames use a piece of glass to provide pressure and give good contact between the negative and the printing paper. The glass must be perfectly clean, free of dust, dirt, or smudges.

6. Open the printing frame, taking care not to leave any fingerprints on the glass.

7. Place the negatives in the frame. Position them in such a way that, when the printing paper is inserted into the frame, the emulsion of the negatives will be in contact with the emulsion of the printing paper.

8. Position the enlarger head. Switch on the enlarger lamp, and adjust the enlarger so that the light projected onto the easel covers all of the contact-printing frame. Switch the lamp off.

9. Check solution temperatures. Be sure they are all within the 65–75-degree range, and all within a degree of each other.

10. With the room lights off and the safelights on, remove a sheet of printing paper, being sure to close the box securely afterward.

11. Identify the emulsion side of the paper. Paper, like film, curls toward the emulsion side. The emulsion side is usually shinier than the base side of the paper. The emulsion side of the printing paper must be in contact with the emulsion side of the negative or no print can be made. Write the negative file number on the back of the paper with a soft lead pencil.

12. Place the printing paper in the printing frame. Slide the paper over the negatives, making certain the emulsion side of the paper faces the emulsion side of the negatives.

13. Close the contact-printing frame. Be sure it is properly closed to insure contact between the negatives and the printing paper.

Negatives are placed in printing frame emulsion side up.

Adjust the enlarger for even light across the printing frame.

Printing paper curls towards the emulsion side. Negatives and paper must be placed emulsion to emulsion in the printing frame.

14. Adjust the enlarger-lens aperture diaphragm to the largest aperture so that maximum light will reach the printing frame and expose the printing paper.

15. Set the enlarger timer. To contact print a roll of negatives of average density, set the timer for 5 seconds. If the processed contact print is too light or too dark, the timer should be adjusted accordingly. If the contact print is too light, more exposure should be given; if it's too dark, less exposure.

16. Make the exposure. With the loaded contact frame on the easel of the enlarger, press the timer button and expose the print.

17. Remove the contact paper from the printing frame, taking care not to disturb the negatives so they will be ready for another attempt if the first test print is not satisfactory.

18. Begin processing. Holding the printing paper by the edge, slip it smoothly into the developer. Agitate the print by hand or with developer tongs. The print should be developed for about a minute-and-a-half.

19. When the tones of the print appear satisfactory (after about a minute-and-a-half), lift the print from the developer and drain for a few seconds.

20. Transfer the print to the stop bath. Slip it in smoothly and agitate it gently for 15 seconds.

21. Transfer the print to the hypo. Lift it from the stop bath, allow to drain, and slip it into the tray of hypo. Leave it in hypo about 6 minutes, agitating occasionally.

22. Take the print to the holding tray. The holding tray stores the fixed print in water until you are ready to begin washing the prints made during this session.

23. Wash the prints—an hour is recommended—in running water.

24. Dry the prints in blotter rolls or in a mechanical print dryer.

The exposed contact print is developed for 1½ minutes.

The print is transferred to a stopbath and agitated for about 15 seconds.

The print is placed in a fixing bath for six minutes with occasional agitation, then washed for an hour and dried.

Photographic Papers for Contact Printing

Most photographers use the same printing papers for contact printing as for enlargements. This is possible when the same light source is used for both printing methods. If you are working with a special contact printer, a device made for the production of contact prints only, it is usually necessary to purchase a special paper intended just for contact printing.

Popular papers used to produce contact prints with an enlarger light source include Polycontrast F, Polycontrast Rapid F, and Kodabromide. Selection of a photographic paper with a glossy surface makes sense; it allows better viewing of detail in each frame of the proof sheet. A coarse-surface paper, such as a silk or tapestry finish, may hide some fine detail in the small contact prints.

"A photograph draws its beauty from the truth with which it is marked. For this very reason I refuse all the tricks of the trade and professional virtuosity which could make me betray my canon. As soon as I find a subject which interests me, I leave it to the lens to record it truthfully."
ANDRE KERTESZ

Alfred Stieglitz
"Spring Showers." 1902. (N.G.A.)

Frederick H. Evans
"Klemscott Manor Attic." c. 1897.
From a platinum print. (G.E.H.)

Lewis W. Hine
"Untitled." c. 1908. Contemporary print from the original
5x7 glass negative. Best known for his "human documents"
of immigrants and industrial exploitation of children he was
an influence in passage of child labor laws. He documented
construction of Empire State Building. (G.E.H.)

Floyd Gunnison
"Automobile." 1916.
Contemporary print from dry plate. (G.E.H.)

Brett Weston
"Ice Form." 1952.
Contact print from 8x10 negative.

Wynn Bullock
"Girl and Dog in Forest." 1953.
Contact print from 8x10 negative.

PROJECTION PRINTING 6

big prints from small negatives

6

Projection printing is essentially a replay of the first two stages of photography: recording light on film and developing the negative. All enlarging papers are basically the same. They consist of a light-sensitive emulsion coated on an opaque paper base. The emulsion is composed of silver salts suspended in gelatin. By varying the ingredients in the emulsion, the manufacturer controls the paper's ability to record the number of midtones between absolute black and absolute white.

A paper which registers the full range of tones of a properly exposed and developed negative is called a *normal* paper. However, a very contrasty negative, with dense highlights and thin shadows, will require the use of another paper which can compress the excessive tonal range of the negative and produce a normal print. This is called a *low-contrast* paper. A flat negative with little density difference between highlight and shadow areas demands a paper which does the opposite—increases the contrast by expanding the tones within the black-and-white tonal scale. This is called a *high-contrast* paper.

All manufacturers use a number system to designate their low-, normal-, and high-contrast printing papers. Number 1 signifies the lowest-contrast paper; number 2 is considered normal contrast for use with normal negatives; and numbers 3 and 4 are for negatives lacking in contrast. Higher-contrast papers (numbers 5 and 6) are available for use with extremely thin and flat negatives or for special high-contrast effects with normal negatives.

Projection printing is a very personal activity. The proper exposure of the printing paper is usually determined visually, rather than by a light meter. In the darkroom the photographer makes tests to determine the best exposure for the final print. After examining test strips carefully, a full test print is made. From this test print the photographer is able to make judgments as to whether portions of the print should be made darker or lighter.

Every stage of projection printing offers opportunity for creative altering of the final print. The choice of enlarger has an effect: the diffusion enlarger will produce soft, gentle tones, a condenser enlarger more contrasty prints. The selection of paper will have an effect on the final print. There are hundreds of types of printing papers available today. They provide a variety of options in texture, finish, weight, and image tone. Most types of paper come in several contrast grades. By carefully selecting your enlarging paper, the tones of which can be influenced by the developer, you contrtol the mood and strength of your prints. Good taste and experimentation will dictate the combination of paper, developer, and enlarger for your quality projection prints.

Selection of negatives for projection printing should be based on careful study of your contact proof sheets, those small prints you produced to serve as a guide in determining the quality of your negatives. Study them with a magnifying glass and select those negatives best suited for projection printing. Many of the negatives

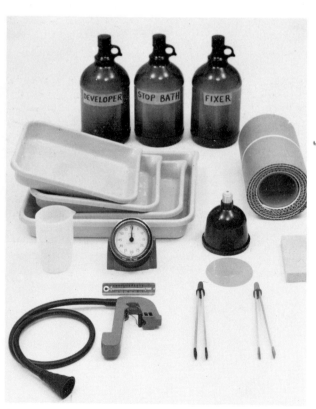

An assortment of materials used in photographic printing.

will differ only slightly from each other, particularly if you have bracketed your exposures (taken several exposures of the same scene at different *f*-stop and shutter-speed combinations).

As you examine each frame in the contact proof sheets, ask yourself, "Is the lighting pleasing? Is it the strongest photograph in the sequence? Do the expressions seem natural? Is the negative sharp? Is it correctly exposed?" Look for details such as juxtaposition of edges. Use the grease pencil to experiment with cropping, selecting a smaller rectangle from within the frame for enlargement.

ENLARGING EQUIPMENT

The photographic enlarger is the key element in projection printing. It is used to magnify small negatives into enlarged prints through projection. A quality enlarger permits use of small cameras and economical film. It broadens esthetic possibilities and provides many options for control of the picture, enabling the photographer to express his visual statement explicitly. Exposure over several portions of the print can be controlled. It is possible to alter perspective or create distortion. Part or all of a negative can be used.

The enlarger is essentially a camera in reverse. It functions like a slide projector mounted on a vertical column. Instead of the light entering through the lens and striking the film, light from the lamphead passes through the negative and is focused by the lens to cast an image of the negative on printing paper. The distance between lens and projected image determines the enlargement size.

Enlargers have a few simple controls. The distance from the lens to the paper is adjusted by moving the entire head (containing light source, negative carrier, and optical system) upward or downward on the column. Image focusing is accomplished by manipulating a knob to raise or lower the lens. The lens has a standard diaphragm adjusted just as with a camera to regulate the amount of light falling on the easel.

"Work incessantly, cultivate discrimination, gather freedom from your own hard-earned results. Disregard successes but go back to them for help in an immediate problem. The possibility of discovery is everywhere."

PAUL CAPONIGRO

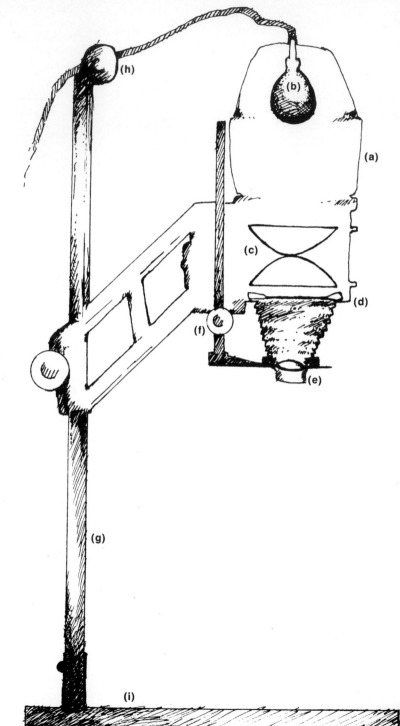

(a) **The enlarger head** consists of light source, negative carrier, and optical system. The position of the enlarger head is a factor in size of projected image.

(b) **The enlarger lamp** illuminates the negative permitting a magnified image to be projected on to the base.

(c) **Condenser lenses** provide uniform illumination for negative. Diffusion glass alone or in combination with condensers may also be used to provide even illumination.

(d) **Negative carrier** supports negative in position above lens.

(e) **The lens** forms enlarged optical image of negative on enlarger base.

(f) **The focusing control** adjusts the lens to form sharp magnified image of negative.

(g) **The enlarger column** carries the head and serves as a rail to allow up and down movement of the head.

(h) **The counterbalance mechanism** allows heavy enlarger head to be raised or lowered easily.

(i) **The base** supports column and head and serves as a surface for an easel in which enlarging paper is positioned.

A diffusion enlarger employs a sheet of opal or ground glass to spread the light from the lamp for uniform illumination. Diffused light has the effect of reducing contrast in the projected image.

A condenser enlarger uses two large lenses to collect and evenly concentrate light over the negative. This concentrated and directional light yields a crisp and brilliant image on the easel. The condenser system provides maximum contrast in projected images.

Diffusion/Condenser enlargers employ large lenses to collect the greatest amount of lamp light and a diffuser to prevent excessive contrast in the projected image.

Enlarger Light Sources

There are three types of enlarger illumination systems: *diffusion, condenser*, and combination *diffusion-condenser*. Each has its advantages, depending upon the type of work it will be used for.

If raw light traveled directly from the enlarger lamp to the negative, it would be brightest at the center of the picture and dimmest at the edges, causing the final print to be darker in the middle than it should be. In a diffusion enlarger, a sheet of sandblasted glass above the negative helps to provide even illumination. A diffusion enlarger also usually contains a frosted enlarging lamp. Since its illumination is scattered thoroughly, light rays strike the negative at all angles. The illumination is scattered additionally by the negative, particularly in dense portions. As a result, the lens sees and projects an image of lower contrast than if a point source of illumination had been used.

The condenser enlarger uses a relatively large lamp, light from which passes through two plano-convex condensers that uniformly concentrate the light so that it passes straight through the negative. This system uses the available illumination more efficiently, since most of the light reaches the lens. The concentrated light also yields more contrast and crisp detail, since light from different points in the negative does not overlap. The efficient transmission of light lends itself to shorter exposure times, thereby keeping the negative from becoming overheated during enlargement. Generally, a print made with a condenser enlarger is more contrasty than one made from the same negative with a diffusion enlarger. This difference can vary from about one-half to one grade of paper contrast.

The combination diffusion-condenser enlarger offers a compromise. It has condenser lenses to collect light and focus it through the negative, and a sheet of ground glass to eliminate excessive contrast.

For best results, you should make your negatives to fit the enlarger you have. Normally exposed and developed negatives will be fine for diffusion enlargers, but normal exposure and somewhat less film development will be necessary for negatives used in condenser enlargers. This is because less-than-normal development gives both smaller grain and lower negative contrast.

MAKING A PROJECTION PRINT

After you have selected a negative for projection printing, clean it carefully. Insert it in the negative carrier of your enlarger (emulsion side down). Double check for dust on both the emulsion and base sides of the negative. Insert the negative carrier in the enlarger. Turn the room lights off. Place a sheet of plain white paper on the easel below the enlarger. Turn the enlarger light on. Raise or lower the enlarger to get the desired degree of magnification. Move the easel around to compose the picture effectively. Carefully focus the negative image on the easel by turning the knob that raises or lowers the lens.

Making Test Prints to Determine Exposure

The best way to determine print exposure is to make test prints or strips. Strips are sections of the print with varying exposures. When you have the image composed and critically focused, close down the lens to $f/11$. With the safelight on and the enlarger lamp off, place a piece of enlarger paper (emulsion side up) on the easel. (Be sure to cover paper supply to avoid accidental fogging.) Set your timer for 5 seconds. Cover most of the printing paper with a piece of cardboard, and expose the uncovered section for 5 seconds. Slide the cardboard to uncover a larger section of your test paper and expose for another 5 seconds. Move the cardboard to uncover still more and expose another 5 seconds. Make two more 5-second exposures in the same manner. You now have a test paper with strips exposed from 5 to 25 seconds.

Place the test paper in developer for about a minute-and-a-half. Lift the print from the developer, allow it to drain, and transfer it to the stop bath. Agitate it for about 15 seconds. Lift the paper from the stop bath, drain, and transfer it to the fixing tray for at least 2 minutes. Turn the room lights on and examine the print carefully. Determine which section of the test print has the best exposure. Counting 5 additional seconds for each subsequent strip, you can easily determine the exposure time of the best section.

Identify frame to be enlarged and the emulsion side of strip. As with printing paper, film curls towards the emulsion side.

Place negative strip in carrier with emulsion side down and position in enlarger.

Enlarger is adjusted for desired magnification before placing paper in easel and exposing test sheet.

Making sure your hands are completely rinsed and dry, place a full-size piece of enlarging paper on the easel and expose it for the amount of time which yielded the best image in the test strips. Process this print in the same manner as you did the test strips. After it has been in the fixer for at least 2 minutes, turn on the room lights and examine the print.

Evaluating Test Prints

If the overall exposure seems to be correct but the print has a general feeling of flatness and lack of contrast, you will need to use a higher-contrast grade of paper. Test prints are usually made on a number-2–contrast grade paper. A number-3 grade will give more contrasty results. If a higher-contrast grade of paper is indicated, repeat the entire process, beginning with the test strips. If the first test strips seem too contrasty, try again with a lower grade of paper, perhaps a number-1 grade, making test strips and then a full-size print.

When you have a test print with correct exposure and contrast, examine the print carefully to determine whether any additional controls should be exercised. Most prints require some dodging or burning-in of bright or dark areas to obtain maximum detail. In *dodging*, light is held back from a shadow area that might be getting too much exposure, resulting in loss of detail. For *burning-in*, a cardboard or hand shields most of the picture while one small section is given longer exposure time to register detail in bright areas.

Prints you intend to keep should be put in a standard fixing bath, with agitation once every minute, for a minimum of 6 minutes. After 6 minutes, remove the prints from the fixing bath and place them in a tray of water—a holding bath—from which they are transferred to the print washer. Any prints you care about should be washed in running water for an hour. Then sponge them off and dry in blotter rolls or on a mechanical print dryer.

Develop test print for 1½ minutes with continuous agitation.

Development is halted by transferring print to the acid stopbath for 15 seconds.

The test print should be in the fixing bath for at least one minute before turning on white light to evaluate exposure.

CUSTOM ENLARGEMENTS 7

quality control techniques

The art of custom printmaking lends itself to relaxed, unhurried creativity. Under the orange glow of the safelight, borderline negatives can be saved and ordinary negatives coaxed into something special. It is here that you can shape and tune your image: enlarge it, enhance its tones, alter its shades of light and dark, expand or reduce contrast between tones, crop out unwanted sections, and otherwise make it ready for presentation.

Every stage of printmaking presents opportunities to enhance the final result. Often judgments based on artistic rather than technical considerations must be made. A serious photographer is able to control the mood and impact of his photographs, emphasizing the brilliance and detail of one picture, the warmth and softness in another.

CONTROL TECHNIQUES FOR BETTER PRINTS

If your final test enlargement seems *almost* satisfactory, it may need local changes in density or contrast. Image areas can be lightened or darkened selectively by dodging or burning-in. Dodging is the technique of shading a part of the print area with your hand or a card during a portion of the exposure so that it receives less light than the rest of the image. A dodged area will be rendered lighter in tone than the rest of the image.

Burning-in is the technique of giving additional light by extra exposure to a small area of the image, making it darker in tone than it normally would be. The two terms are nearly interchangeable in the sense that dodging an area really results in burning-in the rest of the print and vice versa.

Local density adjustments should be made if the test print shows lack of detail in highlights or shadows, or if the overall density distribution appears to be unbalanced. The first step in correcting these defects is to determine with further testing the exposure times which will be required to produce the desired density in each of the less-than-perfect areas. How do you know if a print can be improved by dodging or burning-in? The best answer is to try it and then compare the result with the original, straight print. Exactly how much light should be held back? Again, the only way to find out is to try and see.

Dodging

Dodging implements are best made as the occasion demands. No two negatives will present exactly the same requirements. In one instance a tiny ball of cotton on the end of a straw will be the best tool. An oblong piece of black paper stuck to a length of wire will serve another particular purpose. Or a sheet of cardboard may be needed to hold back an entire dark foreground area. Your hands are often the best and most convenient dodging tool.

In general, hold your dodging tool up about one-third of the dis-

Basic tools for custom printing.

Correctly exposed "straight" print before improvements.

The bottom area of the print is dodged during exposure to give more shadow detail.

Highlight areas are given additional exposure for improved detail.

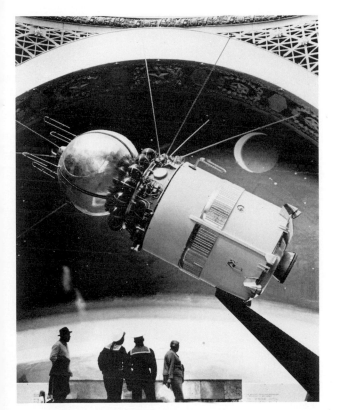

The improved photograph after appropriate dodging. Notice increased detail in both shadows and highlights. Photograph is of first manned space vehicle on exhibit in Moscow.

tance from the easel to the enlarging lens. The closer it is to the easel, the smaller the shadow on the paper; the further it is from the easel, the larger the shadow. Although the size of the dodging implement itself may be constant, the area affected may vary considerably by simply changing the distance between it and the paper.

It is important in most types of dodging to keep the tool in constant but gentle motion while it is being used. If this is done, no definite lines of demarcation will be noticed between affected and unaffected areas in the print. The dodged area should blend in smoothly with the adjoining areas. If the shadows appear too light and unnatural, you have probably dodged them for too long.

Burning-in

Burning-in can darken a distracting background or an excessively brilliant sky, or it can subdue unwanted reflections or highlights of almost any sort. It differs from holding back (dodging) in that density is intentionally added to a specific area instead of being subtracted.

Burning-in is done after the normal printing exposure. Most burning-in can be done by cupping your hands midway between the lens and the easel and blocking out all the picture except just that area you want to receive more exposure. Let only that portion of the light and no more pass through your fingers or palms. If you can't control the light accurately with your hands, cut a hole—approximately the shape of the area which is too light—in the center of a piece of cardboard and hold this over the easel. Be sure to keep your hands or the cardboard moving during the exposure.

Use of these techniques makes it possible for you to improve many of your photographs, since it's a very rare negative which contains perfectly balanced tones. Be careful and use discretion. It's easy to get carried away and produce an image which is obviously doctored, with unpleasant extremes of tone or loss of detail.

THE FLEXIBILITY OF VARIABLE-CONTRAST PAPER

Over the years, enlarging papers have been made in several different contrast grades to match the varying contrasts of black-and-white negatives. Some papers are available in as many as six grades. Such variety in one kind of paper makes printing complex and stock keeping difficult. A solution to these problems lies in using variable-contrast paper whenever possible.

Most variable-contrast papers are coated with two emulsions: one, sensitive to yellow-green light, yields low contrast; the other, sensitive to blue-violet light, produces high contrast. The degree of contrast is varied simply by inserting appropriately colored filters in the enlarger. The filter determines the color of the light that reaches the printing paper and thus controls contrast.

Modern variable-contrast paper is an excellent printing material in every regard. Its tonal range is probably superior to that of many

Polycontrast with #1 filter.

Polycontrast with # 1½ filter.

Polycontrast with #2 filter.

Polycontrast with #2½ filter.

graded papers. Variable-contrast papers have a contrast range equivalent to the first four grades of ordinary paper. However, control of contrast is finer because the filters used yield contrast increases or decreases in half-grade steps. Moreover, when the correct exposure for one filter is known, the exposure for any of the other contrast filters is predictable.

You may occasionally have a negative that needs a low-contrast paper for printing the contrasty highlight areas and a high-contrast paper for the thin, under-exposed shadow areas. A print on a graded paper from this sort of negative will always be a compromise between the shadows and highlights. By using a variable-contrast paper you can print the whole negative through a high-contrast filter to get shadow contrast, and then replace this filter with a low contrast one to get highlight detail by burning-in the contrasty areas. This method of printing difficult negatives often yields results that cannot be obtained in any other way.

Polycontrast with #3 filter.

Polycontrast with #3½ filter.

Polycontrast with #4 filter.

Agfa #6 high contrast paper.

PROBLEM SOLVING FOR THE PRINTMAKER

The secret of better printmaking lies in knowing how to improve those prints you have already made. Here is a summary of some of the problems or defects you may encounter in printmaking:

- ABRASION MARKS. *Cause:* Rough handling of prints; use of a nonhardening fixing bath; washing too many prints together. *Prevention:* Always handle paper with utmost care; use a hardening fixing bath; don't overload the print washer. *Remedy:* If the abrasion is not severe, the print may be salvaged by spotting.
- BLACK SPOTS. *Cause:* Undissolved chemicals in print developer; dirt in any of the processing solutions. *Prevention:* Photographic chemicals should be mixed in a room other than that used for loading film or making prints; processing solutions should be filtered. *Remedy:* Spots may be etched out of print surface.
- BLISTERS AND FRILLING. *Cause:* High processing-solution temperatures; excessively strong acetic acid stop bath; prolonged washing. *Prevention:* Printing paper should always be processed according to the manufacturer's instructions; solutions should be compounded and/or mixed as accurately as possible. *Remedy:* Make a new print.
- BLURRING (local blurred spots). *Cause:* Negative buckled in enlarger negative carrier; paper not flat on easel. *Prevention:* Obvious. *Remedy:* Make a new print.
- BLURRING (general or overall blurring). *Cause:* Enlarger out of focus; movement of easel or enlarger during exposure; negative reversed (in contact prints). *Prevention:* Use a magnifying glass to focus the enlarged image sharply. *Remedy:* Make a new print.
- BROWN SPOTS, MOTTLED AREAS. *Cause:* Contamination of the developer with hypo; oxidized developer; excessive heat when drying. *Prevention:* Thoroughly wash and dry hands on a clean towel after they've been in hypo bath; do not process too many prints in one tray of developer; store stock developer in tightly covered bottles. Use separate print tongs for each solution. *Remedy:* Make a new print.
- CONTRASTY PRINTS. *Cause:* Paper contrast not suited to negative contrast. *Prevention:* Use softer paper; use softer-working print developer. *Remedy:* Make a new print.
- CURLED PRINTS. *Cause:* Drying prints too rapidly; excessively high drying temperature; surface water on prints during drying. *Prevention:* Obvious. *Remedy:* Dampen prints on the reverse side and dry under pressure between flat surfaces.
- DARK PRINTS. *Cause:* Overexposure; overdevelopment. *Prevention:* More careful evaluation of test strips. *Remedy:* Make a new print.
- DULL SPOTS ON GLOSSY PRINTS. *Cause:* Too rapid drying; improperly cleaned ferrotype tin; prints not in perfect contact with ferrotype surface; premature removal of prints from ferrotype surface. *Prevention:* Obvious. *Remedy:* Soak print in glossing solution for five to ten minutes and referrotype.

Something really new is missing here, and this is something one has the right to demand of this young photography . . . I have through this material become acquainted with a hundred young Swedish photographers' girlfriends. No portraits but a sort of appearance description, without psychological dimensions, without charm.

DR. OTTO STEINERT

This print exhibits stains caused by chemical contamination.

- FADED PRINTS. *Cause:* Overfixation; insufficient washing. *Prevention:* Careful adherence to print-processing recommendations. *Remedy:* Make a new print.
- FINGERPRINTS (light or white). *Cause:* Handling sensitized paper with greasy fingers or when fingers are contaminated with hypo. *Prevention:* Each time your hands have been in any of the processing solutions, thoroughly wash and dry them on a clean towel. *Remedy:* Make a new print.
- FINGERPRINTS (dark or black). *Cause:* Handling paper with fingers contaminated with developer. *Prevention:* Same as for light fingerprints. *Remedy:* Make a new print.
- FLAT OR SOFT PRINTS. *Cause:* Paper not suited to negative contrast; print underdeveloped; improperly mixed developer; dirty enlarger lens; use of old or improperly stored paper. *Prevention:* Clean enlarger lens each time you're beginning work; use a contrastier paper; check test strip carefully against correct comparison print. *Remedy:* Make a new print.
- FOGGED PRINTS—grayed print borders and highlights. *Cause:* Safelight illumination too strong; improper safelight filter; use of old paper or paper not stored in a lighttight container; darkroom not lighttight. *Prevention:* Test safelight illumination. *Remedy:* Mild cases of overall fog may be treated successfully with a subtractive chemical reducer such as potassium ferricyanide.
- LIGHT PRINTS. *Cause:* Underexposure; underdevelopment; overfixation. *Prevention:* Check test strips carefully with the correct comparison print, compensating for exposure and development accordingly. *Remedy:* Make a new print.
- MOTTLED PRINTS. *Cause:* Overexposure and underdevelopment; old paper; weak or worn-out paper developer. *Prevention:* Developing time should not be less than 45 seconds at .68°F; use fresh solutions—there's no economy in squeezing extra prints through oxidized developer. *Remedy:* Make a new print.
- STREAKS. *Cause:* Lack of agitation of the print in developer or hypo bath or both; printing paper edge-fogged, resulting in streaks along print borders. *Prevention:* Obvious. *Remedy:* Make a new print.
- WHITE SPOTS—small and well defined. *Cause:* Dirt or dust on the negative or paper surface when making the print exposure; hypo particles on the paper surface. *Prevention:* Clean negative before printing. Keep print room clean. *Remedy:* Spot the print.
- YELLOW STAINS. *Cause:* Excessively long developing time; exhausted developer; lifting print out of developer to inspect it too frequently; insufficient washing. *Prevention:* Process prints according to recommendations. *Remedy:* Make a new print.

Arnold Newman
"Piet Mondrian." (L.G.)

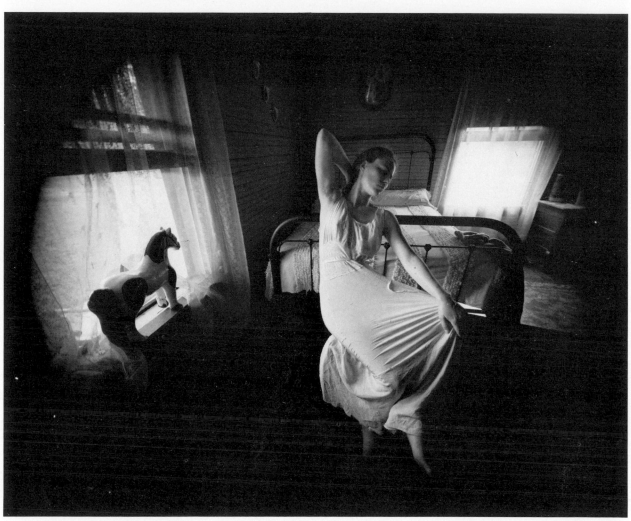

Emmet Gowin
"Edith, Danville, Va." 1971. (L.G.)

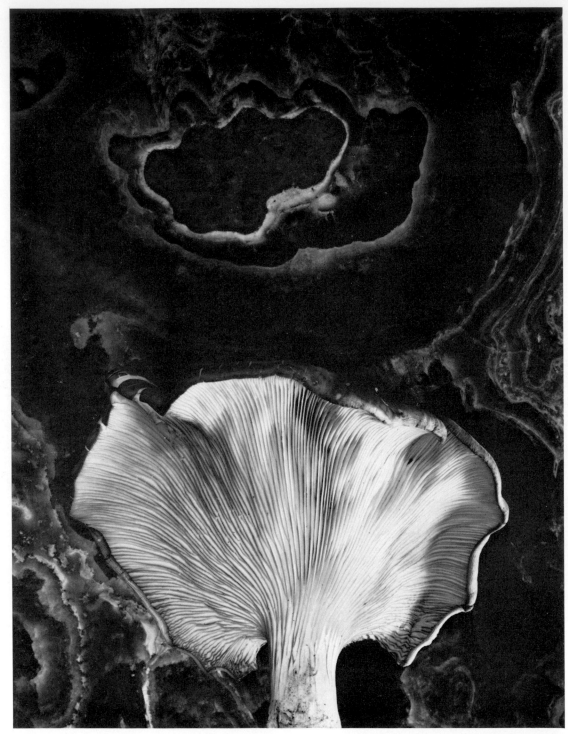

Paul Caponigro
"Mushroom, Ipswich, Mass." 1962.

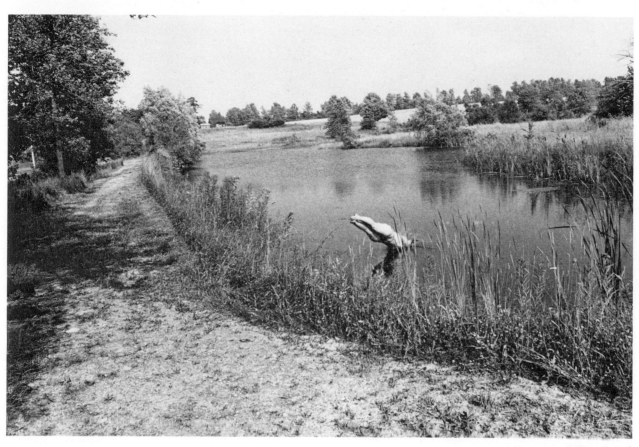

Arthur Freed
"Nude Diver." 1972.

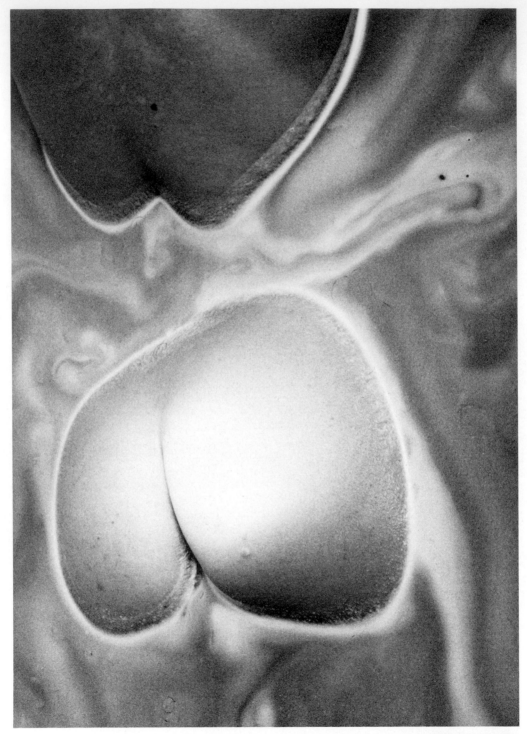

Ralph Hattersley
"Nude in Tub." 1961.

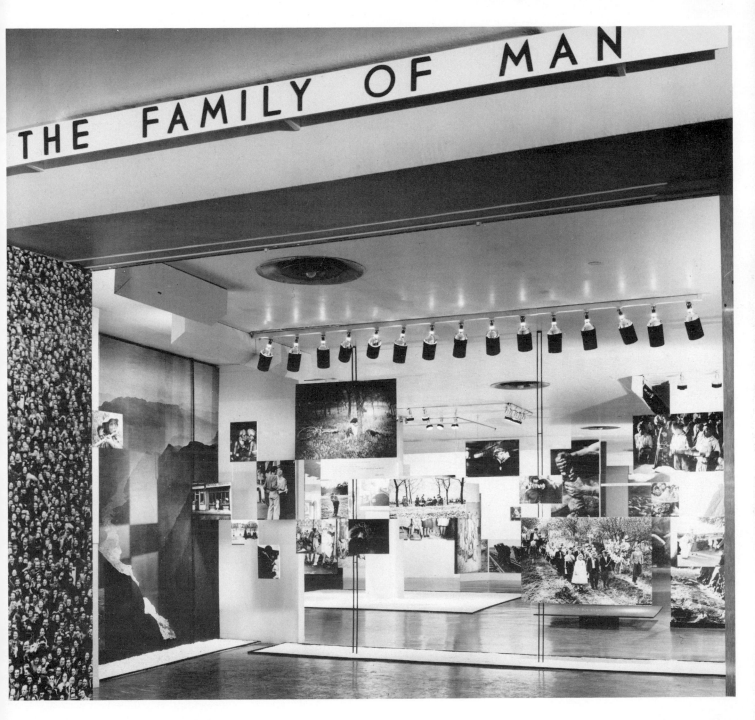

8

For most photographers the delight of making pictures reaches a climax in the print darkroom. Here is where the image is finally seen as previsualized. Unfortunately, too many photographers look upon the new print floating in the hypo tray as the final result. Concerned and skillful print finishing are hallmarks of the serious photographer. There's no need for photographs to appear before the public with dogeared corners, fingerprints, and dust spots. Attention to the craftsmanship of print presentation can do no less than enhance good prints.

Assuming that your prints have been carefully and adequately washed to remove all traces of chemicals, your next step is to select the method of drying. You have a choice of drying for a *matte* finish or for a ferrotype *glossy* finish.

Matte prints can be dried on twin-belt machines made for this purpose, or on a ferrotype machine with the back of the paper in contact with the drum. Another way of drying matte prints is to place them on drying racks or between special photographic-quality print blotters. A drying rack is a light wooden rack with muslin or similar fabric stretched tightly over it. The prints are placed face down on the rack, and they dry flat if the relative humidity in the drying area is not too low.

Regardless of the method of drying, matte prints should first be drained and sponged free of surface water. This is to insure that the prints will dry flat and to prevent water marks. If you are machine drying your prints, use only enough heat to dry the paper. If the temperature of the drum is too high, it will make the paper and the emulsion brittle and the prints will dry with a curl that's difficult to work with. Very low relative humidity, such as encountered in heated buildings in the winter, has the same effect.

Drum dryers are used for rapidly drying large quantities of prints. They consist of a large, polished-metal, heated drum, an endless apron to bring and keep wet prints in contact with the drum surface, and a system to keep the drum in continuous rotation. The prints are dried in one rotation of the drum. Most dryers permit prints to be finished with either a matte or glossy finish.

FERROTYPING GLOSSY PRINTS

Ferrotyping, or glazing, imparts a high gloss to the surface of certain photographic papers. Most manufacturers make a specific type of paper with a surface suitable for ferrotyping. A glossy surface increases the apparent tonal range of the print, and the absence of texture helps to reveal fine detail.

Most ferrotyping is done on heated drums; but if you have only a few prints, they can be ferrotyped by squeeging them into contact with a chromium-plated sheet or other highly polished surface. Glass is sometimes used, but the prints tend to stick to its surface.

The best finish on glossy prints is obtained by first soaking them in a glossing solution for a few minutes. Remove the prints from the tray, drain, and squeegee only the back of the print. This will allow the emulsion to have a thin film of liquid on it before it comes in contact with the hot drum. Place the prints, emulsion side down, on the drum surface. The dryer should be hot enough to dry the prints thoroughly before they emerge. They should drop off the

Drying racks support prints to be air dried. Of simple construction, they have cheese cloth or plastic mesh drying surfaces to allow even air circulation over both sides of the prints. Technicians producing archival quality prints advocate the use of drying racks to reduce hazards of both chemical and thermal contamination.

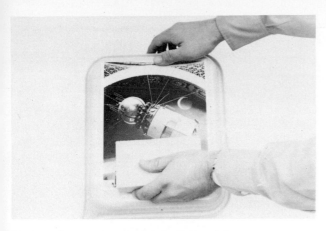

Drain and sponge surface water from prints.

Prints are placed face down on the linen-like material of a photo blotter roll.

If a print sticks to the ferrotype plate, moisten back and carefully lift it free.

drum by themselves, and their surface should be mirror-smooth and flawless.

Because the surface of a ferrotyped print takes the form of the surface onto which it is pressed and dried, the plate or drum must be perfectly smooth and clean. Any marks or foreign matter on the surface of the drum will be visible on the print. Clean new plates and drums before using them. For those in constant use, residue from the water and possibly particles of gelatin and other substances will build up on the plated surface. This residue will mar the print or cause it to stick to the drum. As a matter of routine, always clean the drum before using it.

Careful drying will prevent at least four potential problems:

- **Oyster-shelling**, one form of uneven drying (semi-circular imperfections). The outer edges of the print dry before the center does. The dry edges lift off the drum surface and shrink while the center section is still damp and stuck to the drum. Oyster-shelling will ruin the print. It can be prevented by blotting dry the back of the print before placing it on the dryer.
- **Imperfect gloss**, caused by dirt and bits of gelatin (causing little circular dull spots). The particles usually remain stuck to the emulsion. Be sure the glossing solution is clean. Filter it, if necessary, before placing prints in it.
- **Air bubbles** between the print and the drum. These are usually very small flecks on the print surface, usually due to insufficient pressure between the dryer roller and the drum.
- **Prints sticking** to the drum surface. This is sometimes caused by static electricity, in which case the prints can be peeled off with no damage. But sometimes the prints will actually adhere to the surface and can only be removed physically. The best way to get a stuck print off the surface is to moisten it thoroughly before attempting to pull it off. If sticking persists, try adding additional hardener to your fixing bath. This will result in a harder print emulsion.

Dry mounting tissue is attached to back of print with tacking-iron. Print (and tissue) should be trimmed to size with a good quality paper cutter.

Print is carefully oriented on mount board and then two or three corners of mounting tissue are lightly tacked to board with hot tacking iron.

MOUNTING

After drying, inspect your prints and prepare those you deem worthy of exhibition for mounting. Matboard or illustration board is the usual material on which to mount prints.

There are a number of methods for mounting prints, but the most common involves the use of *dry-mount tissue* and a *dry-mount press*. The dry-mount tissue is a shellac-impregnated sheet of thin paper. Shellac will melt at a fairly high temperature, bonding the print and the mount board together.

Turn on the mounting press and set the temperature to about 275°F. Leave the press lightly closed so that the base pad can warm up. If your mounting board has absorbed considerable moisture, it's a good idea to dry it out in the press.

Tack a piece of the dry-mount tissue to the back of the print with a hot tacking iron. You can trim both the print and the tissue at the same time. Position the print on the mounting board. Without changing the position of the print, lift one edge of the print and tack the tissue to the board in two places. The print will then stay in position while you place it in the press.

When the press has reached operating temperature, place the board with the print tacked onto it, print side up, on the press. Cover the face of the print with a large sheet of clean paper, and close the press firmly. Leave it in the press about thirty seconds. When the print comes out of the press it should be firmly bonded to the mount and quite warm. To prevent any gentle curling of the mount board, place it under a large metal sheet which will absorb the heat.

Check the print to be sure it is perfectly bonded to the mount. If the print is stuck more or less firmly to the tissue but the tissue is not adhering to the mount board, it may not have had enough time in the press. Put it back in the press for a longer time. If the tissue is stuck to the mount board but not to the print, it may have had too much heat or too much time in the press. You may not be able to restick the print. Heated again, it may stick or it may come off entirely. If it comes off, repeat the entire procedure using another piece of dry-mount tissue.

SPOTTING

After it is mounted, examine the print closely for any white spots. White spots or specks are usually caused by dust on the negative while it's in the enlarger. They can be removed easily by "spotting" with a fine brush and special dyes. A most satisfactory dye for removing dust spots is marketed under the brand name **Spot-tone**. This dye does not change the print surface even of glossy prints.

Place mount board with attached print in preheated mounting press under pressure for 30 seconds. Remove print, allow to cool, and check for good bond.

Spotting is essential to craftsmanship-like print presentation.

Dye spotting is fairly easy to do with a little practice. Find a well-lighted, comfortable area in which to work. Select a bottle of dye of the appropriate color to match your prints. You will also need a small container of water, a saucer, a good-quality red sable watercolor brush (about number 00), a paper towel to blot and clean the brush, and a few reject prints on which to practice.

Position the print on a stable surface. Dip a brushful of dye out of the bottle and spread it on the saucer. Dip the brush in water and add a few drops to the saucer near the dye. Holding the brush nearly parallel to the blotter surface, stroke it lightly so as to form a fine point. When the brush is nearly dry, touch the point to an old print and get a feeling for the kind of mark it will make. Check the density of the mark made by your brush and match it with some tones requiring spotting in the print you're working with. Don't try to obliterate the spot; simply try to blend it in with the surrounding area.

It is particularly difficult to hide white spots in completely dark areas. Use the dye full-strength and work slowly and carefully. If progress seems slow, abandon that spot for a few minutes and come back to it later. Best results come from a gradual building up of the tones.

Black spots, caused by scratches or air bubbles on the film during development, may be removed by bleaching. Using an old spotting brush, bleach the spots with a concentrated solution of potassium ferricyanide, or with a weak solution of ordinary laundry bleach such as Clorox. After a few applications of bleach, the black spot will turn white. Sponge the bleach from the print, dry, and correct the white spots with the spotting process.

Spotting is the final finishing operation in craftsmanship presentation and should not be neglected. Any photograph—regardless of its artistic quality—will look bad if it's covered with white or black spots.

Wet Mounting

Prints can also be mounted on wood or masonite panels. This is a particularly good way to mount large prints. Be sure the print is completely wet. Then blot both sides until they are merely damp. Apply ordinary wallpaper paste to the mounting surface. Starting at one end, roll the damp print onto the damp surface, smoothing it out to avoid trapping air bubbles. Roll out any small air bubbles, starting at the center and working out to the edges of the print.

The print should be larger than the surface on which it is being mounted so that the edges can be wrapped around and glued to the back of the panel. Pay special attention to the corners to give them a neat finish. If the preceding steps are executed carefully, the print will dry on the panel and be smooth and drumtight, with a very professional finish.

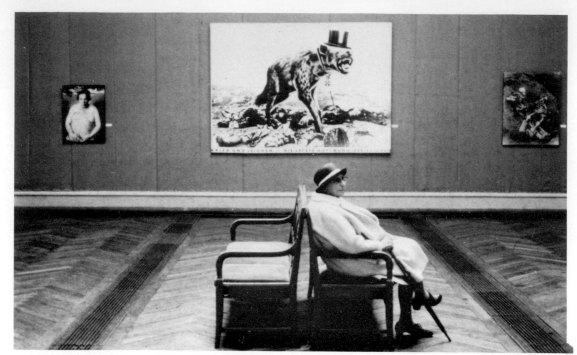

Exhibition: "*Hartfield.*" 1970.
Copenhagen, Denmark.

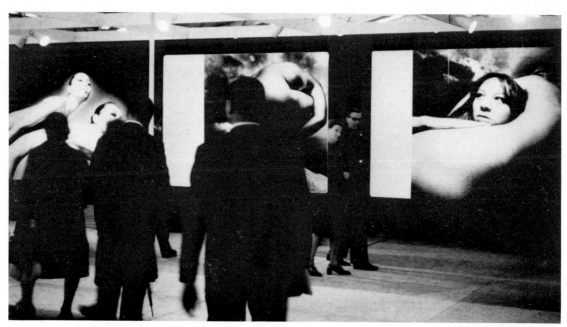

Exhibition: PHOTOKINA. 1970.
Cologne, Germany.

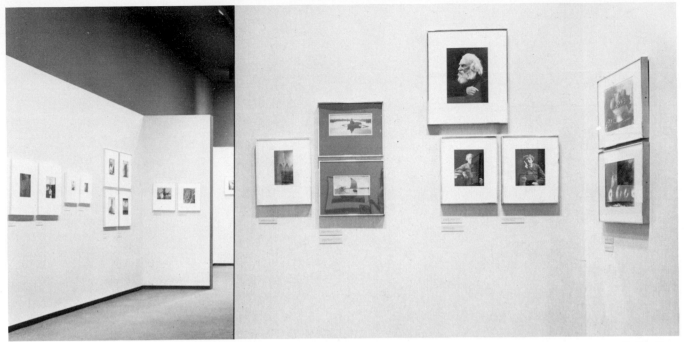

Exhibition: Permanent Collection.
New York, N.Y. (M.O.M.A.)

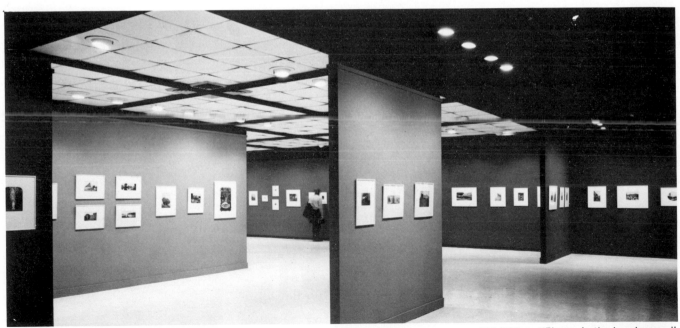

Exhibition: *"Figure in the Landscape."*
Rochester, New York. (G.E.H.)

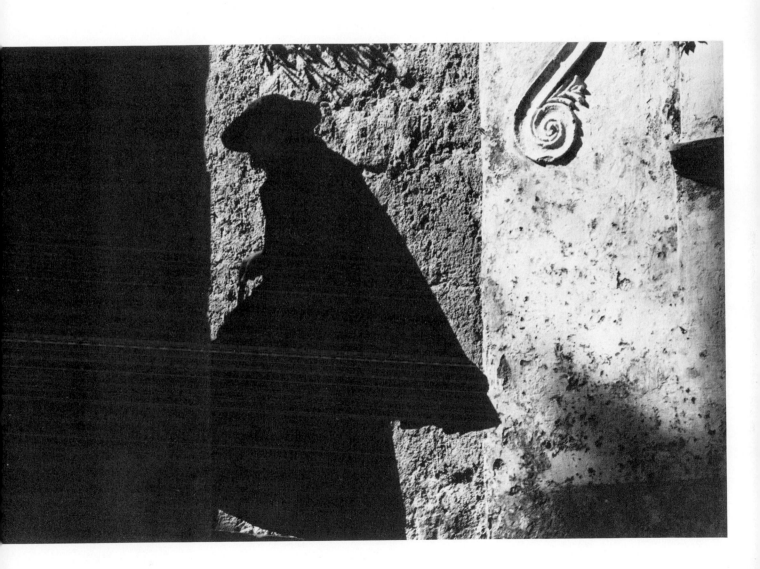

9

Ansel Adams, an acknowledged master of natural-landscape photography, has said, "Light is as much an actuality as is substance such as rock or flesh. It is an element to be evaluated and interpreted. The impression of light and the impression of substance which are achieved through careful use of light are equally essential to the realistic photographic image."

LEARNING TO BE AWARE OF LIGHT

One of the primary differences between a beginning photographer and an experienced and competent photographer is that the latter has highly developed powers of observation. To learn to make good pictures, like the acquisition of any other skill requires practice—practice in observing light, since light more than the mechanics of camera operation usually determines the quality of your finished photograph.

Give yourself an assignment to make a good photograph of an old building. You'll soon find that chance has little to do with the selection of the precise time of day at which the lighting is best. A successful effort on this assignment will require you to go back to the building several times, at different times of the day, on different sorts of days—on brilliant, crystal-clear, sunlit days, on hazy days, just before and just after a storm. You may make photographs each time you visit this building, or you may somehow sense that the lighting is not right yet and continue to visit the building until one day everything seems to be just right—the particular light on the building is the most appropriate light by which to photograph that building.

There are several ways to develop your ability to see with a photographer's eye. Study every lighting effect you like in actual scenes and in photographs. If you're interested in landscapes, check out a book of pictures from the library, perhaps one of Ansel Adams's books. Try to imagine the photographer's reaction while trying to make the photograph, trying to find the right time, the right light. Look closely at the shadows, at the sky, at how light is reflected from the subject. If you can imagine a quality of light in your mind's eye as you look at a scene or subject, you should better be able to recognize it or to estimate when that kind of light exists.

Everywhere you go, in everything you do, the opportunities for observing light are unlimited. Look critically at the lighting on television, in motion pictures, when walking through a park, while riding a bus. Watch the light on people, on buildings, on anything. Look at the lighting effects in your own living room. There's a maze of shadows, of shapes. Notice how various objects are revealed according to the angle of the light source falling on them.

As you look at, study, and explore light, try to "pre-visualize" how this light would look in a photographic print. Carry a camera with you. Photograph light—the light on the trunk of a tree, the light

".... innocence of eye has a quality of its own. It means to see as a child sees, with freshness and acknowledgment of the wonder; it also means to see as an adult sees who has gone full circle and once again sees as a child—with freshness and an even deeper sense of wonder."

MINOR WHITE

on the face of a child, the light on a building. Use your camera and film as a sketchbook to build a visual library of light.

The Many Moods of Natural Light

Even today, some people adhere to the adage, "Take pictures after 10 in the morning and before 2 in the afternoon, with the sun at your back." The first time a photographer breaks the rules by trying to make a photograph at dawn or in the rain, he's usually astonished at the results. The tones will differ from those at midday in the sun. Some of the most beautiful photographs are those which ignore the rules and take advantage of the infinite variety of tones provided by natural light.

The day follows a predictable light cycle. *Dawn*—in the earliest hours of the day the world is essentially black and gray. The light exhibits a cool, almost shadowless quality. Colors are muted; they change slowly, although right up to the moment of sunrise they remain opalescent and flat. *Early morning*—as soon as the sun is up the light changes dramatically. Because the sun is so low and must penetrate such a great amount of atmosphere, the light that gets through is much warmer in color than it will be later in the day. Shadows look bluish because they lack the high, brilliant, cold sunlight, and because of the great amount of blue from the overhead sky. *Midday*—the higher the sun climbs in the sky, the more the contrast between colors. At noon the light may be harsh, stark, crisp. Colors stand out strongly, each in its own hue. The shadows are black and deep. *Late afternoon*—as the sun drops toward the horizon the light begins to warm up again. It's a very gradual warming and should be observed carefully. On a clear evening objects will begin to take on an unearthly glow. The shadows will lengthen and become blue. Surfaces will become strongly textured. Increasing amount of detail will be revealed as the sun gets lower. *Evening*—after sunset there is still a great amount of light in the sky, often with sunset colors reflected from the clouds. Just as at dawn, the light is very soft, and contrast between tones and colors is at a minimum. Finally, the world again becomes a pattern of blacks and grays.

Weather

There really is no such thing as bad weather for photographs. Fog gives pearly, opalescent, muted tones. Storms add drama and a sense of mystery. Rain mutes some colors and enriches others, while creating glossy surfaces with brilliant reflections.

The definition of good light depends on the photographer's intent. To utilize natural light fully, you must know how to evaluate its intensities and qualities, not only in their effect on sensitive emulsions but also in relation to the intangible elements of insight and emotion that are expressed in a good photograph. An esthetic awareness is involved, something more than the physical conditions of light and exposure.

Learning to Previsualize Light

The natural outdoor light on a clear day is a mixture of two sources of illumination: the direct light from the sun and the bluish light from the sky. These two light sources are nicely defined on a clear day, but are fused and constitute one source under overcast conditions.

Outdoor illumination on a clear day is similar in nature to the combination of a main light and a fill-in light in a studio situation. The sun corresponds to a direct, intense, main light, providing most of the light falling on the subject. The sky can be compared to a large, diffuse fill-in light used for general overall illumination. The intensity or strength of sunlight is relatively constant, but sky-light will vary in both quality and quantity. The relative amount of skylight will depend upon the area of the sky illuminating the subject, the presence or absence of clouds, and the amount of haze present.

On a clear day with the sky a deep blue, the brightness of the light from the sun is about seven times the brightness of the light from the sky, giving a lighting ratio of 7:1. On a completely overcast sky, all of the light falling on the subject is properly designated as skylight. This illumination level may fall as low as two hundred foot-candles in certain conditions. Whatever the illumination level, it is almost even or uniform over most of the subject. These conditions will give a very low light ratio, approaching 1:1, between lighted and shadow areas.

The lighting contrast on any given subject depends upon the position of the subject with respect to its surroundings and the direction of the lighting, as well as upon the existing atmospheric conditions. Shadow areas in a scene tend to reproduce relatively darker in the photograph than they appear to the eye. To prevent the reproduction of shadow detail from being unpleasantly dark, additional light can be added to the shadows with reflectors.

The soft gentle light of a hazy day tends to produce the best lighting for closeups, making supplementary illumination unnecessary. Photographs of distant landscapes will reproduce best when made by the brilliant light of a clear sunny day.

Direct sunlight is specular—that is, highly directional. One way of controlling the harshness of direct sunlight is to set up a large white cloth screen in such a way that the light falling on the subject or model is diffused and softened by passing through the screen. This technique is practical only for medium closeups of people or objects.

Without reflector: The light provides crisp detail and modeling but leaves one side of the subject in deep shadow.

NATURAL OR ARTIFICIAL REFLECTORS TO MODIFY LIGHT

One of the oldest and simplest techniques of modifying lighting ratios on a subject is to use a reflector to bounce additional sunlight into the shadow areas. Any surface which redirects light onto the subject will serve as a reflector. Reflectors are preferable to supplementary flash illumination because (1) they are less expensive, (2) the effect of the reflected light can easily be seen, and (3) it's possible to experiment by visually adjusting the reflector before actually making the photograph. Usually no change in camera exposure is required when a reflector is used.

A reflector should be neutral in color, unless some special effect is desired. Some effective photographs have been made using a gold-colored reflector to add a bit of warm color to the subject. Natural surroundings such as neutral-colored walls or structures can serve as reflectors. Snow is a very effective reflector, bouncing a large quantity of light into all areas of a subject, lighting the shadows and reducing contrast. The reflecting possibilities of natural surroundings should be used whenever possible. In many cases it's necessary to move the subject only a few feet to take advantage of an existing natural reflector.

A polished metal reflector, such as a ferrotype plate or a mirror, will give the largest amount of reflected light. This type of reflector can be used even at a great distance from the subject to illuminate dark backgrounds, giving separation between the subject and the background. It is not wise to use such a reflector to bounce light directly onto a model: the reflected light is so intense that it's usually impossible for a model to avoid squinting under this light.

A softer type of fill light can be generated by crumpling a sheet of aluminum foil, flattening it out, and mounting it on a piece of cardboard. This type of reflector is very efficient when diffuse illumination Is desired. A piece of white paper or white mount board can be used as a reflector to give very diffuse illumination. It bounces light in all directions, but is useful only when placed close to the subject.

Reflectors are most easily positioned with the aid of an assistant. This allows the light to be carefully directed to the subject, and of course provides mobility. Reflectors can also be placed on the ground or propped against camera bags.

The chief disadvantages of reflectors are their size and the need to have an assistant or some sort of device to hold them in the right place.

With reflector: A flat sheet of white mountboard was positioned on the shadow side of the subject to bounce light into the shadow areas providing detail and reducing the harshness and excessive contrast.

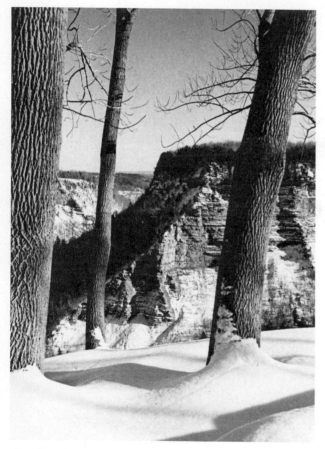

RED

GREEN

BLUE

A yellow filter absorbs just enough blue light to render skies in tones that we consider normal. This filter absorbed 50 per cent of the light which required a one stop increase in exposure.

APPLICATIONS OF CONTRAST AND COLOR-CORRECTION FILTERS

It isn't necessary to know everything about how filters work to use them effectively. Filters for black-and-white photography can be divided into four main types:

- *Correction filters*, which change the response of the film so that all colors are recorded at approximately the relative brightness values seen by the eye.
- *Contrast filters*, which change the relative brightness values so that two colors that would otherwise record as nearly the same shade of gray will have decidedly different brightnesses in the picture, or vice versa.
- *Polarizing filters*, which eliminate reflections and darken blue skies.
- *Haze filters*, which reduce the effects of haze or overcast conditions.

Correction Filters

Panchromatic films respond to all the colors the eye sees, but not exactly in the same way. They do not produce all colors with the relative brightness that the eye sees. For example, panchromatic film is more sensitive to blue and violet than to green, causing green to appear relatively darker in a black-and-white photograph. A *correction filter* can correct the response of the film to reproduce colors with the relative brightness to which we are accustomed. A number 8 (K2) filter with panchromatic films will reproduce a daylight scene in the shades of gray that best represent the relationship that the eye sees. Under tungsten light, use a number 11 (X1) filter to compensate for the excess red emitted by most tungsten lamps.

Contrast Filters

Sometimes it may be appropriate to increase contrast between two objects that would normally reproduce as nearly the same shade of gray. *Contrast filters* will lighten or darken certain colors in the subject. For example, a red balloon and a green sweater may photograph as nearly the same tone of gray. But using a number 25 (A) red filter will make the balloon appear lighter than the sweater. Because we normally think of a red balloon as being brighter than a green sweater, the resulting print will appear more natural.

Remember that a filter transmits its own color, making that color lighter in a black-and-white print. To make a color darker, use a filter which will absorb that color. The filter guide shown below will assist you in selecting a filter for the effect you want.

FILTER-FACTOR GUIDE FOR BLACK-AND-WHITE FILMS

Filter number	Color of filter	Filter factor	Daylight Open the lens by (f-stops)
8 (K2)	Yellow	2	1
11 (X1)	Yellow-green	4	2
15 (G)	Deep yellow	2.5	1⅓
25 (A)	Red	8	3
58 (B)	Green	6	2⅔
47 (C5)	Blue	6	2⅔
Polarizing filter	Gray	2.5	1⅓

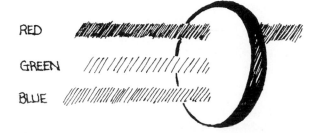

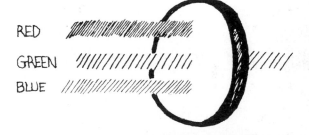

A red filter absorbs blue and green causing the sky to be rendered much darker than normal. Shadow areas, usually illuminated by bluish skylight, will also be darker. Exposure is increased by three stops to compensate for the light blocked by the filter.

A green filter absorbs both red and blue light. It is used to provide a more natural rendering of subjects in some situations. An exposure increase of 2⅔ stops is necessary to compensate for light absorption.

Polarizing Filters

A *polarizing filter* can effectively darken a blue sky, and is an effective tool for removing reflections from any object except a metal surface. At the same time, it can give the illusion of an increase in contrast because of its properties of eliminating reflections. The maximum effect with a polarizer occurs when you take pictures at right angles to the sun. Since polarizing filters do not change the color rendition of a scene, they can also be used with color films.

To understand how a polarizing filter works, you need to know a few things about the nature of light. Light travels in a straight line. Light also vibrates in all directions perpendicular to its direction of travel. When a light ray hits anything but a metallic surface, the vibration in only one direction or plane is reflected. Reflected light is called polarized light. Light from a blue sky is polarized because it is reflected off the atmosphere. A polarizing filter will pass the vibration of a light ray in only one plane. When the filter is oriented to pass the light vibration in this plane, you will see little or no effect on reflections or on the sky. If you rotate the filter, the screen will be disoriented to the polarized light and remove the reflection or darken a blue sky.

A polarizing filter has a factor of 2.5, making it necessary to increase exposure by 1⅓ stops.

Haze Filters

High-altitude aerial views and distant landscapes often are veiled by a bluish haze. This haze results from the scattering of light by small particles of dust and water vapor. The haze scatters a great amount of ultraviolet light invisible to the eye. Since photographic film is very sensitive to ultraviolet, you often end up with more haze in the photograph than was apparent at the time the film was exposed.

The effects of haze in black-and-white photographs can be reduced by filtering out some of the blue and ultraviolet light with a *haze filter*. Numbers 8, 15, and 25 filters are increasingly effective in reducing haze.

No filter will help if you're photographing a scene through mist or fog. Both mist and fog are composed of water droplets that are essentially white.

A polarizing filter passes light of like polarity and blocks all light of differing orientation. The filter contains minute crystals all oriented in the same direction. Light waves will pass through the filter only when they are parallel to the crystals. A polarizing filter is useful for eliminating reflections and darkening blue skies without affecting the rendition of other colors in the scene. It is the only filter to be used for darkening skies in color photography.

UNPOLARIZED LIGHT

POLARIZED LIGHT

UNPOLARIZED LIGHT

Without polarizing filter.

With polarizing

Walker Evans
"Garage in Southern City Outskirts." 1936. (L.C.)

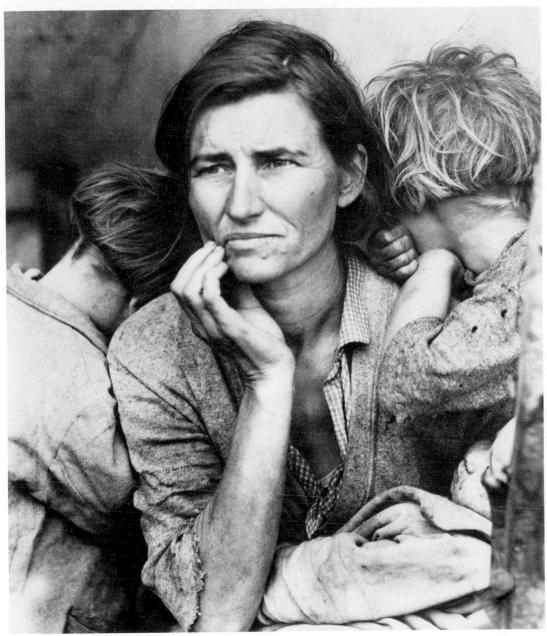

Dorothea Lange
"Migrant Mother, Nipomo, California." 1936. (L.C.)

Dave Heath
"Girl with Crutches." 1963.

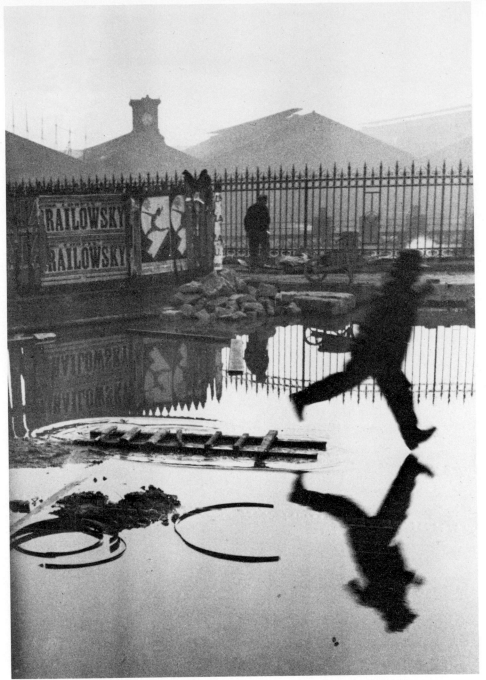

Henri Cartier-Bresson
"Man Jumping Puddle." (Magnum)

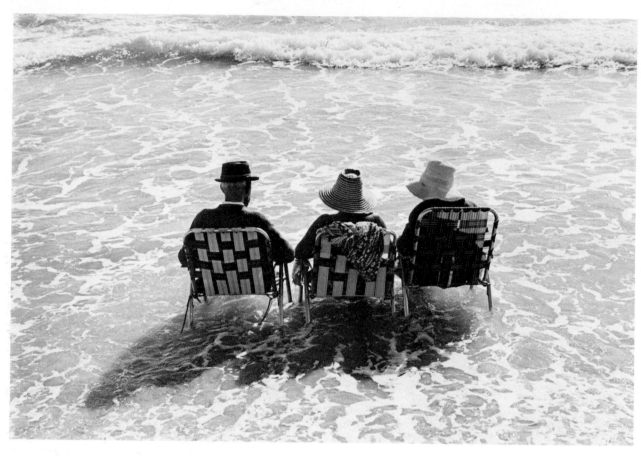

Michael Wesselink
"Three Beach Sitters." 1972. From: *"Portrait of a Beach."*

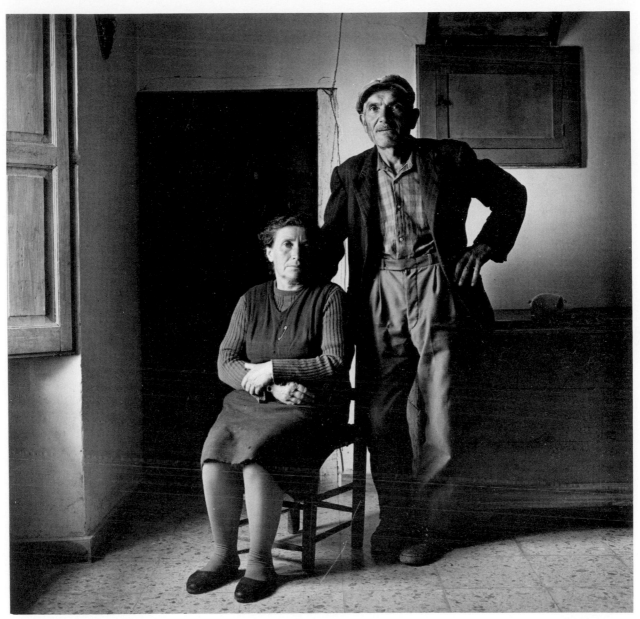

Douglas Lyttle
"Italian Couple." 1972.

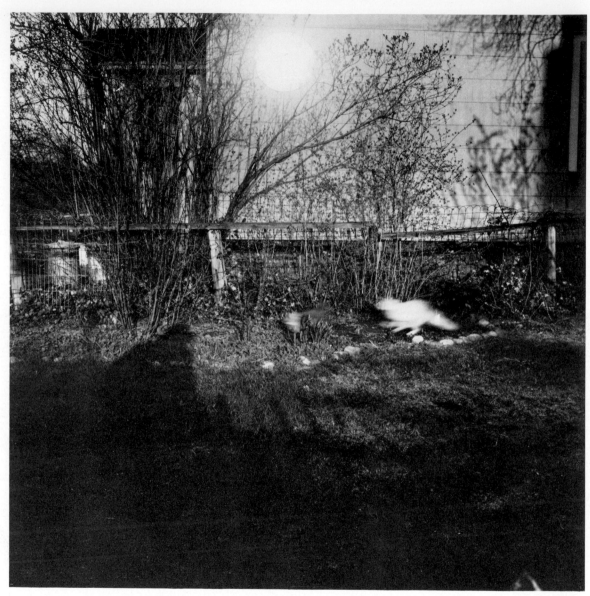

Harold Jones
"Backyard." (L.G.)

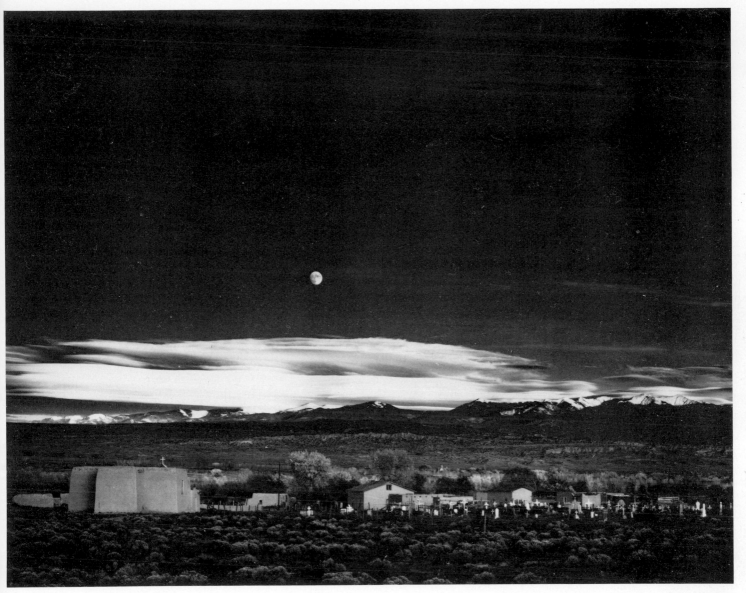

Ansel Adams
"Moonrise, Hernandez, N.M." 1941.

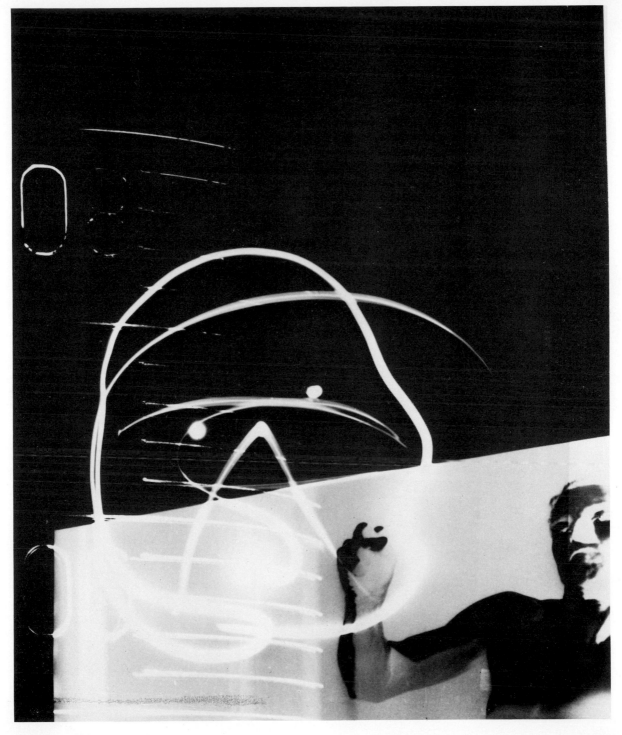

10

With today's fast films and lenses, no one has to wait for the sun to come out to take photographs. Typical room illumination provides adequate light for fine photographs. In many situations a supplementary light source can do much to improve photographs, bringing out the detail in shadows, giving an impression of three dimensions, or providing special dramatic effects.

It may be preferable to use floodlights or spotlights when circumstances permit. Their continuous light is easily controlled so that the pattern of illumination—the highlights and the shadows—can be manipulated to suit the visual requirements. Very effective photographs with artificial light can be made with simple equipment.

Lighting has a tremendous influence on the characteristics of a subject. It can idealize or enhance. It can distort or destroy. It is not unusual for a photograph to be judged on whether or not the lighting alone is a success or failure. Nothing detracts more from a photograph than light which is inappropriate to the mood or to the subject.

Successful lighting depends upon:

- the photographer's ability to be aware of and accept the physical limitations of his medium, and
- his skill and ability to see and arrange the light in a scene with good taste and judgment.

For most subjects, there should be one dominant light source and enough secondary illumination to fill in the shadows. When confronted with the problem of artificially lighting a subject or situation, it's extremely important to see with a "camera's eye;" to look at things in terms of light. A camera does not reproduce the subject, it simply records the light being reflected from the subject.

The effect of any direct light source is controlled by:

- changing the angle at which the light strikes the subject by raising or lowering the unit,
- varying the distance between the light and the subject, and/or
- varying the position of the light so that it shines from behind the subject, in front of the subject, or from any other point around the subject.

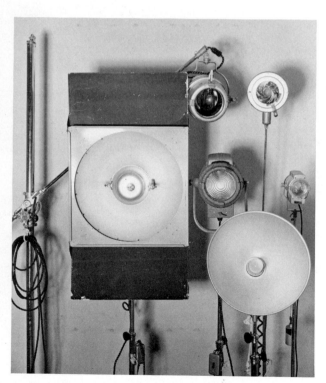

A collection of tungsten studio lights.

These are the three most common controls. Others include modifying the quality of the light with diffusion screens or color filters, varying the voltage being fed to one or more of the lights, or modulating the light with shields or shades.

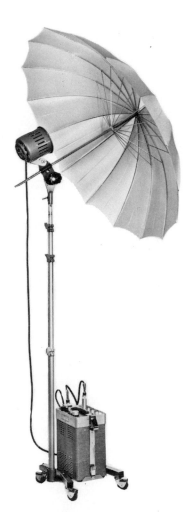

Electronic flash for studio and location with umbrella unit for soft lighting.

LEARNING TO WORK WITH EXISTING LIGHT

Photographers often incorrectly use the terms *existing light* and *available light* interchangeably. Existing light is best defined as the found light—the light actually existing in a room or an environment. Available light is best defined as all the light you can muster, borrow, beg, and carry.

Existing-light photography often results in more natural, more beautiful images. It's often the light which initially stimulated your interest in a scene or subject. While the existing light may be very beautiful, very appropriate, or very meaningful, it's not always the best light photographically.

There are times when the great range of illumination from deep shadows to bright highlights is beyond the recording capability of even the most versatile of contemporary films. In these situations with extremely high lighting ratios, it's necessary to compromise. You may find that the best solution is to calculate exposure for the highlights and middle tones and let the shadows go black, or to expose for the shadows and let the highlights fall where they may. Some processing techniques may help in this situation. You can reduce the development time. Expose for the shadows and, through decreased development, retain detail in the highlights. You may want to experiment with water bath processing techniques (see Chapter 13), which are extremely effective in getting a great range of brightness on a piece of film. Compensating developers (see Chapter 13) are available which will be of great help in retaining detail throughout the scene. Or, it may be appropriate to use a reflector to direct light into the shadows.

Other situations present the opposite problem of light: the area to be photographed has extremely flat lighting. In these circumstances it may be necessary to increase development to get more brilliance and contrast in the final print.

Photographers noted for their skill and ability with existing-light photography include W. Eugene Smith, Bill Eppridge, Alfred Eisenstaedt, and Bill Pierce. These men, who work a great deal with existing light, continue to practice and experiment so that when they encounter unusual or difficult existing-light situations they can reach into their bag of tricks and come up with successful and effective photographs.

Bill Eppridge was present at the assassination of Robert Kennedy. Working under miserable existing light, he came up with a series of memorable and dramatic photographs of this tragic event.

W. Eugene Smith was making a transatlantic crossing aboard the liner *Andrea Doria* when it collided with a freighter at night and sunk a few hours after dawn. His remarkable photographs, made under the poorest of lighting conditions, are a powerful visual document of confusion, panic, and compassion.

Front lighting.

Light from below.

High side lighting.

WORKING WITH STUDIO LIGHTS

Solving any lighting problem depends first on an understanding of the principles involved, then patient manipulation of the lights. A combination of floodlights and spotlights permits precise control over the result of a photograph. Continuous light can be turned on or off at will, making it possible to observe immediately the effects that different lights and their placement actually produce, and to control these effects by moving lights and reflectors around until the illumination is appropriate for the subject.

Basic lighting is concerned with creating a natural and attractive lighting which simulates an *outdoor* effect. The word *outdoor* is emphasized because outdoor lighting is the standard of comparison for most lighting. People are accustomed to seeing things by outdoor lighting; therefore, the following principles should be considered in using artificial light:

1. It is important for light from the main source to come from above, usually at a 40- to 60-degree angle to the subject, because that is the customary sun angle by which most objects are viewed outdoors.
2. Just as outdoors there is one sun creating one set of shadows, an indoor studio-lighting setup must have one dominant light source and one set of dominant shadows if it is to appear natural.
3. Outdoors, no matter how contrasty the sunlight becomes, our eyes, because of their variable sensitivity, can always discern shadow detail. Therefore, average studio lighting should always have sufficient shadow illumination.
4. The outdoor effect of overcast days has its counterpart in shadowless studio lighting for shiny-object photography. Also, this directionless lighting has found new use in modern color photography, where the color itself renders many more objects adaptable to this treatment than if the photograph were in black and white.

Illuminating Subjects with One Light

Most beginners in photography panic when given a problem in artificial lighting. The simplest way to approach the problem is to begin lighting experiments using just one light—to spend time and film experimenting and discovering the possibilities offered by using one simple light source, such as a floodlight. It is extremely worthwhile to invest time and film in acquiring an understanding of how the position of the main light source can influence the character of the image. In photography, one principal source of light is appropriate because we are accustomed to seeing things illuminated in this way. If there are several equally important sources of illumination in a photograph, the result tends to be visually confusing.

Top lighting.

Side lighting.

Side rear lighting.

Artificial-light criteria are usually based on natural light, which comes from overhead. But very slight changes in the angle of illumination can alter the overall result significantly, and the exact position of the main light source depends both on the subject and on the interpretation of the subject.

Study the illustrations on these pages. Carry out a series of your own experiments in lighting. Consider the following possibilities:

- *Front lighting.* Place the light at the camera position; the illumination is straight, even, and fairly flat.
- *Light from below.* Lower the light source in relation to the subject. Notice how the face assumes strange, unreal shadows, perhaps even a suggestion of evil.
- *High side lighting.* Position and aim the light at about a 45-degree angle to the subject. This type of lighting can model a face nicely into a three-dimensional form.
- *Top lighting.* Place the light nearly directly above the subject, creating deep shadows in the eye sockets and under the nose and chin.
- *Side lighting.* Place the light directly to the side of the subject. This type of lighting often gives the appearance of splitting the subject in half. It's useful for emphasizing texture.
- *Side rear lighting.* Place the light to the side and a bit behind the subject. This produces a dramatic effect, bringing out the shape and the silhouette of the subject, and emphasizing texture even more than side lighting.

While it's possible to make strong and effective photographs with one flood or spotlight, additional modification is usually needed to open up the shadows and preserve some detail in the areas not illuminated directly by the light. The simplest and most effective way to achieve this is to use a reflector to bounce some of the main light into the shadow area. A piece of white mount board, approximately twenty by twenty-four inches, makes a simple reflector. Cover the back of it with aluminum foil. The white side gives soft, diffused light suitable for lightening shadows; the foil side gives a hard, brilliant light that is particularly effective in highlighting surface textures.

Advanced Lighting Techniques

There are times when it takes more than one simple floodlight and reflectors to illuminate a complex subject properly. To give each part of such a scene the kind of light required, professionals build up an overall illumination using several lights, each of them carefully arranged to serve a specific purpose.

First the position, quality, and intensity of the main light must be determined. A second light is then positioned to lighten any dark shadows cast by the main light. A third light may be used to add highlights or accents suggesting depth, and to emphasize shape and dimension. A fourth light may be placed to illuminate the

background and thus aid in separating the subject from the background.

Study the lighting examples on these pages. Consider the lighting diagrams in terms of what the photographer was trying to say with the pictures and how he emphasized his statement through careful and restrained lighting.

An Approach to Lighting for Portraits

Chance has very little to do with the successful lighting of a person. Shoving lights about aimlessly hoping you'll hit on something good is an inefficient and usually nonproductive method of working.

You should start with a fairly specific idea of what is important about the subject and some notion of the lighting which will support this statement. It may take a bit of experimenting before the desired effect is achieved. A minor adjustment of the lights may give a somewhat improved version of your basic idea. This isn't aimless motion. If you're observant, looking carefully, you can recognize an improvement in the lighting when you see it.

To know what you want and to be able to recognize it when you get it are the secrets of good lighting.

More photographs are made of people than of any other subject. However, not all of these pictures can be considered portraits. A portrait is more than a photograph. It is more intimate. It makes a statement about the person's personality and character. And it should be a good likeness of that person. Effective lighting helps you achieve these objectives.

The correct placement of the lights is of extreme importance. It will depend upon the position of the subject's head: the direction he is facing, the way his head is tilted, and where he is looking. For the most part, a lighting diagram is only a rough guide to the general placement of light. It makes much more sense to understand the principles of lighting and to use the lights accordingly.

The first step is to determine where the *main*, or *key, light* will be placed: how far from the subject, how high, and how much to the side. With the subject facing the camera, place your main light about five feet in front of him. Observe the highlight areas on the bone structure of his face. While watching these areas very carefully, move the light closer to the subject, until it is about three feet away. At this point the highlights may have flattened out and the illuminated portion of the face will assume a flat, chalky appearance.

Slowly move the light back to about ten feet from the model, watching the highlights on the face. When the light is too far back, the highlights will be too small. When it is too close, they may be

162

Main light.

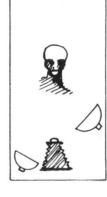

Main and fill light.

Main and fill plus hair and background light.
(Photographed by Frederick H. Krizan.)

so large that the entire illuminated portion of the face is actually a huge highlight. Somewhere in between these extreme positions the protruding bone structure of the face will appear round and with appropriate highlights. This point is the correct distance for the main light from the subject.

When you've established the distance for the main light, determine how high it must be. The best guide is the length of the shadow underneath the nose. Start with the main light at the subject's eye level, where there will be almost no shadow under the nose, and slowly raise the light. The point at which to stop raising the light is just before the nose shadow cuts into the upper lip. If a person has deep-set eyes, the light should be a bit lower.

The photographer's judgment determines how far to place the main light to the side of the subject. Any one of several positions is acceptable. If the subject is facing the camera and the light is moved to one side so that it illuminates the nearer half of the face and a small patch of the far cheek, it is referred to as *three-quarter light*. This is the lighting most commonly used in portraiture.

With the main light positioned, the next step is to open the dark shadows. This is done with a second light called a *fill-in light*. The position of the fill-in light is determined primarily by the depth of the shadows desired. In an average black-and-white portrait, the ratio of intensity between the main light and the fill-in should be about 3:1 or 4:1. Since light decreases in intensity as the square of the distance (the inverse-square law), a fill-in light at ten feet from the subject and a main light at five feet would produce a 4:1 ratio.

Separately lighting a person's hair is desirable from two standpoints. First, it helps separate the subject from the background, particularly where someone with dark hair is being photographed against a dark background. And, even when there is good tone separation, a hair light shows the hair in more detail and often adds a desirable sparkle to the picture.

One or two spotlights can be used to light a person's hair. They should be placed high and behind the subject, on one side or the other, so that the light stands won't end up in the picture. It is extremely important that the illumination from any hair light does not shine accidently into the camera's lens. This could cause a flare effect and ruin the negative. It's usually wise to use too little hair light rather than too much. If the light is too close or too intense, the hair can be "burned out," giving an excessively large highlight area with no detail. Be careful too to avoid creating an excessively bright highlight on the face or on the side of the subject's nose.

In portraiture the last light to be positioned is the *background light*. It provides some change of tone across the background against which the subject is being photographed. If the brightest part of the background light is directed behind the subject's head, his head will stand out from the background rather than blending in with it.

PRINCIPLES OF FLASH PHOTOGRAPHY

In the early days of photography, getting enough light of any kind to record a recognizable image indoors was a most frustrating problem. In the 1850s came the discovery that burning magnesium wire produced an extremely bright light similar to daylight. It wasn't long before photographers were using burning magnesium to make previously impossible photographs. Unfortunately, burning magnesium produced choking clouds of white smoke which forced the photographer to flee immediately after making the photograph.

From the 1880s on, most artificial-light pictures were made with *flashpowder*—an explosive mixture of finely ground magnesium, potassium chlorate, and antimony. It produced a very effective but extremely dangerous light. Many photographers were burned or blinded by accidental explosions of flashpowder.

Flash photography became simple and safe in the 1930s with the introduction of *flashbulbs*. These first flashbulbs, which looked like ordinary electric lightbulbs, contained crumpled aluminum foil and oxygen which generated an intense light when touched off by a powder primer activated by batteries. Flashbulbs or *cubes* are the most popular sources of artificial light among amateur photographers today. They are inexpensive and easy to use. The flashcubes, the most recent development, contains four individual bulbs each with its own reflector. It is constructed so that four pictures can be made in rapid succession.

Electronic Flash

Electronic flash is a still more versatile light source. The idea behind electronic flash dates back to the beginnings of photography. William Henry Fox Talbot fashioned a device which would produce an electrical spark from a battery of Leyden jars in 1851. He used this spark to photograph successfully a spinning page of the **London Times**.

Contemporary electronic flash units operate much like a bolt of lightning. Electricity is built up to a very high voltage—as much as four thousand volts in some units—and stored in the unit's circuit. When the switch is pressed, this high-voltage electricity jumps from one electrode to another inside a glass tube filled with a mixture of gases such as *krypton* and *xenon*. This electrical discharge causes the gases to glow intensely for a moment with a color approximating daylight. This burst of light is extremely short—as fast as a fifty-thousandth of a second in some units—and is very effective at stopping fast action. Electronic flash units are frequently referred to as *strobes*. This is a misnomer, coming from the days when the electronic flash unit was employed as a stroboscope, a light that flashes repeatedly at a controllable rate for studying motion.

Portable, battery-powered, electronic flash unit. Units of similar size and construction are often used for news photography.

164

Flashpowder, a highly explosive mixture of magnesium, potassium chlorate, and antimony sulfide, was used to provide a blinding flash of light illuminating interiors for the camera. Dangerous and difficult to control, it quickly became synonymous with caricatures of bumbling press photographers. The best examples of fine photography with flashpowder were produced by Jacob Riis in an early social documentary entitled "*How the Other Half Lives*" published in 1890.

"*I've got incredible power in my closet. Not power to do harm—just the feeling that I've captured people who since have died and people who will never look that way again. The camera is cruel, so I try to be as good as I can to make things even.*"
DIANE ARBUS

The brief, bright pulse of light from a flash unit is awkward to control, and the effect of the light is nearly impossible to observe. Photographers using flash may use Polaroid film as a check on the lighting being produced by the units. Polaroid film can also be used as an exposure guide by simply adjusting the f-stop used with Polaroid proportionally for the changes necessary when going to the standard film.

Experimentation and practice are the best teachers for gaining skill and confidence with flash photography.

How to Determine Exposure for Flash

The distance between the flash and the subject is the prime factor in determining flash exposure. A flashbulb 6 feet from the subject puts twice as much light on the subject as the same bulb at 8½ feet, and four times as much light as the same bulb at 12 feet. The amount of light falling on the subject is inversely proportional to the square of the distance.

Other factors in determining correct flash exposure include:

- *The nature of the room in which the pictures are being made.* A room with white walls will reflect and bounce much more light around than a room with dark-colored walls.
- *The type of flash reflector.* A matte reflector will give a softer, less intense light than a highly polished reflector.

To simplify exposure determination, manufacturers of film and flash equipment publish *guide numbers* calculated by a formula that takes into account the lamp's light output, the particular shutter speed, the speed of the film, and the reflector being used.

Finding and Using Guide Numbers

The appropriate guide numbers are determined by consulting a chart furnished with the flashbulbs, the film, or the flash equipment. You must know the speed of your film and the shutter speed at which you are going to photograph. With these two figures, you can find the appropriate guide number from the chart. Dividing the distance in feet between the flash and the subject into the guide number gives you the f-number.

Remember that a guide number is just what the name implies— a guide. Variations in equipment, development, subject, and environment all have to be taken into account. The numbers are intended for average indoor subjects in an average-size room with light-colored walls and ceiling. If you're photographing in a gymnasium, you won't get much light reflected from walls and ceiling. Correct exposure in that situation is probably at least one stop more than indicated by the guide number. If you're using flash outdoors at night, you will need to open up at least one stop.

It's wise to make a series of test exposures with a particular flash-bulb or electronic flash unit at the shutter speed you use most often. The subject should be 10 feet from the flashlamp. Make a series of exposures at half-stop intervals. A slate marked with the *f*-number used can be included in each test shot for easy identification of the negative. Start, for example, at *f*/4; then shoot at halfway between *f*/4 and *f*/5.6; at *f*/5.6; halfway between *f*/5.6 and *f*/8; *f*/8; halfway between *f*/8 and *f*/11; and so on. Process the film and select the negative or transparency with the best exposure.

Your own personal guide number for that film and shutter speed is then the product of the lamp-to-subject distance times the *f*-number used for this best exposure. Once you have determined your working guide number, write it on an adhesive sticker and place it on your flash unit.

When working with electronic flash, the shutter speed is not a factor because the duration of the flash is always shorter than the shutter speed you would normally use. Some of the newest electronic flash units have built-in devices which, given the film speed and *f*-number being used, automatically quench the flash when the light reflected back from the subject indicates enough exposure.

SYNCHRONIZATION

Flashbulbs and electronic flash supply an intense but brief illumination. A method must be provided to insure that the shutter of the camera is open when the flash is at its peak. This is called *synchronization*.

A leaf shutter takes between 2 and 4 milliseconds to open and an equal amount of time to close. At a shutter speed of 1/100 second, the blades are fully opened for a total time of about 8 milliseconds. This means the shutter starts to close 12 milliseconds after it has begun opening and will be fully closed after 16 milliseconds. The usual flashbulb needs 15 milliseconds to reach peak light. This discrepancy between shutter and flash peak is even more pronounced at higher shutter speeds.

If we could get away with taking all flash pictures at slow shutter speeds—perhaps 1/30 second—we could start the flashbulb and the shutter at the same time. The shutter is open for nearly 40 milliseconds at a setting of 1/30 second, long enough for the bulb to reach its peak and start to fade. But most flash pictures are made at higher shutter speeds, so there has to be some provision for the bulb to start burning before the shutter is released. This is the purpose of synchronization settings on the camera.

A camera with a leaf shutter usually gives a choice of synchronization settings. A setting marked **X** is intended primarily for electronic flash, which peaks in less than 1 millisecond. The **M**

"Through this bright world the photographer walks like a zombie, blind unless a camera is strapped around his neck. The one time he appears without it is when he visits the clearing at night and discovers there the corpse. His immediate reaction is to run home for his camera. Only in a photograph does reality become meaningful for him."

ARTHUR KNIGHT (On "Blow-Up")

setting on the shutter is for medium-peak flashbulbs. The electrical contact firing the bulb is made first, and after a predetermined delay the shutter begins to open.

With focal-plane shutters, synchronization is a more complex problem. The focal plane-shutter has a slit which travels across the film. The slit may be set to expose each bit of the film for 1/200 second, but it may take 1/50 second to travel completely across the film. Some flashbulbs and electronic flash units work with focal-plane shutters at slow shutter speeds (1/60 second or slower). With higher shutter speeds, however, there will not be even illumination on the film. This is the reason for *FP bulbs,* which give a relatively even illumination during the focal-plane shutter's travel across the film. FP bulbs have a long peak of illumination, giving the focal-plane shutter time to travel across the length of the negative.

The careful photographer checks the synchronization setting on his shutter frequently when doing extensive flash photography. If the selected synchronization setting is inadvertently pushed to the wrong position, many pictures will be spoiled.

Flash Meters

Several manufacturers now produce simple and easy-to-use light meters designed specifically to measure the brief burst of light from a flashbulb or electronic flash. These units, ranging in price from about fifty to one hundred fifty dollars, are a worthwhile investment if you are doing a great deal of flash photography.

The units come with a full set of instructions for turning up or zeroing the meter for your own particular working conditions. Manufacturers of flash meters include Calumet, Wien, Gossen, and Minolta.

Special Flash Techniques

A single flash at the camera is the simplest method of making a flash picture. An adequately exposed picture is almost guaranteed if the simple instructions that come with the unit are followed. But the resulting picture almost always comes out flat, with no modeling; the roundness or volume of the subject is lost. There are no shadows to suggest depth and texture, and details are often bleached out with the head-on burst of light. This is not the flash, but of the way it is used.

Significant improvement in quality will result as soon as the flash is positioned away from the camera, which is referred to as *off-camera flash.* Natural light, whether sunlight, a household lamp, or a ceiling fixture, most usually comes from above the subject. The most natural-looking flash pictures will result when the light is held above the level of the lens and slightly to one side, or

Electronic flash meter.

bounced in such a way that light comes from above. Bouncing some of the flash light off walls or adding a second or even third flash helps give an even quality of light, providing the interesting textures and depths and soft shadows that most people prefer in photographs. Remember, placement of the light is all-important in achieving quality flash photographs. Exposure must be based on the lamp-to-subject distance, not on the camera-to-subject distance.

Synchro-Sunlight—A Useful Flash Technique

Flash can be used effectively outdoors to open up shadows cast by brilliant sunlight, and indoors to balance light from an outdoor scene that will be included in the picture through a window.

Flash outdoors is intended to fill in the shadows enough to record detail without eliminating the shadows. It is an especially useful technique with color film, using blue bulbs or electronic flash so that the color temperature of the flash matches that of sunlight.

Exposure is based on the sunlight. The distance the flash must be from the subject is determined from the guide number and the f-stop selected for the sunlight exposure. For example, if the exposure selected for the photograph in sunlight is $f/22$ at 1/60 second and the appropriate guide number is 160, dividing $f/22$ into 160 gives 7 feet. That is the distance at which the flash would effectively balance sunlight—in other words, eliminate the sunlight's shadows. To keep the shadows, the flash must be moved to about 10 feet; the sunlight-to-flash ratio would then be approximately 2:1.

This is a particularly good ratio when working with color films. It can be adjusted or manipulated to suit your particular needs by moving the light or covering the reflector with a clean white handkerchief. Covering the reflector will cut the light from the flash by one-half. If the flash is fired without a reflector, the light is reduced by one-half again.

With electronic flash you can alter the flash-to-sunlight relationship by changing the shutter speed, for electronic flash exposure is controlled by the f-number only. Changing the exposure from $f/11$ at 1/125 to $f/16$ at 1/60 will give the same exposure as far as the sunlight is concerned, but will reduce the exposure from the flash.

A flash fill is also effective in opening up shadows on an indoor subject positioned next to a window.

"Be master of the camera and technique—not slave. Develop a statement of your own. Shout, don't whisper."

ALEXIS BRODOVITCH

This photograph, made in harsh sunlight, contains excessively deep shadows.

With synchro-sunlight flash serving as a fill light, the shadows are balanced with the sunlight, giving better detail.

Weegee (Arthur Fellig)
"The Critic." 1943.

Irving Penn
"Colette." 1960.
(Courtesy Condé-Nast)

Michael Spencer
"Untitled." 1972.
Subject "painted" with small
spotlight during long exposure.

COLOR PHOTOGRAPHY 11
theory, process, and controls

Art Kane
"Flag and People."

Christopher R. Harris
"*Motorcycle Jump.*" © 1970.
Photographed with Infra red.

Eliot Porter
"Tamarisk and Grass." Glen Canyon. 1961.

Syl Labrot
"Carbro Print."

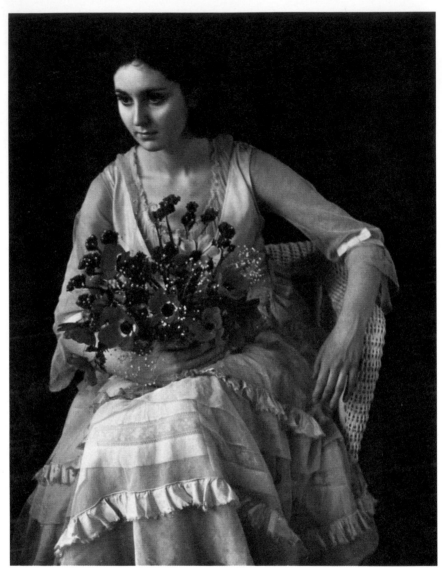

Marie Cosindas
"Polaroid Color."

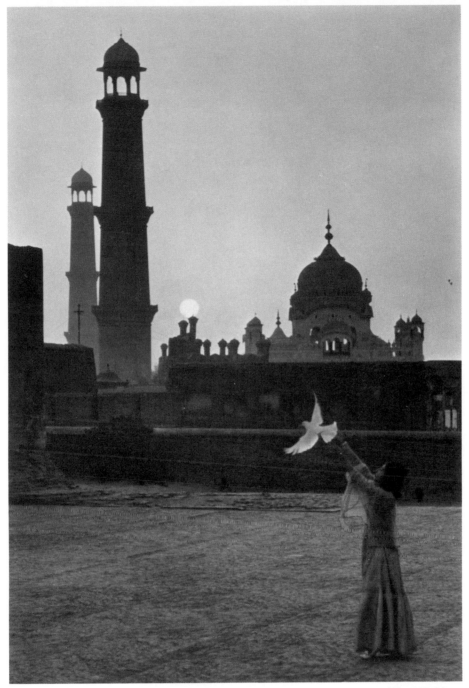

Albert Moldvay
"Pakistani Girl." Lahore. *"I had only three pigeons."*
(N.G.S.)

Pete Turner
"Cannon Ball, Mozambique." © 1972.

Color photography is a challenging and provocative medium of visual communication. Color adds an exciting dimension to almost any photographic subject, from the snapshot of the girl next door to the carefully planned and executed advertising illustration.

A practical color photography process was first marketed in 1935 by Eastman Kodak after more than a century of research on both sides of the Atlantic. Until then color photography had been the realm of a small number of professionals and adventurous amateurs.

In spite of all its practitioners and advocates, color photography today is not without controversy. Many photographic purists ignore or avoid working with color film. They argue that color film gives less-than-perfect rendering of the subject, that it lacks archival quality, that it is too garish or posterlike, and that it adds an undesired esthetic quality to their images. The wisest course may be to ignore the criticisms and comments of these workers and enjoy their often-superb black-and-white photography.

Color has possibilities of multiplying a picture's impact in many ways. In the hands of a creative photographer, color can bring out the subtleties of a person and his many-faceted emotions. Color can evoke abstract human responses. Color can be its own justification. The pure, simple beauty of color can be the success factor in views of wildflowers, tranquil oceans, fiery sunsets, misty harbors, and the garishly painted clowns of the world's circuses.

Sophisticated use of color can evoke the same response in many people, photographers and viewers alike. Color gives the visual communicator an opportunity to celebrate the rediscovered beauty of the world's spectrum. The clever color photographer has the option of converting reality into a fantasy of multi-colored hues. "Beauty pains, and when it pains most I shoot" (Ernst Haas).

Today's variety of color films, papers, and processes gives the inventive photographer the option of generating colors that never were and the capability of exploring a world of synthetic color. The wonder of modern color film is that, despite the bewildering lights and hues of the world, it can meet nearly every challenge. What is the color of love, of despair, of hope, or of triumph? The creative color photographers of today are seeking and finding the photographic answers.

"It is only when the photographer can control either his emulsion or reality that he can photograph heartbreaking things in color."

ERNST HAAS

COLOR THEORY

All color is the color of light and all light possesses color, whether you perceive it or not. The unique color associated with an object depends on what happens to the light which strikes the object. Isaac Newton, in 1666, first demonstrated that light is the source of color. Newton placed a glass prism in a beam of sunlight to produce the rainbowlike array of hues of the visible spectrum. He went on to pass his miniature rainbow through a second prism that reconstituted the original beam of white sunlight. His conclusion was revolutionary: color is in the light; the light man sees as white is really a mixture of all the colors in the spectrum.

When white light strikes an object, some of the colors may be absorbed. The colors we see are those reflected by the object. For example, a white egg reflects all colors of light, so the eye sees it as white. On the other hand, a ripe tomato reflects mainly red light and absorbs most other colors. So the tomato looks "red" to our eyes.

Modern methods of color photography take advantage of a fact long known to painters: nearly all of the colors visible in light can be reproduced by mixing a few basic colors. In photography the primary colors are red, green, and blue. Color films are made up of three color-sensitive layers, each of which records the wavelengths of light in a different third of the spectrum. From these three separate color impressions, all the colors of the subject photographed can be mixed during processing of the film; the result provides light in colors that seem to duplicate the original.

With the aid of a prism Isaac Newton demonstrated that sunlight is composed of all the colors of the visible spectrum.

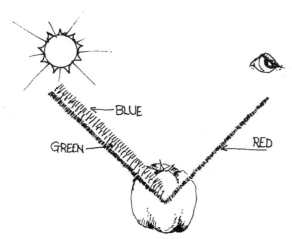

In white light, tomatoes appear red because they absorb most light from the green-blue portion of the spectrum and reflect light from the red portion.

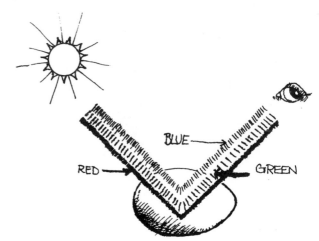

Eggs reflect virtually all the wavelengths, or colors, of light that fall on them. When this light comes from a source containing all colors such as sunlight, the mixture of these reflected colors makes the eggs appear white.

COLOR FOR PHOTOGRAPHY

Technically speaking, there are two basic methods for producing color photographs: the *additive* process and the *subtractive* process.

The additive process starts with varying amounts of red, green, and blue and adds them together to yield some other color. Mixed in varying proportions, red, green, and blue light will give nearly all colors. Equal amounts of red, green, and blue will give the color we call white.

The subtractive color process starts with white light. The desired color is obtained by filtering out unwanted colors. In the subtractive system, cyan, magenta, and yellow dyes are used to absorb varying quantities of red, green, and blue from white light. The combination of equal amounts of cyan, magenta, and yellow can absorb all colors, producing the color we call black. Mixed in varying densities, cyan, magenta, and yellow can give almost any color in the visible spectrum.

The additive process was the first workable method for early color photography, but the subtractive method has turned out to be more practical and is the basis of all modern color films and papers.

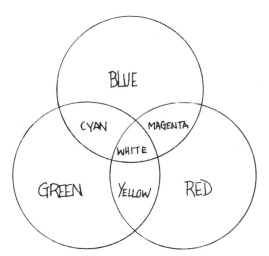

The additive process produces a spectrum of color through the combination of varying amounts of red, green, and blue light. A mixture of blue plus red giving magenta, for example. Overlapping all three of the primary colors in equal amounts produces the sensation of white.

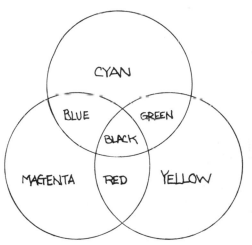

The subtractive color process operates by removing some colors from white light. The "blocking" filters are always cyan, magenta, or yellow. When paired, they pass red, green, or blue. Whenever all three overlap, all wavelengths are absorbed, producing the sensation of black. Color transparency film such as ektachrome has three layers, or "filters," of cyan, magenta, and yellow dye which overlap in various places and degrees to produce virtually all the colors of nature.

Making Color Transparencies

Modern color film consists of three black-and-white emulsion layers. These three layers, one over another, are coated on a transparent base. They are specially sensitized and filtered so that each layer reacts to only one of the primary colors. The bottom layer, closest to the film base, is sensitive to red light. The middle layer is sensitive to green. And the top layer is sensitive to blue.

Most contemporary color films have chemical compounds called color couplers in each of the emulsion layers. These color couplers react with chemicals in the color developer to produce dyes.

Thus a color photograph begins as three black-and-white negatives. After a color transparency film has been exposed, it is first processed in a solution which is essentially a black-and-white developer. In this solution a negative image is formed in each of the three layers of film. These three black-and-white images are chemically fixed in the next solution. The film is then given a second overall exposure, or fogging, either with a flash of light or by means of a chemical agent. This fogging forms a latent image wherever the film originally received no exposure.

The film is next placed in a color developer which reduces the exposed silver halides to metallic silver. The developer is oxidized in the process. The product of this oxidation combines with chemical couplers to produce dyes forming three positive color images with the metallic silver positive image. At this point in the process, the film will appear to be very dense. It has metallic silver negative images, and silver and dye positive images: a yellow dye image in the blue-sensitive layer, a magenta image in the green-sensitive layer, and a cyan image in the red-sensitive layer.

The color film is next transferred to a bleaching solution which removes all metallic silver in the emulsion, leaving only the positive color dye image. When white light passes through these superimposed color images, each of the colors of the original scene is reproduced by the subtraction of the other colors from white light.

To reproduce a blue, for example, magenta and cyan dye images are formed but no yellow image. The greens and reds of the white-light source will have been subtracted by the magenta and cyan dyes, leaving blue. At the same time, varying mixtures of dyes in the transparency will yield the whole range of colors of the original scene.

Shadows in the scene are produced where all the colors of white light were subtracted. Highlights, or white areas in the scene, are represented by areas where no dye was formed, allowing the white-light source to be transmitted without filtration.

Processing of the reversal color film is completed by washing in the normal manner to remove all chemicals, and drying with standard techniques.

Color Negatives for Prints

Kodacolor, Ektacolor, Anscocolor, and Agfacolor are some of the contemporary films designed to produce color negatives. These films give a negative dye image in colors complementary to colors of the original scene. A color negative of the United States flag would have a light yellow field containing black stars, and stripes of cyan and black. The negative color results because the dyes are formed during the development of the negative image.

The color film negative is processed by a special color developer which produces a black-and-white negative. At the same time, the oxidized developer and chemical couplers react to form dyes. The film is transferred to a solution of bleach, where the negative silver image is bleached out, leaving three emulsion layers containing cyan, magenta, and yellow dye images. When the color negative is held up to white light, the three layers of dyes absorb all the original colors of the image and transmit their complementary colors. For example, wherever there was green in the original scene, green light is absorbed by its magenta image on the negative, while red and blue light is transmitted. Wherever there were blues and reds in the original, their complements, yellow and green, will appear in the negative image.

A color positive from the color negative can be made by printing the negative image on a three-layered emulsion similar to that of the original color negative film. The color paper would be exposed to the complementary colors found in the negative. Dyes, reproducing the colors found in the original scene, will be formed along with a metallic silver negative image during development. When the silver is bleached out, the magenta area of the negative has been reproduced as yellow and cyan. This will give the green area of the original.

The colors which appear in a color print are those reflected back to the eye from white light falling on the print. The full colors of the print are a product of the colors subtracted from the white light by the three superimposed dye images—cyan, magenta, and yellow.

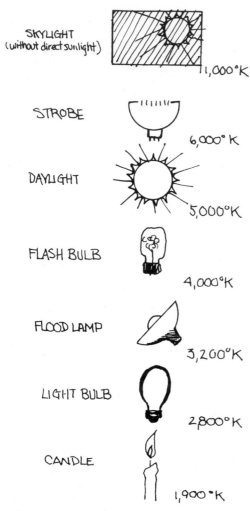

SKYLIGHT
(without direct sunlight)
1,000°K

STROBE
6,000°K

DAYLIGHT
5,000°K

FLASH BULB
4,000°K

FLOOD LAMP
3,200°K

LIGHT BULB
2,800°K

CANDLE
1,900°K

This color temperature chart illustrates the differing "white" light sources a photographer may have to deal with. He must select a color film or correction filters to match the illumination or his pictures will have an unacceptable color shift.

Choosing the Correct Color Film

The problem of matching a color film to a subject or situation is twofold. The first consideration is to select a color film balanced for the illumination of the scene. Film balanced for daylight must be used either in daylight or with electronic flash. Type-B or tungsten film should be used when photographing by artificial light. Color film does not adjust and accept the changes in color under artificial light as our eyes do. Color film will be sensitive to the subtle difference of a white shirt illuminated by daylight and the same shirt seen under tungsten light. The sensitivities of the emulsion layers of color films have to be adjusted to reproduce colors the way we expect to see them.

The second consideration in selecting a color film deals with the unique visual characteristics of a given film. There is an impressive array of color films available today: some which are contrasty and yield posterlike renditions, others which are soft and low in contrast, grainy films, and films which produce some colors better than others. Every film, whether manufactured by Kodak, Agfa, Fugi, or GAF, has its own unique characteristics.

The palette of color films available is impressive. Your choice of brand and speed rating really depends on which values of color you prefer in a transparency or print.

Fast color films offer some advantages, but they also have disadvantages. You may have to sacrifice some color values, and the color is usually grainier, less saturated (vivid), and less contrasty with fast color films.

Prints from color negatives may show differences in color rendition due to print-processing variations, but the negatives can always be reprinted and the colors of the picture adjusted.

The most effective way to learn about the differences in color films is to buy several different films and run a series of tests. The best test is made by selecting or organizing a colorful scene similar to those situations in which you'll be doing most of your color photography. Photograph this scene with each of the color films, keeping a careful record of exposure and remembering to bracket exposures so that the processed results will give you some indication of the *latitude* of the film—how well or how poorly it responds to overexposure and underexposure. After processing, place the color transparencies on a light box for careful and critical evaluation. Evaluate them for color rendition, latitude, graininess, and contrast. Select the film which best satisfies your personal taste and requirements and stay with it.

Color Balance

A color film is supposed to reproduce colors approximately as the eye sees them. The film's response to red, green, and blue

parts of white light must bear the same relation to each other as the responses of the eye to these same colors.

If a color film is too sensitive to red light, for example, red objects in the scene will appear too light in the color reproduction and white objects will appear slightly reddish. All color films have a certain *color balance* which is determined at the time of manufacture. The color balance of a film may be affected by such factors as high temperature or high humidity during storage and variations in processing. The best possible reproduction in a transparency can be obtained only when the illumination is of the particular color quality for which that film is balanced. Daylight and the various types of artificial light differ in color quality.

When selecting color films you have three options in terms of color balance: (1) you can use daylight-type films, which are color balanced for sunlight on a clear day; (2) you can select a type-A film, which is balanced for photoflood lamps operated at their rated voltage; or (3) you can select type-B film, which is balanced for 3200° Kelvin photolamps operated at their rated voltage.

When it's necessary for you to expose color film by light of a color quality other than for which it was balanced, corrections can be made by the use of filters.

Filters

The filters designed for use in color photography are much paler in color than those used for black-and-white films. Filters usually used with color films include the polarizing filter, which, under proper conditions, will darken blue skies and to a limited extent penetrate light blue haze. The polarizing filter can also be used to reduce or eliminate glare from various objects in the scene.

A skylight filter is used to prevent excessive bluishness when the film is exposed in open shade or overcast conditions. When it's necessary to expose color films balanced for tungsten light in daylight, use a number 85 or 85B filter. Although type-A and type-B films are intended for use with tungsten illumination, type-A film can be used in daylight with an 85 filter, and type-B film can be used in daylight with an 85B filter. Although these two filters are somewhat similar in appearance, they are not interchangeable. If a tungsten film is used in daylight without a filter, the results will be strongly blue or blue-green. This happens because films balanced for tungsten or clear flashbulbs have relatively high sensitivity to blue light, which is relatively weak in artificial-light sources.

When exposed under fluorescent light, most color pictures will take on a greenish cast produced by the predominance of green wavelengths in fluorescent light. This problem can be corrected to a great extent by photographing with a weak magenta filter (30M), which will absorb much of the excess green light, resulting in pictures which appear as the brain expects them to be.

"Color film straight out of the can is a damn primitive vehicle."

ELIOT ELISOFON

12

The view camera was photography's first camera. The remarkable thing about this ancient piece of photographic apparatus is that its basic design remains essentially unchanged down to the present day. Even the tripod on which the view camera is placed is little changed from the camera supports used more than a hundred years ago. The operating controls of contemporary view cameras have been refined and made more precise, and are constructed of metal rather than wood for lightness and precision.

The view camera is photography's most versatile instrument. There comes a time in every serious photographer's development when he must graduate to the view camera, when no other camera can produce the photographic images he requires. This necessity to use the view camera can be stimulated by a variety of factors:

- The view camera generates a unique relationship between the photographer's eye and mind and the ground glass image. The image can be assembled, in effect, by carefully observing the optical picture, arranging the objects, studying the relationships of tones, shapes, lines, textures.
- The view camera is designed to use large-format film: 4x5, 5x7, or 8x10.
- A special visual awareness occurs while working under the dark cloth, studying a large, inverted ground glass image. It's a unique photographic experience to go into the field for the first time with an 8x10 view camera. Many young photographers are so profoundly affected by the delight of viewing their image on a large, brilliant 8x10 ground glass that the act of actually exposing film becomes almost anticlimactic.
- A view camera permits the film and lens to be deliberately unaligned. This capability permits making pictures which would be impossible with a rigid camera.

View cameras typically permit adjustments in the positions of the lens and film. All view cameras allow the use of interchangeable lenses. View cameras have long bellows, and permit the use of large-format film. The high quality of the resulting photographic image is an advantage that attracts many photographers to the view camera.

The view camera is not without limitations and disadvantages. It must be used on a tripod or other support. There is an unavoidable delay in composing the image on the ground glass and exposing the film. View cameras are heavy, awkward, and impractical for photographing moving objects. They are expensive; a good view camera plus an appropriate tripod, a selection of lenses, and a supply of film holders constitutes an outfit selling for several hundred dollars. The sheet film it uses is more expensive than roll film, although you will find yourself making fewer negatives for an equal number of satisfactory pictures because you tend to work more carefully, more precisely, and more confidently with a view camera.

"I don't like to arrange my subjects. But once in awhile something has great possibilities except that it's in the wrong place. Say I'm shooting in the Jersey Meadows and I see a tin can that isn't quite right. I'll pick it up, close my eyes, twirl around three times and let it fly. Then I'll go find it."

BRUCE DAVIDSON

ALL THE MOVES:
THE SPECIAL CONTROLS OF A VIEW CAMERA

Rising and Falling Front

The rising and falling front and back of a view camera allow correction of perspective convergence which can occur when photographing a tall building from the ground. Convergence is caused by the fact that the top of the building is further from the camera than the foundation of the building. Distant objects are normally seen as being smaller than close objects. It follows, then, that the top of a tall office building must appear smaller than the bottom. Photographically this is true when the camera is tilted up to include the entire building in the negative. If a camera is pointed horizontally at the building front, all lines will remain parallel but the top of the building will be out of the picture.

The camera movements of the view camera provide a solution to this problem. Align the camera's optical axis horizontally and the ground glass screen vertically. Raise the lens until the desired upper limit of the picture area has been reached. Since the back of the camera was not tilted with respect to the subject, there will be no convergence of the vertical lines of the building.

A simple variation of this technique is used when a tall building is photographed from the top of a nearby building. In this situation the lens board is dropped to a lower position to include the bottom of the building in the negative.

View camera: normal configuration.

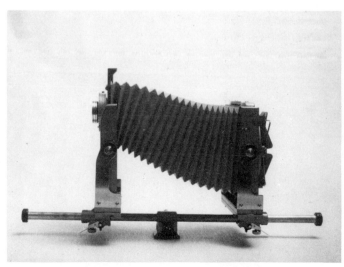

Front raised.

Rising and Falling Back

Raising or lowering the camera back is useful for changing the location of the image on the ground glass, and yet does not affect the shape of the image. Moving the back gives, in effect, a different cropping without moving the camera. These movements are particularly useful when an obstruction prevents the camera from being placed in a particular location.

Back and Front Shift

View camera shift is a sideways movement of either the front or the back of the camera. Rise and shift are essentially the same in that neither changes the angle between the planes of the film, lens, and subject. If you lay a view camera on its side and operate the rising or falling controls, you have essentially shifted the front or the back of the camera. All shifting of the back does is to place a different part of the film directly behind the lens. Shifting the lens does affect the spatial relationship of objects in the scene because even a slight movement of the lens causes the subject to be viewed from a slightly different point. This control is useful when you need to make a slight adjustment in camera viewpoint.

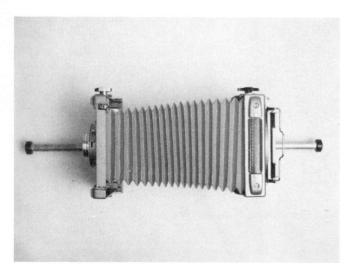

Normal configuration.

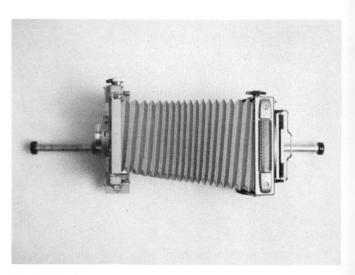

Front shifted.

Tilts and Swings

Raising or lowering or shifting the front or back of a view camera has little effect on the shape of the object being photographed. These movements do not change the relationship of the planes of film, lens, and object.

Tilts or swings of the front or back of the camera do change the angular relationship of film, lens, and object. This causes two things to happen:

1. When the angle between film and lens is changed by tilting or swinging the back of the camera, the shape of the object changes. A minor focusing adjustment is often needed.
2. When the angle between the lens and the object is changed by tilting or swinging the front of the camera, the focus on the object changes.

Consider this rule: the further the image travels inside the camera, the larger it gets. Images appear upside down in a view camera. Tilting the top of the camera back to the rear will make the bottom of the object bigger in the photograph. All changes in size and shape caused by back tilt or swing can be explained by this rule.

Front tilt or swing does not change distances inside the camera. It has no effect on image size or shape. It does affect focus by altering the lens's focal plane. Tilting or shifting the lens will bring the focal plane more nearly in parallel with some part of the subject, thereby improving the focus on that part of the subject.

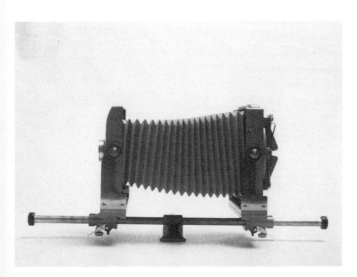

Normal configuration.

Front and back tilted.

Rising, Falling, Shifting, Tilting, and Swinging: Getting It All Together

The creative and practical applications of view camera movements are virtually endless. Effects of the movements are subtle and complicated, particularly when used in combination. When first working with a view camera, expect to be confused and uncertain as to which control or adjustment to crank in and when. Remember the simple rule: adjust the camera back first, then adjust the lens board. The camera back provides control of perspective or distortion and large adjustments of the depth-of-field coverage. The lens shifts, tilts, or swings should only be used for minor refinements of the image.

Combining Camera Movements

The functions of the individual camera movements can be summarized as follows:

- Rising-falling front and back, shifting front, and shifting back alter the framing of the picture.
- Lens swing and lens tilt alter the position of the zone of sharp focus.
- Swinging and tilting the back controls perspective and assists in increasing depth of field.

It follows, then, that:

- Sharpness is controlled by swinging or tilting the back or lens. Lens swings or tilts demand lenses of great covering power.
- Perspective is controlled by swinging or tilting the back. The control of swinging or tilting the back can be used with all lenses as long as they normally cover the format.

It often happens that a still life or complex scene requires the use of more than one view camera adjustment. By cranking adjustments into the camera one at a time, it's possible to arrive at the desired image.

Getting Maximum Depth of Field

A large-format view camera enables the photographer to break through normal barriers of technical impossibilities. One of the most common frustrations is trying to photograph a scene keeping both close and distant objects in sharp focus. For example, you may want to photograph a seashell on the beach (closeup), with a boat floating near shore and the horizon in sharp focus. If you focus on the seashell, the boat and horizon will be hopelessly blurred. A compromise focus, pinpointed on the boat near shore, might work if you stop your lens down to increase your depth of field. But this would require a long exposure, and since boats tend to rock, the result might not be satisfactory.

"The photographs that excite me are photographs that say something in a new manner, not for the sake of being different but ones that are different because the individual is different and the individual expresses himself."

HARRY CALLAHAN

The view camera can solve this problem. It provides an opportunity to achieve sharp focus from here to infinity with maximum apertures. This is possible through the Scheimpflug principle, discovered in the nineteenth century by an Austrian surveyor. Scheimpflug observed that if the plane of the film, the plane of the lens, and the plane of the subject all meet on a common line, a picture of the subject will be sharp from near edge to far. This principle and its application are demonstrated by the two illustrations on this page.

As usual, the principle in practice is simpler than the theory. First, focus the camera for infinity. Watching the image on the ground glass, swing the camera back in the opposite direction to the plane of the subject, or the lens in the same direction until the subject is sharp throughout. Usually some readjustment of focus will be necessary.

Photographed without any adjustment for increased depth of field.

Photographed with front and back of camera adjusted for maximum depth of field.

Controlling Distortion

Every time a three-dimensional object is projected onto a two-dimensional surface, a distortion of one kind or another results. Correcting distortion in one part of a photograph usually causes a different kind of distortion in another area. The two still lifes on this page are examples of this. In the first picture (made from above with all camera adjustments at zero), the book is distorted. Since its bottom is further away from the camera than its top, the bottom looks smaller.

Distortion can be corrected by using a combination of tilts, swings, and falls. A left swing of the camera back squares up the face of the book. Dropping the camera back lowers the image since these controls have enlarged the image somewhat. But the problem is not solved that easily. In the second picture, the book has been squared up nicely, looking as though it were being viewed head-on, but the lens, which was round in the first picture, has become somewhat oblong. All pictures contain distortions; the only recourse is to manipulate the camera to arrive at the most pleasing photograph.

Photographed with no distortion correction.

With adjustments to correct distortion of the book. Notice distortion that now is apparent in round object.

Modifying Apparent Point of View

It is not always possible when a frontal view is required to place the camera squarely in front of the subject. This may be for optical reasons, or due to space limitations. An optical consideration may be the elimination of the reflection of a camera in a mirror. Moving the camera to one side or the other may solve the problem of the reflection, but the mirror's shape will be distorted.

Appropriate use of camera movements can restore the straight-on viewpoint. All that is necessary is to swing the camera back so that it is once more parallel to the plane of the subject—in this case, the mirror surface. As a result of this movement, one side of the picture will become unsharp. This unsharpness can be corrected either by stopping down, or by swinging the lens so that it is parallel to the camera back. The mirror will now appear straight-on, perfectly sharp, with no reflection of the camera.

(Joel Shawn)

Photographed head-on with no adjustments.

Camera moved to one side with compensating adjustments of front and rear of the view camera to avoid distortion and unsharpness.

Rebuilding Buildings

Contemporary office buildings are so huge that it is difficult to photograph them without distortion. A standard, street-level photograph of a modern office building is shown in the first of the five pictures on these pages. There is a great deal of dull street and sidewalk, and the top of the building is cut off. As most photographers know, tipping the camera up to include the top and to eliminate the street (second photograph) is not the solution. The lines of the building are no longer parallel and it appears to be falling over. The third photograph, taken with the camera front raised, includes the top of the building and eliminates much of the street, but it gives a peaked and unnatural-looking angle to the top of the building. This effect can be reduced in either of two ways: the camera back can be swung to the left, which puts the film plane more nearly in line with the narrow side of the building, squaring it up somewhat; or the back can be swung to the right, which squares up the wide side of the building.

Each of the latter three photographs is corrected for distortion. The choice depends upon which view best satisfies the photographer's vision of the building.

Camera-back parallel to building with normal configuration.

Camera, with normal configuration, pointed up to include top of building.

"Camera could be useless if you don't put yourself into this piece of hardware. Photography is not occupational therapy."

ALEXIS BRODOVITCH

Back parallel to building with front raised.

With front raised, camera back swung to left.

Front raised and camera back swung to right.

SHEET FILM: LOADING AND PROCESSING

Nearly all photography with a view camera requires the use of *sheet film* and *sheet-film holders*. A holder is constructed so as to contain two sheets of film, one on each side of the holder. Each sheet of film is protected from the light by a *dark slide,* with an end tab which is black on one side and white- or silver-colored on the other, to indicate whether the film has been exposed. The dark slide is removed after the holder is in place in the view camera. After exposure of the film, the dark slide is replaced in the holder before the holder is removed from the camera.

Loading sheet film holder.

Sheet film must be placed in the holders with the emulsion side out or up. All sheet film is *code-notched*. These code notches are used to identify the type of film and to assist the photographer in determining the emulsion side of the film. If you hold a piece of sheet film with the long sides vertical and the notches in the upper right corner, the emulsion side will be facing you. The shape and number of the code notches are different for each type of film. For example, Plus-X sheet films are coded with one V-shaped notch, a space, then two closely spaced square notches, reading from the center. The notching codes are printed on each box of film.

Loading film hanger for tank processing.

Film holders must be loaded in total darkness. Remove the dark slides from the holders and reinsert them about a half-inch into the holder with the light side facing out. Position the holder so that the bottom flap is to the right. With the lights out, take a sheet of film, position it so that the emulsion side is up with the notches at the lower right, and slide the sheet under the narrow metal guides positioned on each side of the holder. Close the flap and push the dark slide all the way into the holder. Flip the holder over and repeat the same steps to load the other side.

After the film has been exposed in the camera, the slide should be reinserted with the dark tab out. This will indicate to you that the film on that side of the holder has been exposed.

Sheet films can be developed in trays or in special tanks. Three or four sheets of film can be processed conveniently in a tray. While in developer, stop bath, and fixer, keep lifting the bottom sheet and stacking it on top of the other sheets in the tray. Avoid an excess flow of water during washing.

The primary danger in tray processing is the possibility of scratching or scraping the emulsion with your fingernails or with other pieces of film in the tray. This problem can usually be avoided by handling the sheets with your fingertips, never your fingernails.

Larger quantities of sheet film can be handled more easily in tank-and-hanger equipment. The tank-and-hanger system requires that sheets be loaded into special hangers before processing. The darkroom should be organized to provide a convenient area

Hangers properly placed in processing tank.

Agitation requires that hangers be lifted from solutions and drained from alternate bottom corners.

Film may be dried in hangers or removed and hung from clips.

for the loaded and unloaded hangers, since they must be loaded in total darkness. Keep the hangers on a special bracket within easy reach. Provide space for the hangers to be stacked against the wall after they are loaded and before they are placed in the developing tank.

To load, spring back the hinged top channel of the hanger so that the side channels are exposed. Hold the hanger in your left hand and pick up the film with your right hand. Insert the film into the hanger so that the edges slide into the channels; it may be necessary to tap the back of the film lightly with your fingers to make sure that it falls into the bottom channel. Spring the hinged top back into place. The emulsion side of each film should be facing you.

Place the loaded hangers in the tank of developer, agitate briskly for the first 15 seconds, then for 5 seconds every 30 seconds until fully developed. Lift the hangers from the tank, allowing excess developer to drain back into the tank. Transfer the hangers to the stop bath (or water) tank and agitate for 30 seconds. Next transfer the hangers to the fixer tank and agitate for the first 15 seconds, then for 5 seconds every 30 seconds until the film is completely fixed. Turn on the lights and transfer the hangers to an empty tank for washing. Temperature and flow of wash water should be regulated according to the film manufacturer's recommendations.

After processing and washing, dry sheet film by hanging it by one corner with a film clip, or in the film hangers. Store negatives in glassine envelopes to protect them from scratches, fingerprints, and dust.

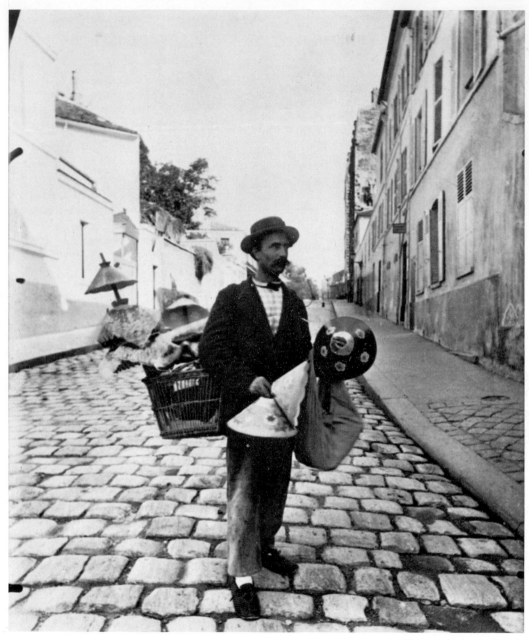

Eugene Auguste Atget
"Lampshade Peddler, Paris." c. 1910. (G.E.H.)

William Henry Jackson
"Mt. Hood from Lost Lake." 1878. (G.E.H.)

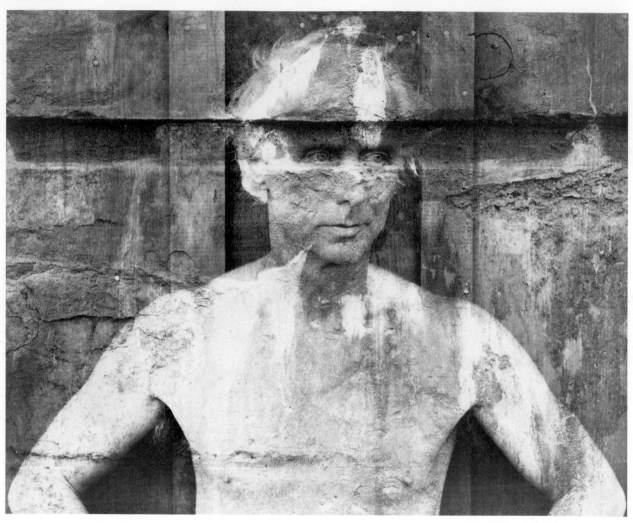

Frederick Sommer
"Max Ernst." 1946. (L.G.)

Bruce Davidson
"Family Group." 1968.
From: "*East 100th Street.*" (Magnum)

Aaron Siskind
"Martha's Vineyard 124." 1954. (L.G.)

Harry Callahan
"Untitled." (L.G.)

LABORATORY TECHNIQUES 13

specialized processes and approaches

13

Until now, our primary concern has been with making straight photographs—photographs made without the use of any special control techniques. The photographic laboratory is a fertile ground for the application of a variety of special techniques for controlling the density and contrast in negatives and for experimenting with the merits and applications of specialized developers. Creative darkroom procedures can permit greater flexibility in recording difficult subjects. Borderline negatives can be saved by intensification or reduction. There are advanced laboratory techniques which permit transforming a continuous-tone photograph into a high-contrast image, a semi-bas relief image, or a combination positive-negative image.

Advanced control techniques with a print include the use of custom developers and print toning. Double printing, photographic montages, vignetting—all are possibilities for enhancing your photographic statement.

Jerry Uelsmann has said, "Let us not be afraid to allow for post-visualization, to the willingness on the part of the photographer to revisualize the final image at any point in the entire photographic process."

There are those who feel that any deviation from the straight photograph is a corruption of the art. But what contemporary artist restricts himself to the traditional use of his medium or feels bound to use only traditional materials? The next chapter quickly reveals that contemporary photographers feel that their work has to be an extension of themselves. The exciting photographers of today are constantly and joyfully challenging the boundaries of the medium.

THE NEGATIVE: DENSITY AND CONTRAST CONTROL

All photographers at some time in their careers experiment with film-and-developer combinations in search of new and useful results. Critical advanced work requires exact control of negative density and contrast. A rudimentary understanding of photographic sensitometry is appropriate. It is essential to understand how the process functions. This understanding makes it possible to move into new applications of photography.

Emphasis on technique is justified insofar as it will simplify and clarify the statement of the photographer's concept. The physics of what actually occurs when light strikes the sensitive emulsion of the photographic film is not completely understood. For our purposes, however, it is enough to know that the silver halide is altered in such a way that it reacts to the developer, being chemically reduced from its original form to metallic silver.

In 1890, the principle of the action of light on a silver halide—the density-exposure relationship—was revealed by Hurter and Driffield. This relationship is expressed by what is known as the H&D

"An artist creates images which somehow communicate on many levels, most of them mysterious."

RALPH HATTERSLEY

Variations in film development affect contrast of negatives. Increasing development yields contrastier negatives.

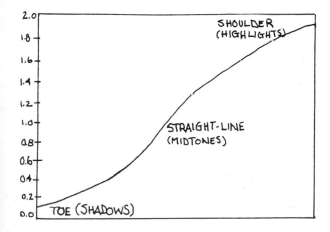

A typical film curve.

curve (also referred to as the *D*–log *E* curve). This *characteristic curve* is the foundation of the science of sensitometry. The characteristic curve as described by sensitometrists may be confusing to the practising photographer, but it is really only necessary that you be aware of the practical basis of sensitometry. You should look upon the characteristic curve as merely a symbol of the density-exposure relationship.

Look at the typical set of film curves from a technical data book. These curves serve to illustrate the differences in density buildup resulting from different development times. You will notice that an underdeveloped negative will have a low maximum density, whereas an overdeveloped negative will have a very high maximum density. These maximum densities relate directly to the highlights in a typical scene. From these curves we may conclude that development has a great effect on the highlights and brighter parts of the scene, and only a negligible effect on the shadow areas or low densities in the negative.

In a characteristic curve, the exposure variations are indicated in logarithmic values along the bottom axis of the graph. In general, an increase in exposure will cause an increase in density. From these curves you can see that image density resulting from any given amount of exposure and any given time of development can be found by reading straight up from the exposure value on the bottom axis to the appropriate development curve, then horizontally across to read the density.

The characteristic curve can be roughly divided into three sections:

- The *foot* or *toe* of the curve, an area in which the steepness (which indicates the rate at which density increases with greater exposure) is progressively greater as exposure is increased. Notice that changes in exposure cause only small changes in density.
- The *straight-line portion* of the curve, where the ratio between increased exposure and increased density is uniform. The continued doubling of exposure in this region increases density by identical amounts. The steepness of this straight-line section of the curve indicates the basic contrast of the negative: the steeper the line, the higher the contrast.
- The *shoulder* of the curve, where as maximum possible density is approached, the steepness falls off. This means that increasing exposure here results in a diminishing increase in density.

All characteristic curves have the same general features; their individual shapes and proportions differ. Curves will have longer or shorter toes, steeper straight-line portions, broad or sharp shoulders. For example, the curve of a soft portrait film has a long toe and a relatively short straight-line section and shoulder. Process film giving maximum contrast has a short toe and an exceptionally long and steep straight-line section. If you know the significance of these variations, you can recognize some of the

basic properties of any negative material by looking at its characteristic curve.

The proof of a good negative is in the printing. A negative which will print easily, produce a full range of tones, and include the necessary detail in highlight and shadow areas is a good negative. It is a good negative because it matches the exposure scale of the printing paper. It makes sense to expose and develop every negative in such a way that it will print easily. An average good negative will have a density range of about 1.2 to 1.3 for an average subject. Unfortunately, subject matter varies in brightness and brightness range. From this you should conclude that if you have a very contrasty subject with a great brightness range, it will be necessary to reduce development of the negative to preserve a negative density range of 1.2 to 1.3. And if you're photographing a subject with a very low contrast or brightness range, such as someone in the shade, it will be necessary to increase development of the negative to attain a normal negative density range.

It makes good sense to do some experimenting to find appropriate negative developing times for flat subjects, normal subjects, and contrasty subjects.

SOME THOUGHTS ON THE ZONE SYSTEM

The Zone System, developed by Ansel Adams, is extremely useful for measuring the brightness range of your subject and applying this information to the development of your negative to produce a print with definite and previsualized qualities.

The Zone System is named for Adams' classification of the photographic gray scale. The system can be used to predict the effect of exposure and development on a film, and to predict certain tones on the print before the photograph is exposed. The Zone System can also be used to previsualize possible changes if you wish to depart from a naturalistic rendition.

The ten zones of the system fall into three groups:

- *The low zones*—0, I, II, and III—are the maximum black of the paper, almost black, very dark, and dark.
- *The middle zones*—IV, V, and VI—are dark gray, middle gray, and light gray. Zone V is the color of the Kodak 18 Percent Gray Card. Zone VI represents average Caucasian skin tone.
- The *high zones*—VII, VIII, and IX—are a lighter gray, pale gray, and white. Zone VII contains the last significant detail. Zone VIII contains just vestiges of detail. Zone IX is the white paper.

Important textures and tones occur in the middle zones; brilliance and strength are the products of the low and high zones.

For more information on the Zone System, read *The Zone System*

"As the language or vocabulary of photography has been extended the emphasis of meaning has shifted, shifted from what the world looks like to what we feel about the world and what we want the world to mean."

AARON SISSKIND

Manual by Minor White (Morgan and Morgan) or Adams' *The Negative* (Morgan and Morgan).

SPECIALIZED DEVELOPERS

Specialized film developers are sometimes used to reduce the effects of shortcomings in the exposure, to boost effective film speed, or to achieve finer grain. These specialized developers can help, but usually an improvement in one characteristic of the finished negative is arrived at only at the expense of another.

There are occasions when it's necessary to photograph under conditions that make underexposure and/or low contrast unavoidable. In these instances the negative can be improved somewhat by extending the development time—i.e., by employing *forced development*. The contrast particularly will be increased by forced development. Forced development gives only a limited increase in film speed. For years photographers have referred to "pushing"—for example, "I pushed Tri-X to ASA 4800." Experiments have shown that film rated at or near the recommended speed and given normal development will give the best prints.

When exposure is about eight times less than normal, forced development will give some improvement. But even here the improvement is seldom enough to give print quality matching that of a film which has been normally exposed and normally developed.

Acufine is a good special developer for film exposed under low light levels. Specific speed ratings have been established for films to be processed in this developer. The result is generally a higher effective film speed with not a great deal of loss in quality. Processing in Acufine is not the same as forced development in a standard developer.

Two-Solution Developers

Two-solution developers are worthy of serious consideration. In the first solution, the film is saturated with a developing agent. Some development may take place in this solution; it depends on the composition of the developer. Usually there is no alkali in the first solution and little or no development will occur. The film is then transferred to a second solution of dilute alkali and development occurs until all the developer soaked up by the emulsion has been exhausted. *Diafine* is a commercially available two-solution developer.

One of the most popular and effective two-solution-developer techniques consists of first processing the film in Kodak D-23 for 5 minutes with 5 seconds' agitation every 30 seconds at 68°F, then immersing it in a 1% Kodalk solution. This divided development yields a *compensating* effect: a proportionately greater development of the low-density (shadow) areas of the image in

relation to the development of the high-density areas. D-23 yields a soft negative with full shadow density. Used with a 1% Kodalk solution, the developer absorbed by the emulsion is activated to exhaustion, building maximum density in the shadows with little increase in highlight density. A 3-minute immersion in the 1% Kodalk is optimum.

Compensating Developers

Compensating developers give improved control in both the very high and very low densities. A compensating developer particularly effective when working directly into the light (where light sources appear in the subject), is the pyrocatechin sodium hydroxide formula which follows. The emulsion speed is reduced about one-half; this must be compensated for when exposing the film.

You should make careful experiments with this developer before using it. Its effects varies with different negative emulsions. Since this developer stains the negative, the type of printing light may considerably alter the contrast in the print. Experiment! Experiment! Experiment!

Monobath Developers

Another specialized developer is referred to as the *monobath*. This is a mixture which combines developer and fixer in a single solution. Some developing agents function even if large amounts of hypo are present in the same solution. This means that the negative can be developed and fixed simultaneously in the same solution. Development and fixation are completed in about six minutes, washing in five, and with rapid film drying you can have a negative ready to print in ten to fifteen minutes. But almost no contrast control is possible with a given monobath solution. Another disadvantage is that the negatives tend to be contrasty and grainy. Some monobaths cause a loss of effective film speed and/or substandard tone gradation.

Specialized developers are useful and valuable technical tools, but they often have limited application and should never be used for serious photography without prior experimentation.

PYROCATECHIN COMPENSATING DEVELOPER

Solution A
 Water (distilled or boiled) 100.0 cc
 Sodium sulfite, desiccated 1.25 grams
 Pyrocatechin 8.0 grams
Solution B
 Sodium hydroxide 1.0 gram
 Cold water to make 100.0 cc
For use with extremely contrasty subjects
 (tank development):
 20 parts of A
 50 parts of B
 500 parts of water
 Try 12 to 15 minutes in tank at 68°F with
 normal agitation.
Notes: Use only once, then discard.
 Emulsion speed reduced about 50% in
 lower part of scale.
 Stain increases printing contrast; do
 not be misled with apparent low
 opacity of the negative.

From a negative with standard processing.

(Bruce Senior)

From a negative developed with water-bath process.

Water Bath Processing

The problem of making a good negative of a subject with an extreme range of brightnesses may be solved best by resorting to a *water bath processing* technique. This is a method of development which gives excellent separation of shadow and middle-tone regions of the negative, while preventing, the highlight areas from being completely washed out.

There are several variations of the water bath system. They all depend on the fact that the emulsion is first saturated with developer. When placed in still water the absorbed developer continues to develop the exposed silver halides until exhausted. Heavily exposed areas—the highlights—exhaust the absorbed developer more rapidly than do the lightly exposed areas. The shadow and middle tones are therefore more fully developed in proportion to the highlight values.

The technique of water bath processing is simple and effective. The negative must remain in the developer just long enough for complete saturation: use vigorous agitation. Then place the negative directly into a tray of water and allow it to lie **without agitation** for at least two minutes. Return the film to the developer, agitate, and saturate with fresh developer. Place it in the water. Again, development continues in the water until the absorbed developer is exhausted. The number of times this procedure should be repeated depends on the strength of the developing solution and the degree of development required. Upon completion of the developer/water sequence, the negative should be fixed, washed, and dried normally.

WATER BATH DEVELOPER

Water	750.0 cc
Sodium sulfite, desiccated	20.0 grams
Amidol	5.0 grams
Water to make	1.0 liter

To use:
Plan 1. Immerse negative in developer (constant agitation) for 40 seconds; then to tray of water (no agitation) for 2 minutes; then in developer for 50 seconds; then to tray of water (no agitation) 2 minutes; then in developer for 90 seconds; then to tray of water (no agitation) 2 minutes.
Plan 2. A sequence of short immersions in the developer (with constant agitation), alternating with 2-minute immersions in water (with no agitation) as follows:

30 sec.—W—15 sec.—W—15 sec.—W—15 sec.—W—15 sec.—W

With prior desensitization (followed with rinse), the negative can be easily examined at the end of the sequences, and further treatment can be given if required. To be fully effective, the negative must lie flat in the water with no movement whatever. It is not efficient to have the film in a development hanger for this process; the edges of the negative may be unequally developed. The negative *must* be constantly agitated when in the developer.

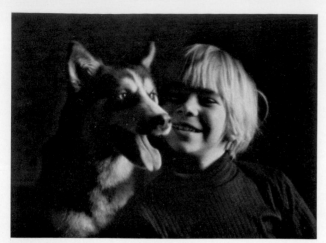

Thin, underdeveloped, negative.

(Lynne Bentley)

Same negative after intensification.

SALVAGING INFERIOR NEGATIVES

From time to time, hopefully infrequently, it happens that you produce a negative that is far from perfect. It may be extremely dense because of overexposure or inadvertent overdevelopment, or it may be extremely thin, lacking in density and low in contrast from insufficient exposure or from being processed in weak or exhausted developer.

By intensification or reduction, it is often possible to save such negatives. The corrected negative will probably be inferior to a well-exposed and properly developed negative but, in some cases, a photographer has no choice.

Negative Intensification

Negative *intensification* gives an increase in contrast and density. There are three types of intensifiers:

- *Subproportional intensifiers.* These increase the density chiefly in the lowest parts of the curve and are useful for decreasing contrast to balance underdeveloped negatives of contrasty subjects. *Example:* Kodak In-1.
- *Proportional intensifiers.* These are used most often to increase densities throughout the negative, helping to correct underexposure and underdevelopment. *Example:* Kodak In-5.

INTENSIFIER: Kodak In-5 (Proportional Intensifier)

Stock solution no. 1 (Store in a brown bottle)		
Silver nitrate, crystals	60.0	grams
Distilled water to make	1.0	liter
Stock solution no. 2		
Sodium sulfite, desiccated	60.0	grams
Water to make	1.0	liter
Stock solution no. 3		
Sodium thiosulfate (hypo)	105.0	grams
Water to make	1.0	liter
Stock solution no. 4		
Sodium sulfite, desiccated	15.0	grams
Elon	24.0	grams
Water to make	3.0	liters

Prepare the intensifier solution for use as follows: Slowly add 1 part of solution no. 2 to 1 part of solution no. 1, shaking or stirring to obtain thorough mixing. The white precipitate which appears is then dissolved by the addition of 1 part of solution no. 3. Allow the resulting solution to stand a few minutes until clear. Then add, with stirring, 3 parts of solution no. 4. The intensifier is then ready for use and the film should be treated immediately. The degree of intensification obtained depends upon the time of treatment, which should not exceed 25 minutes. After intensification, immerse the film for 2 minutes with agitation in a plain 30% hypo solution. Then wash thoroughly. The mixed intensifier solution is stable for approximately 30 minutes at 68°F.

- *Superproportional intensifiers.* These increase the density of highlight areas in the negative more than the density of the shadow areas and have the effect of increasing negative contrast. *Example:* copper or tin intensifier.

Overexposed negative.

(Joan Morris)

Same negative after treatment in R-4 reducer.

Negative Reduction

A negative *reducer* is used to lower the densities of the developed image by treatment in a bath that dissolves part of the silver from the negative. There are three general types of negative reducers:

- *Contrast or cutting reducers.* These reduce contrast in the shadow areas of the negative more than in the denser parts, having the effect of increasing contrast and removing fog. They are especially useful for overexposed negatives. *Examples:* Kodak R-4 and R-4A.
- *Proportional reducers.* These reduce all of the image in proportion to its original densities so that contrast remains unchanged. They are particularly useful in correcting overexposed and overdeveloped negatives. *Examples:* Kodak R-4B and R-5.

KODAK R-5 PROPORTIONAL REDUCER

For Correcting Overdeveloped Negatives

Stock solution A	
Water	1.0 liter
Potassium permanganate	0.3 gram
Sulphuric acid* (10% solution)	16.0 cc
Stock solution B	
Water	3.0 liters
Ammonium persulphate	90.0 grams

For use, take 1 part of solution A to 3 parts of solution B. When sufficient reduction is secured, the negative should be cleared in a 1% solution of sodium bisulphite. Wash the negative thoroughly before drying.

*To make a 10% solution of sulphuric acid, take 1 part of concentrated acid and add it to 9 parts of water, slowly with stirring. *Never add the water to the acid*, because the solution may boil and spatter the acid on the hands or face, causing serious burns.

- *Superproportional reducers.* These cause greater reduction in the highlight areas of the negative than in the shadow areas and have the effect of decreasing contrast. They are particularly useful for negatives that are overdeveloped or too contrasty. *Examples:* Kodak R-1 and R-8.

Any negative that you plan to reduce must be thoroughly fixed and washed. It's a good idea to treat the negative in a formalin hardener before carrying out the reduction process. In any event, presoak the negative in water before putting it in the reducer. Use a white enamel tray to hold the reducer to better see its effects. Put the negative in it and agitate vigorously. Examine it frequently with a diffuse viewing light. Reduce only one negative at a time. When reduction is completed, rinse the negative carefully to remove most of the solution and then wash it thoroughly.

Some of the chemicals used in reduction and intensification are poisonous and should be handled accordingly.

Print with normal processing.

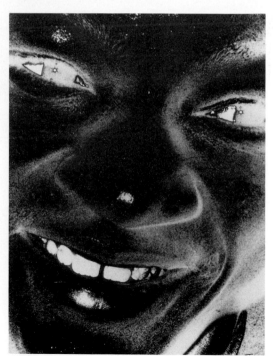
Print intentionally exposed to light during processing with resulting Sabattier Effect.

NEGATIVE DERIVATIONS

There comes a point in the evolution of a photographer when he rebels against the inevitable absoluteness of the straight photographic image, against the prejudged claim of photography to show things as they are. He feels the need to interfere with the automatic nature of the photographic process, the urge to get away from photographic realism. This need can be satisfied through a variety of laboratory techniques which will transform the straight photographic image into harsh black/white lines, tone, shapes, and masses devoid of minute and varied detail.

The esthetic potential of the experimental, transformed, or off-beat print is only now being seriously explored. The laboratory techniques involved can powerfully convey ideas and a feeling of dreamlike beauty. The photographic images created in the laboratories of nontraditional photographic artists have developed into a significant and meaningful art form.

If light-sensitive printing paper is looked upon in the same way as a new white canvas, its potential as a visual medium becomes obvious. You have only to think of light as your palette and brush. Images can be formed with a penlight or objects; multiple negatives, double printing, solarization, and any number of other possibilities can be used to generate visually exciting images.

The Sabattier Effect (Solarization)

The simplest and most common photographic derivation is that commonly referred to as *solarization*. This technique gives a print both negative and positive qualities while adding halolike bands of light around or between highlight and shadow areas. These halos are known as *Mackie lines*, after the man who first described them.

The unreal quality of the solarized print comes from a combination of chemical reactions. A photographic print is produced normally except that a bright light is turned on for a moment about three-fourths of the way through development. After flashing the print during development and allowing additional development time, the print is treated normally in a stop bath and fixer and washed as a regular print.

The light has little or no effect on the shadow areas of the print because most of the silver halides in those areas have already been exposed and converted to metallic silver by the developer. The highlight or bright areas are most affected by this flash of light. They contain unexposed, undeveloped silver halides that respond to the flash of light and to further development. These bright areas turn gray. Between areas of light and dark, the silver halides interact and inhibit development. These borders remain almost white, forming the Mackie lines. These lines are most visible where there are strong contrasts between shadows and highlight.

Negative image.

Positive image.

Positive and negative image combined slightly out of register producing a Bas Relief image.

This unique printing phenomenon is properly called the *Sabattier effect* after Armand Sabattier, a French photographer who discovered it in 1862.

Learning to control the possibilities of working with the Sabattier effect requires experimentation. Careful notes will be useful the next time you attempt to produce Sabattier images.

Bas Relief

A bas relief photograph is essentially an optical illusion. This illusion is generated by an artificial enhancement of shadows in a photograph. In a bas relief photograph, existing shadows or shadow lines are exaggerated and artificial ones are introduced through printing a negative and a positive together.

Bas relief photographs are very simple to produce. You need only a negative and a film positive image. This is most easily accomplished if the original negative is a 4x5. With smaller negatives it's simplest to enlarge the original negative onto a sheet of high-contrast film such as Kodalith. This copy yields a positive transparency. Put this enlarged film positive in contact with another piece of Kodalith, and expose and process it to yield a negative of the same size.

These positive and negative images are combined on a light box in such a way that their images do not quite match up. This slight off-registration causes the exaggerated and unusual shadows in a print from these two pieces of film.

The Tone-Line Process

The *tone-line process* produces a positive line image of the original photograph. To arrive at a tone-line image, you have only to take the positive and negative films used in the bas relief process and return to the light box. This time, combine the two images in perfect register. Tape them together. Place this film sandwich in a printing frame with a sheet of enlarging paper or film. Place the printing frame on a rotating turntable and expose to light coming from one side so that the light rays penetrate only through the small space between the two emulsion layers along the outlines. The thickness of the lines can be controlled by controlling the amount of space between the two emulsion layers of the positive and negative images. The lines will be very thin if the positive and negative are placed emulsion to emulsion, and thicker if placed base to base. An example of this process may be seen in the portfolio at the end of the chapter.

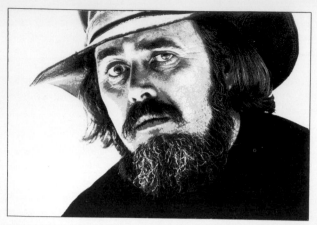

Robert Stolk. *"Eight-Tone Separation."* 1972. Kodalith negatives, each representing a different tone, were printed consecutively with careful registration controls.

Tone Separation

The tone-separation process involves isolating various negative gradations into individual images. One approach uses the original negative to make a film positive which is printed twice, to give a contrasty shadow negative recording only the deepest shadows, and again to give a soft highlight negative showing detail in the brightest highlights. These two negatives are then printed together to give a print with posterlike effects.

The example of the tone-separation process shown here was produced by isolating several tones from the original photograph on as many pieces of film, which were then printed onto one piece of enlarging paper in careful register.

Experimenting with the Sabattier effect, bas relief, tone lines, and tone separations will generate additional ideas or approaches. The possibilities are limited only by your imagination and willingness to try out variations of techniques and by your efforts to develop new techniques.

CUSTOM PAPER DEVELOPERS

Photographic paper developer is a solution of chemicals working together to make visible the latent exposed image. Variations in the chemical proportions produce different visual effects. Nearly all your prints will be processed with a standard developer such as Dektol or D-72. These developers are stable, dependable, and certainly adequate for most work. But on occasion it is desirable to modify a standard developer or to use a special-purpose developer.

Developers can be modified to affect contrast or image color. Contrast can be reduced by simply diluting the developer.

The basic components of developers are:

- *A reducing agent* that causes the latent image to convert to metallic silver. Standard developers use two reducers, metol and hydroquinone. Metol produces a low-contrast image. Hydroquinone is an active developer producing high-contrast images; when it is used in various proportions with metol, it is possible to vary the contrast of prints made on the same grade of paper.
- *A preservative.* Sodium sulfite is the most commonly used preservative. Its function is to remove oxygen from the developing solution. Without this preservative, the metol and hydroquinone would rapidly be exhausted.
- *An accelerator.* Sodium carbonate is used to increase the activity of metol and hydroquinone.
- *A restrainer*, which prevents indiscriminate development and changes the color of the silver image. Potassium bromide is the most common restrainer in developers. Restrainer has an effect on the contrast of the print image. An increase in the amount of restrainer will increase the contrast.
- *A solvent*, usually water. The chemicals are dissolved so that they may interact and be carried into the emulsion on the paper.

A developer containing metol can be modified to increase contrast by adding a small additional amount of hydroquinone. A soft-working developer has equal amounts of metol and hydroquinone. A high-contrast developer will have seven times as much hydroquinone.

Beers Developer

A particularly useful developer, not available premixed, is the Beers formula. This developer consists of two stock solutions, A and B. When mixed in varying amounts with water, a large range of print contrasts are possible with the same grade of paper. For example, if you're working with a grade 2 contrast paper, using different dilutions of the Beers formula makes possible more than a full grade of contrast control. The Beers formula and its dilution table are shown below.

BEERS FORMULA

Chemical	A	B
Metol	16.0 grams	—
Sodium sulfite	40.0 grams	40.0 grams
Hydroquinone	—	16.0 grams
Sodium carbonate	47.0 grams	63.0 grams
Potassium bromide	22 milliliters	44 milliliters
Water	2 liters	2 liters

BEERS FORMULA DILUTION TABLE

(in ounces to make 32 oz. of working solution)

	Low	2	3	Medium	5	6	High
A	16	14	12	10	8	6	4
B	0	2	4	6	8	10	28
Water	16	16	16	16	16	16	0

Dilution Ratios For Contrast Control

A scale is needed to weigh the chemicals accurately. The chemicals must be mixed in the order listed. During mixing, water should be about 100°F. The hydroquinone stock is stable for only two weeks.

Pre-Packaged Developers for Contrast Control

Professional photographic printers often work with three print developers in the sink. They first place an exposed print in the standard developer. If it appears that the finished print will be excessively contrasty, it is transferred immediately to a low-contrast developer such as Selectol or Selectol Soft. If, on the other hand, the print appears flat and lacking in contrast in the standard developer, it is transferred to an undiluted stock solution such as D-72 or Dektol. This technique can speed print production and often results in fine prints without the additional cost of using another sheet of enlarging paper.

STABILIZATION PROCESSING

Stabilization processing is a recently available method of processing, using special black-and-white paper, that yields prints much more quickly than is possible by the ordinary develop-stop-fix-wash method. Stabilized prints are not permanent because the chemical reactions in the emulsion have only been halted temporarily. These prints do last long enough, however, to serve a practical function such as for editing or meeting a tight newsphoto deadline. They can be made permanent by fixing and washing.

The differences between stabilization processing and conventional print processing are the speed of activation or development and the method of treating the unexposed silver halide left in the emulsion after development. In the stabilization process, developing agents are incorporated in the paper emulsion. A stabilizer is then applied to neutralize the activator.

Stabilization processing is a machine operation. The prints are processed in fifteen seconds. Since the paper is not soaked with solution, the prints are only slightly damp as they come out of the machine. They dry completely in a few minutes at room temperature and can be used immediately.

Stabilization paper can also be processed in ordinary print-processing chemicals. Ordinary printing papers, however, cannot be processed in stabilization chemicals. Stabilization materials and processing machines are made by several photographic manufacturers. The printing papers are available in several contrast surfaces.

A stabilization processor used for rapid print processing.

CREATIVE PRINT TONING

The image color of a black-and-white print may be changed by *print toning*. Toning is strictly a chemical process; it consists of combining the metallic silver of the image with some other chemical to form a new compound possessing a different color.

Print toning may be used to enhance the effect of a picture. The tone should always be suitable to the subject matter. It's a waste of time to tone prints indiscriminately; they should be toned only when it will improve or enhance the photograph.

There are a variety of print toners available. You can find a wide choice of brown tones; blue-black to bluish colors are possible with some papers; and a red tone can be generated by blue toning a print which has been toned in a sepia or Kodak brown tone. Every toner-and-paper combination gives a characteristic color, provided that the processing was normal. A radical change in the color of toned prints will occur if they are dried by heat.

Successful print toning demands meticulous processing techniques. Any sloppiness will be obvious immediately. Incomplete fixing and washing will produce a degradation of the highlights because of the action between the hypo salts remaining on the

highlights and the toning chemicals. All prints to be toned should be fixed for at least ten minutes each in two separate fixing baths; the second bath should be strictly fresh. Washing is important and should be a minimum of sixty minutes' duration.

Prints may be toned while still wet (after being thoroughly washed), or they may be resoaked and toned at some subsequent time.

Kodak Poly-Toner

Kodak Poly-Toner is a good formula with which to start your toning experiments. It yields brown tones on Kodak warm-tone papers. By diluting the stock solution with different quantities of water, you can get a variety of brown tones ranging from the reddish-brown of Kodak Selenium Toner to the yellowish tone of Kodak Brown Toner. As the dilution is increased, the tone becomes progressively warmer. The standard dilutions of Kodak Poly-Toner are 1:4, 1:24, and 1:50.

Toning in the 1:4 dilution increases shadow density slightly. This is best compensated by a slight reduction in developing time, perhaps twenty to thirty seconds. If you inadvertently make some prints a little too light, this dilution can be used with advantage.

The 1:24 dilution requires no modification in processing; a normal print tones without change in density or contrast. This dilution is the primary recommendation for toning warm-tone papers.

The 1:50 dilution has a slight reducing effect on the shadows of a print. Use this dilution when a slight loss of density is not important.

Sepia Toning With the Bleach-and-Redevelopment Process

Sepia toning can be accomplished by a process in which you first bleach the silver image, which will fade to a pale yellow color in two or three minutes. The second step in the process is the redevelopment of the bleached image with sodium sulfide. The new permanent image consists of silver sulfide, which is very handsome and stable when properly processed. The tone of the print depends on the original exposure, the amount of potassium bromide in the original developer, and the development time.

You can also find at most camera stores a variety of *dye toners,* which give an overall color to prints. They come in a variety of colors and can be mixed to yield additional colors. Edwal toners are probably the most popular brand available.

Dye toners do not chemically change the photographic image; rather, they rely upon a staining effect for color. Some interesting work has been done with toning local areas of a print with dye

"Obscure photographers everywhere still sit retouching portraits in their studios; but they also announce their readiness to go out and make a record of outside events."

MICHEL F. BRAIVE

toner. It's possible to immerse the print in a red toner, for example, then to apply a toner of another color to specific areas of the print. Or two-thirds of the print can be toned in one color, and another two-thirds' portion in a second color; overlapping areas will take on a third color.

Ansel Adams is one of many photographers who use a selenium toner to give added depth and richness to their prints. Selenium toners contain sodium selenite as the principal toning agent. The silver image is oxidized by the selenite to a reddish-brown silver selenite. Both the contrast and density are increased slightly by this toning process. A Kodalk prebath should be used to neutralize any acid from the fixing bath. Otherwise, traces of acid remaining in the print will cause stains.

Print toning is a photographic tool to be used tastefully. The prime criterion should be, "Does it help the photograph to make a more powerful statement?"

DOUBLE PRINTING

There are three general methods by which to make double-printed photographic images:

- Printing two negatives simultaneously
- Photographing a combination pasteup
- Printing two negatives separately

It's extremely rare when two negatives just happen to be suitable for printing together. And cutting out a section of one print and pasting it over another never results in topnotch quality. Consequently, the third method makes the most sense, because it is sufficiently versatile for nearly all situations and can produce excellent results.

Double Printing Procedure

The secret of success is careful masking of sections of the print with the aid of cutout paper masks. Try this approach.

1. Carefully place a piece of clean plate glass on supports about halfway between the enlarger lens and the easel. Boxes or bricks or concrete blocks or anything else which will give the right height and is reasonably stable can be used.
2. Insert the first negative in the enlarger. Focus it on the easel.
3. Lay a large piece of white opaque paper on the plate glass so that it intercepts all of the light from the projected image. Fasten the paper in place lightly with tape.
4. With a pencil, trace the edge of the area to be masked onto the paper. Remove the paper.

"A certain amount of contempt for the material employed to express an idea is indispensable to the purist realization of the idea."

MAN RAY

Image #1.

Image #2.

Double-printed photograph using portions from two negatives.

5. With a very sharp knife, cut just inside the traced line so that the projected edge of the area that you want will extend slightly beyond the edge of the mask. This will prevent a white line from forming at the junction of the two images, which would happen if you were to cut directly on the traced outline. Diffusion caused by the light passing over the mask during exposure will keep this line from showing in the print. The mask is now in two pieces. The part with the opening will be used to shield the paper while the first negative is being printed. The second part will be used to mask out the area from the first negative while the second negative is being printed.

6. Trim the opening in the mask along the edge so that a little bit of the image from the second negative will spill over during exposure. Trim away just a small amount—perhaps 1/16 to 1/8 inch.

7. Project the image of the first negative onto the easel. Place on the glass the mask corresponding to the section you want in the print and tape it down. This mask should be positioned exactly. Adjust the lens diaphragm for printing.

8. Make test strips first, then the exposure on a full-size piece of enlarging paper.

9. Make a small mark on the printing paper to indicate the top of the paper and put it in a lighttight container.

10. Remove the first mask. Position the second mask on the glass. Be sure the mask is adjusted accurately and tape it down.

11. Remove the first negative and put the second negative in its place. Adjust the enlarger if necessary. Be careful not to move either the mask or the easel.

12. Make any necessary exposure tests with strips of paper. When you have determined the appropriate exposure, return the full-size sheet of enlarging paper to the easel, positioning it precisely. Expose the second negative.

13. Remove the paper and process it in the usual manner.

You should now have a perfectly blended combination of the two images. If the two sections of the print do not match perfectly, you should be able to determine the cause easily and make a new print with suitable adjustments.

Be sure to take good care of any prints made with this technique. Each print will be unique, and for all intents and purposes it will be impossible to duplicate. It will be very difficult to position the negatives exactly as they were in the original printing. If duplicates are necessary, the simplest answer is to photograph the original print with an appropriate copy film and use that copy negative for the additional prints you need.

With practice, experimentation, and experience you should develop your double-printing skills to the point where you can use two, three, four, or more negatives to make unique multiimage photographs. Prints made with two or more negatives are also referred to as *photo montages*.

Alvin Langdon Coburn
"Vortograph of Ezra Pound." 1917.
Prism used in forming image. (G.E.H.)

Edmund Teske
"*Untitled*." 1972. Multiple exposure.

Lawrence Weissmann
"Toronto." 1972.
Laser beam modification of original photographic image.

Tom Muir Wilson
"Headstone and Figure." 1963.
Sandwiched negatives and staining.

Laszlo Moholy-Nagy
"Mass Psychology." 1927.
Photomontage. (G.E.H.)

John Massey
"Umbrellas." 1972.
Photo-line with Agfa Contour film.

PHOTOGRAPHY TODAY 14

a presentation of contemporary and avant-garde

A SURVEY OF CONTEMPORARY PHOTOGRAPHY

A careful look at contemporary photography indicates that pre-conceptions about the photographic medium seem less significant now than they have in the past. More than ever before, photography is being used as a communication tool or communication resource.

We are witness to a continuing and healthy expansion of the photographer's visual vocabulary. There is a reluctance—no, a refusal—to recognize or accept limitations on photography as a visual communication medium. Old photographic barriers, rules, and truisms have been rudely rejected in the quest to express visually the experience of an individual or the evolution of a culture.

Today's photographic communicators have no qualms about applying acrylics to a photographic print. They joyfully embroider their prints on an old Singer. They effectively lay an image on a piece of plastic and vacuum-form it into the shape of a cow. They apply bleach for superreality. They blur an image for a clearer statement. They photograph their friends and discover them again. They make photography an essential and vital part of the human experience.

A fellow correspondent at Suez reported that "where other photographers slammed their Jeeps up to a scene and snapped the pictures from their seats, Chim was always drifting into the middle of things, endlessly trying to get the perfect frame and the perfect background for the otherwise sensational picture."

JUDITH FRIEDBERG

Photography has achieved a unique distinction as a means of expressing ideas and emotions. Duane Michaels produces power-fully subtle photographic fantasies and dreamlike images. Bill Brandt says, "I try to convey the atmosphere of my subject by intensifying the elements that compose it." Brandt's photographs of nudes are a permanent chapter in the evolution of con-temporary photography.

Photography is gaining an ever-increasing reputation as a means of self-discovery, awareness, and understanding. Photography can reveal subconscious fears and hangups. Ralph Hattersley is famous for his initially shocking images reflecting universal hos-tilities and anxieties.

More and more, young photographers are discovering that this medium is an excellent resource for exploring the contrasts of reality and fancy. Contemporary photographers borrow freely from the work of old and present masters of the medium. They also unabashedly forage in the fields of filmmaking, television commercials, painting, sculpting, and printmaking. The fruit of many sources, it's no surprise that photography varies greatly in style and content.

The present and future state of the art revolves around and de-pends upon dedicated groups of respected visual communicators who have chosen to speak—and seek—with the light-sensitive language. The photography of today reflects a vital concern for the visual communicator's world and for the people with whom he must share it. The representative collection of contemporary

photography presented on these pages is evidence of the vitality in contemporary photographic images.

Photographic approaches and styles invariably overlap and defy the oversimplification which categories suggest. The trends, styles, or schools that seem to dominate contemporary photography are based on decades of tradition and exploration:

- *The straight approach*, explored by Strand, Weston, Adams, and others, exploits the ability of the camera to faithfully record with precise detail and rich tones and is used to document and interpret man and nature. This approach is classical and the resulting fine print is an end in itself.
- *The experimental approach* is a throwback to the dynamic experimentation of the 1920s, especially the work of Ray and Moholy-Nagy. The peculiar characteristics of light-sensitive materials—solarization, double printing, high-contrast effects, positive-negative images—are exploited.
- *Photojournalism* is an approach based on a deep need to communicate, to tell about the world's peoples and about the great human events of the day.
- *The social documentary approach* was first explored by Lewis Hine, the FSA photographers, W. Eugene Smith, and Robert Frank. This approach is characterized by the humanity of the moment and the social comment of the communicator.

Contemporary photography is in ferment, as it should be. It is characterized by debate, constant reexamination, continuing reevaluation, and an unceasing evolution. The work of today stimulates the imagery of tomorrow and becomes the foundation on which tomorrow's imagery will rise.

"War is like an aging actress, more and more dangerous, and less and less photogenic."

ROBERT CAPA

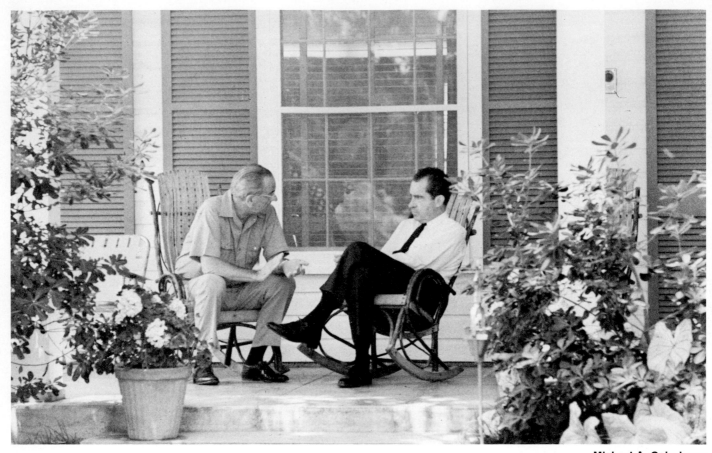

Michael A. Geissinger
"Lyndon Baines Johnson and Richard Milhous Nixon."
8-10-68. Official White House photograph.

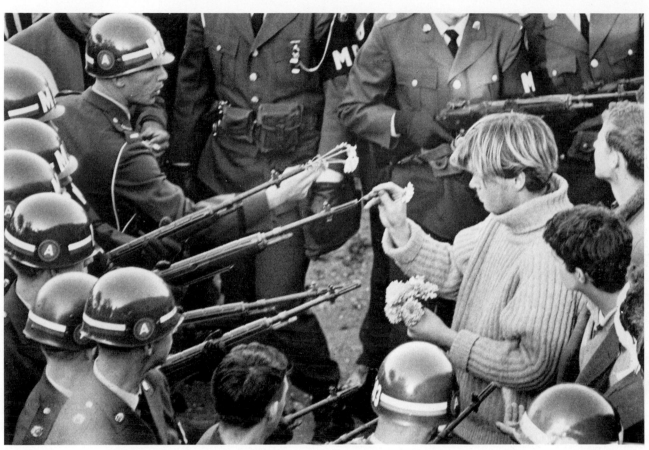

Bernie Boston
"Pentagon Protest." (Courtesy Washington Star-News)

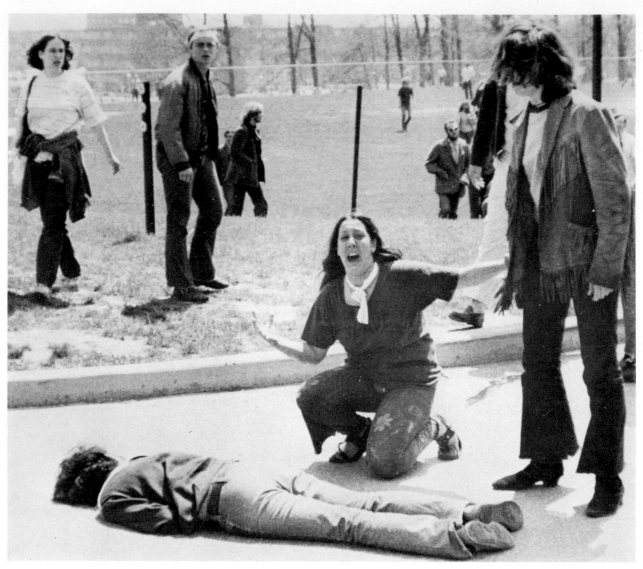

John Filo
"*Kent State Protest.*" 1970.
© Valley Daily News.

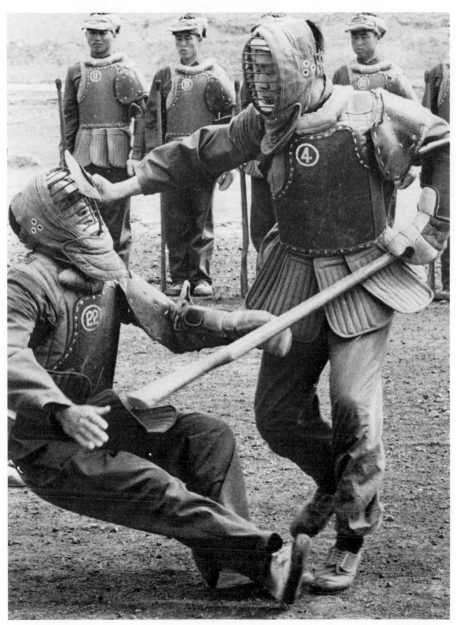

Horst Faas
"*Chinese Army Training.*" China 1972.
(Wide World Photo)

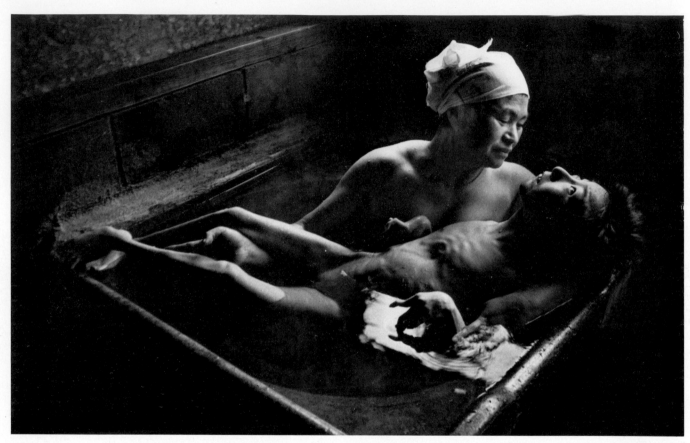

W. Eugene Smith
"Tomoko-Chan and Mother." 1972.
From photo-essay on mercury poisoning in Japanese village.

Cornell Capa
"Boris Pasternak." (Magnum.)

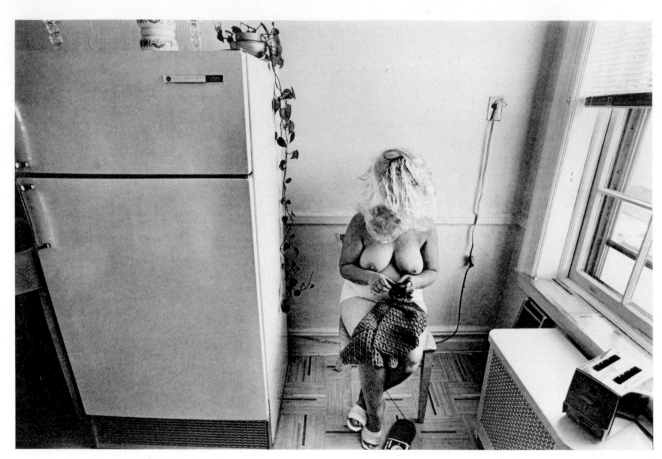

Leslie Krims
"Untitled." 1969.

Thomas F. Barrow
"Untitled." 1972. Verifax Matrix.

Charles A. Arnold Jr.
"*Untitled*." Xerographic image.

Keith Smith
"Untitled." Photo-etching. (L.G.)

Betty Hahn
"Untitled." 1972.
Gum Bichromate image with stitchery.

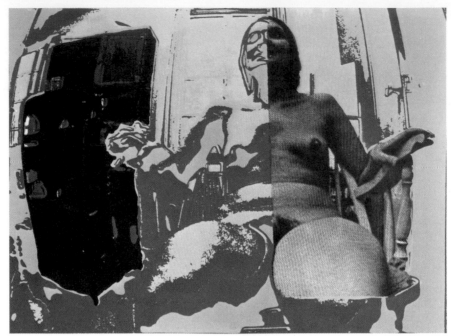

Todd Walker
"Untitled." 1971. Photo Silkscreen. (L.G.)

Naomi Savage
"Halloween Mask."
Extreme photo etching on metal.

Steve Livick
"Summer '71." 1971.
Photo derivation with physical modifications. (L.G.)

Henry Sandbank
"Bulb and Egg." 1972.
Personal still life problem solving.

HIRO
"Automobile." 1971.
Infra red for *LOOK*.

George Ehrlich
"*Mother.*" 1972.
Illustration for a pharmaceutical advertisement.

THE AVANT-GARDE PHOTOGRAPHY OF TOMORROW

The alphabet and vocabulary of photography are caught up in an unending revolution. The breakthroughs called progress are limited not only to technology; the future of photographic technology and of visual communicators is without boundaries. The evolution of man continues at an ever-more-rapid pace. Only recently has real concern for visual literacy surfaced. The education of the future may well include the teaching of how to read visual images.

Photography, among the most powerful forms of image making, is directly related to the basic human need and capacity to symbolize. It is probably because of this inherent need to communicate symbolically that the photographer of tomorrow will have an ever-increasing and ever-critical audience.

Today, there are many signs suggesting that we are on the verge of a new period in the creative use of photographic images. The marriage of diverse photographic techniques with other graphic means seems to be more and more common.

For many who work with the photographic medium the term *photographer* is itself superfluous. Who can say whether "photographers" are really painters, printmakers, graphic designers, social scientists, or reporters, using photography as their expressive vehicle. What do you call someone who uses any means and any materials to express visually an idea, an emotion, or an awareness?

"About the importance of New York: I think it's extremely important. During the Renaissance there was a great revival in art because of the orientation in Florence, for example. New York is the same. It is a photographically-oriented city."

BILL EPPRIDGE

Robert Stolk
Rochester Institute of Technology. Rochester, New York.

STUDENT PORTFOLIO 15

visual vitality from the TV generation

Jean Zichel Komarnichi
Ryerson Polytechnical Institute. Toronto, Ontario Canada.

Paul Fiermonte
San Francisco Art Institute. San Francisco, California.

Leon Hughes
Atlanta School of Art. Atlanta, Georgia.

Robert Polzer
University of Southern Florida. Tampa, Florida.

Paul Atkinson
SUNY at Geneseo. Geneseo. New York

James Dean
Syracuse University. Syracuse, New York.

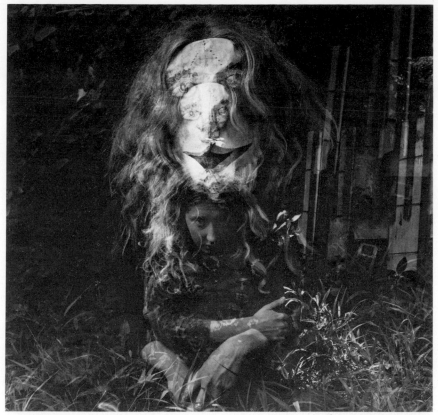

David Howard
San Francisco Art Institute. San Francisco, California.

Gerry Yesdresyski
Ryerson Polytechnical Institute. Toronto, Ontario Canada.

Bill Chase
University of Southern Florida. Tampa, Florida.

Kermit Lee
University of New Mexico. Albuquerque, New Mexico.

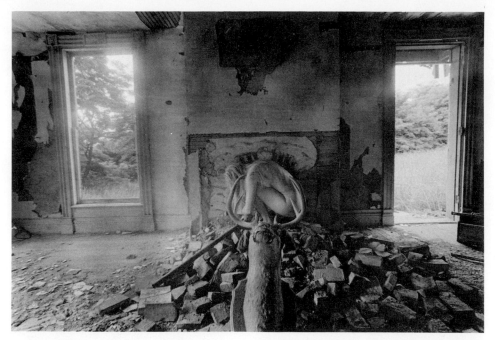

Charles Fisher
Rochester Institute of Technology. Rochester, New York.

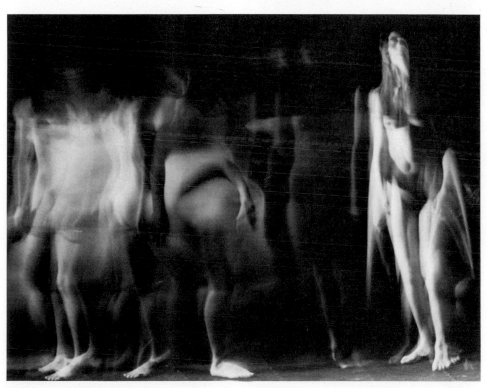

S. J. D'Arco Jr.
SUNY at Geneseo. Geneseo, New York

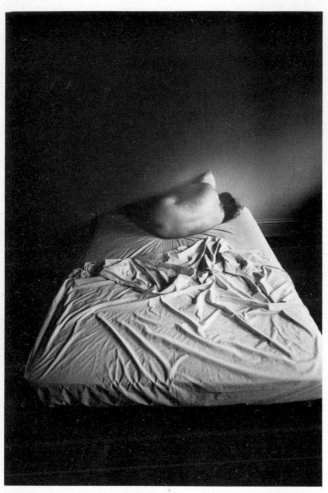

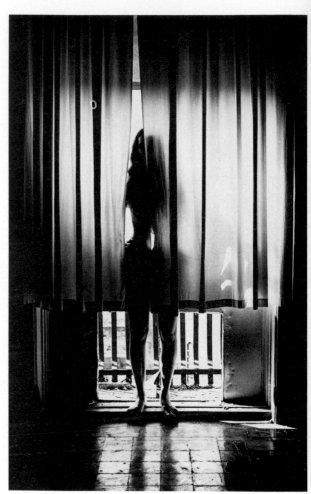

Walter Urie
Maryland Institute. Baltimore, Maryland.

Walter Smalling
University of Southern Florida. Tampa, Florida.

Bussman
Rochester Institute of Technology. Rochester, New York.

Lee Crown
Rochester Institute of Technology. Rochester, New York.

GLOSSARY

Aberrations. Optical defects of a lens which cause less-than-perfect images.

Abrasions. Marks on the surface of an emulsion which appear as scratches. Often caused by rubbing or excess pressure.

Acetic acid. The acid used in stop baths to stop the action of the developer before transferring negatives or prints to the fixing bath. Also used in fixers.

Additive color process. The process in color photography using red, green, and blue in varying quantities to produce all the colors in the visible spectrum.

Agitation. The technique used in processing to keep fresh solution in contact with the emulsion. This is done by moving the film or paper in the solution. Agitation should be consistent for uniform results.

Air bubbles. Small bubbles of air which attach themselves to the emulsion leaving a small area unaffected by the processing solutions. These areas usually appear as black spots in the final print. When developing film, good initial agitation is necessary to prevent air bubbles.

Antihalation backing. A special coating, applied to the back of a film, containing a dye or pigment to absorb light rays, thus preventing reflections of the image from the back of the film.

Aperture. A small circular opening. In cameras, the size of the aperture is variable, regulated by an iris diaphragm. The aperture controls the amount of light passing through the lens.

Bleach. Chemical compound, usually containing potassium ferricyanide, used for bleaching or dissolving silver images. Bleaches are used in both reversal and toning processes.

Blistering. The separation of parts of the emulsion from the film or paper support due to minor faults in processing.

Blowup. Photographic slang for an enlargement from a small negative.

Bracket. After making normal exposure, changing setting to over and under expose.

Brightness. The intensity of light received from a source or reflected from a surface

Bromide paper. A photographic printing paper containing silver bromide, sensitive enough to be used in making enlarged prints.

Bulb. A camera exposure setting which allows the shutter to remain open for as long as the shutter release is held down.

Cable release. A flexible cable used to release the shutter of a camera, minimizing vibration and eliminating camera movement.

Camera obscura. A darkened room or light-tight container in which an image is formed on one side by light entering a small hole in the opposite side.

Carbonates. A term applied to certain alkaline salts, such as potassium carbonate and sodium carbonate, used as the accelerator in developer.

Changing bag. A light-tight fabric bag equipped with openings for the hands in which film can be loaded and unloaded in daylight.

Characteristic curve. A curve obtained by plotting the densities of an emulsion against the corresponding logarithms of exposure values. Film is usually given a series of exposures which vary according to a geometric series.

Chloride paper. A slow-speed printing paper in which the principal light-sensitive material is a chloride. Chloride papers are usually printed by contact and require longer exposures than bromide papers.

Chloro-bromide paper. A photographic printing paper used basically for enlarging. Its emulsion contains a mixture of silver chloride and silver bromide.

Chromatic aberration. A defect in a lens which causes it to separate white light into different colored rays.

Clumping. The partial overlapping of grains of silver causing an effective increase in the grain size of the emulsion.

Collodian. A transparent liquid obtained by dissolving pyroxylin in a mixture of equal parts of alcohol and ether. It is used as the vehicle for carrying the sensitive salts in the wet-plate process.

Color sensitivity. The response of a photographic emulsion to light of different wavelengths.

Complementary colors. Two colors of light which, when combined additively, produce a sensation of gray-white.

Composition. A term referring to the grouping or arrangement of the parts of a picture.

Condenser. A positive lens combination used to collect the divergent rays of a light source and concentrate them in a limited area. Used in the optical systems of enlargers.

Contact print. A photographic print made by placing the emulsion side of the paper in direct contact with the emulsion side of a negative, and then passing light through the negative.

Contrast. A term referring to the variation in brightness of different parts of the subject, or to the density gradations of the negative or positive.

Convertible lens. A lens whose elements can be used alone or together to form combinations of different focal lengths.

Cut film. Another name for sheet film, a flexible, transparent base covered with a light-sensitive emulsion and cut into sheets of various sizes.

Cyan. A blue-green (minus-red) color.

Daguerreotype. An early photographic process which employs a silver-coated plate sensitized with silver iodide and silver bromide. After exposure the plate is developed by subjecting it to mercury vapors. Also refers to the photograph produced with this process.

Definition. Sharpness of detail in an image. Also, the ability of a lens or emulsion to record fine detail.

Densitometer. An instrument for measuring the density of a silver deposit in a photographic image.

Density. A term used in expressing the light-stopping power of a blackened silver deposit in relation to the light falling on it.

Depth of field. The distance between near and far objects which gives satisfactory definition on the image plane.

Desensitizer. A chemical solution in which an exposed film is bathed to reduce its sensitivity to light, permitting its development under a safelight.

Desiccated. A term applied to chemicals from which all moisture has been eliminated.

Developer. A solution used to make visible the image of an exposed emulsion. A developing agent changes the exposed silver halide to black metallic silver.

Developing-out paper. A printing paper in which the image is made visible by development in a chemical solution.

Diaphragm, or stop. The device which regulates the size of the aperture.

Diffraction. An optical term used to denote the spreading of a light ray after it passes the edge of an object.

Diffraction grating. A glass or plastic surface in which a large number of fine parallel slits have been ruled. Under certain condi-

tions, colored images of a light source are observed on either side of the primary image.

Diffusion. Reduction in sharpness of an image by the use of any device which prevents the formation of sharp detail. Also, the scattering of light rays reflected from a rough surface, or the transmission of light through a translucent medium.

DIN. A European system of measuring film speed.

Direct positive. A transparency or print obtained without the use of a negative.

Distortion. Defects in the shape of an object caused by uncorrected lenses.

Dodging. The operation of shading a portion of a negative during exposure in the enlarger to cause that portion to be lighter in the print.

Double exposure. The recording of two separate images on a single piece of film or paper.

Dry mounting. A technique of fastening a print to a mount board by means of a thin tissue of shellac. The tissue is placed between the print and the mount, and heat is applied to melt the shellac, bonding the print and mount together.

Easel. A device to hold enlarging paper in a flat plane on the base of an enlarger. It usually includes adjustable masks to accommodate different paper sizes.

Emulsion. The light-sensitive layer, consisting of silver salts suspended in collodian or gelatin, which is spread over a support such as film, glass, or paper.

Enlargement. A print made from a negative by projecting an enlarged image on light-sensitive material.

Enlarger. A device causing an enlarged image of a negative to be thrown on the easel.

Exposure. The time during which light is allowed to fall on light-sensitive material.

Exposure meter. An instrument for measuring light to determine correct exposure.

Fading. Gradual elimination, usually of the print image, due to the action of light or chemicals.

Farmer's reducer. A solution composed of potassium ferricyanide and hypo used to reduce density in a negative or print.

Ferrotype plate. The highly polished metal plate used to impart high gloss to glossy-coated printing papers.

Film. A sheet or strip of celluloid coated with a light-sensitive emulsion to record an optical image in a camera.

Film pack. A magazine holding a dozen sheet films in such a position in the camera that they can be exposed one at a time.

Film speed. An indication of the sensitivity of a photographic film emulsion, expressed usually as an ASA number. Example: Tri-X is rated at 400 ASA.

Filter. A piece of colored glass, or colored gelatin mounted between glass plates, which is placed in front of the lens to control the color quality of the optical image striking the film. Also used to modify or exaggerate contrast.

Filter factor. A number by which the correct exposure without a filter must be multiplied to obtain the same effective exposure with the filter.

Fixed focus. A term applied to the focusing system of a camera in which the lens is set permanently in such a position as to give a relatively sharp focus of objects from near to far.

Fixing. The process of dissolving unexposed silver salts in a sensitized material by immersion in a hypo solution.

Flare. Fog on the developed negative due to the multiple reflection of a strong light source from the surfaces of the lens elements.

Flat. An expression indicating lack of contrast in a print or negative.

f-number. A number equal to the ratio of the focal length of the lens to the diameter of its aperture openings. The f-number system is in common use for marking the various stop openings of the lens. The term "f-stop" 'is also commonly used.

Focal length. Generally, the distance from a lens to a point where parallel light rays, such as those from the sun, come into sharp focus. Or, the distance from rear nodal point of a lens to the image plane when the lens is focused on infinity.

Focal-plane shutter. A movable cloth or metal curtain placed close to the film with which the exposure to light is controlled. It usually contains a fixed- or variable-sized slit which travels across the film to make the exposure.

Focus. The point where the light rays refracted by a lens produce a clear image.

Fog. A veil or haze over the negative or print due to extraneous light or chemical action.

Footcandle. The intensity of light falling on a surface placed one foot distant from a light source of one candlepower.

Formula. A recipe for combining chemicals into one or more solutions for the performing of some processing operation.

Frilling. The separation of the emulsion from the film or glass or paper support, especially at the edges. It is caused by excessively warm chemicals or wash water.

Gamma. A numerical measure of the contrast to which an emulsion is developed.

Gelatin. A jellylike substance obtained by boiling bones, hoofs, horns, and other parts of animals. The material used in most photographic emulsions to suspend the silver salts.

Ghost images. The reflection of the light from a bright subject by the elements of the lens or its mounting to form a spurious image.

Gradation. The range of tones in a print or negative from highlight to shadows.

Grain. The individual silver particles or groups of particles in the emulsion which, when enlarged, become noticeable.

Ground glass screen. A translucent screen, mounted in the back or top of a camera, upon which the image formed by the lens can be observed.

Halation. The blurring or spreading of the image due to scattering of light by reflection from silver halide particles and to reflection from the back of the emulsion support.

Hard. A term used to indicate excessive contrast in a print.

Hardener. A chemical, such as potassium alum or chrome alum, which is added to the fixing bath to harden the gelatin after development.

High key. A term referring to a type of print in which lighter tones of gray and white predominate with low contrast between the highlights and shadows.

Highlights. The brightest parts of the subject, represented by the denser parts of the negative and the light gray and white tones of the print.

Hue. The term used to distinguish one color from another.

Hydroquinone. A chemical reducing agent which is widely used in compounding developers for photographic materials.

Hypo. A contraction of *sodium hyposulfite*, used in compounding fixing solutions which are used to remove the unexposed silver salts from an emulsion.

Infinity. In photography, infinity is usually considered as a distance of 300 yards or more. In most cases a distance setting on a camera focusing scale generally beyond 40 feet.

Infrared light. Invisible rays of light beyond the red end of the visible spectrum. Some films are sensitive to this radiation.

Intensification. The process of increasing the density of a photographic image through chemical means.

Latent image. The invisible image formed in an emulsion by exposure to light. It is made visible by the process of photographic development.

Lens. A combination of several glass elements which gather the light rays reflected from a subject to produce an image of the subject on the film plane.

Lens shade. A detachable camera accessory used to shield the lens from extraneous light rays.

Light box. A device containing one or more lights which illuminate a frosted glass or plastic surface on which color transparencies may be viewed and edited. Also used to evaluate negatives.

Low key. A print in which the dark tones predominate.

Luminosity. The intensity of light in a color.

Magenta. A reddish-blue (minus-green) color.

Metol. A popular developing agent sold under trade names such as Elon, Pictol, and Rhodal.

Miniature camera. A term more or less generally applied to a camera using 35-mm or smaller-size film.

Monochromatic. A term used in speaking of a single color without specifying any particular hue.

Mottling. An uneven or granular appearance of either the negative or the print. Uneven development is the usual cause.

Negative. A photographic image in which the dark portions of the subject appear light and the light portions appear dark.

Opacity. Resistance of a material to the transmission of light.

Opaque. Incapable of transmitting visible light. Also, a commercial preparation or substance which can be applied to a negative or print to block out certain areas.

Orthochromatic film. A photographic film which is not sensitive to red light.

Panchromatic film. A film which is sensitive to all visible colors.

Panoramic camera. A camera which includes an extremely wide angle of view.

Parallax. The apparent displacement of an object due to an observer's position. Thus, the viewing lens of a twin-lens reflex camera gives a slightly different field of view from that of the taking lens. The difference between the image seen in the viewfinder and that which is actually recorded by the film through the taking lens is called *parallax*.

Perspective. The illusion of three dimensions rendered on a flat surface.

Photography. The process of forming and fixing the optical image of an object on a surface coated with light-sensitive material.

Photomicrography. Photography through a microscope.

Photomontage. A picture composed of several smaller pictures; a photographic collage.

Photosensitive. The term used to describe substances whose chemical composition may react to light.

Pinhole camera. A camera which has a pinhole aperture instead of a lens.

Pinholes. Small holes in the emulsion which are due to air bubbles or dust particles clinging to the film during exposure or development.

Polascreen. A polarizing filter which transmits polarized light properly oriented with respect to the light source. When rotated to a 90-degree angle, it will not transmit the polarized light. Such a filter may be used to vary the contrast between clouds and sky and to eliminate reflections from non-metallic objects.

Positive. The print made from a negative; any image correctly rendering the original subject.

Preservative. A chemical, such as sodium sulfite, which when added to a developing solution tends to prolong its life.

Primary color. Any of the three basic components of white light—blue, green, or red.

Printing frame. A specially constructed frame for holding enlarging paper in contact with a negative while making the exposure.

Printing-out paper. A printing paper in which the image appears when exposed to sunlight, or high-intensity artificial light without the necessity of being developed.

Projection printing. A method of making prints by projecting the image of the negative onto a suitable easel holding the sensitive paper.

Proportional reducer. A chemical reducing solution which reduces the silver in the shadows at the same rate as it reduces silver in the highlights.

Reciprocity law. A law stating that the degree of blackening of photosensitive materials is proportional to the product of light intensity and time of exposure. Reciprocity (law) failure occurs with exceptionally long exposures requiring disproportionate increases in exposure time or light intensity to obtain normal negatives.

Redevelopment. A step in the intensifying or toning procedure in which a bleached photographic image is redeveloped to produce the desired results.

Reducer. A chemical solution used to decrease the overall density of a photographic image.

Reflection. The diversion of light from any surface.

Reflector. A device used to increase the efficiency of a light source by redirecting rays toward the subject to be illuminated.

Reflex camera. A camera in which the image can be seen right side up and full size on the ground glass focusing screen.

Resolving power. The ability of a lens to record fine detail, or of an emulsion to produce fine detail.

Restrainer. Any chemical, such as potassium bromide, which is added to a developing solution for the purpose of slowing down its developing activity.

Reticulation. The formation of a wrinkled surface on a processed emulsion due to excessive expansion or contraction of the gelatin. Caused by acute temperature changes or violent chemical action.

Retouching. A method for altering the quality of a negative or print by the use of a pencil or brush.

Reversal. A process by which a negative image is converted to a positive. The basic principle for all color transparency processes.

Revolving back. A camera back which can be revolved so that either a vertical or horizontal image is recorded. Usually found in large cameras such as press or view cameras.

Safelight. A light used in the darkroom, the intensity and color of which is such that it will not fog light-sensitive materials, at least within normal periods of processing.

Saturation, or purity of color. A measure of the dilution of the color with white light.

Self-timer. A device on the shutter of a camera which permits the shutter to trip about ten seconds after it is released.

Sepia toning. A process which converts the black silver image in a print to a brownish image.

Shadows. A term applied to the thinner portions of a negative, the darker parts of a positive.

Sheet film. A flexible, transparent material coated with a light-sensitive emulsion and cut into sheets of various sizes.

Shutter. On a camera, a mechanical device which controls the length of time light strikes a sensitive material.

Silver halide. The light-sensitive material in a photographic emulsion. Usually silver-chloride or silver-bromide.

Sodium thiosulfate. Sodium hyposulfite, commonly known as hypo.

Soft. A term used to describe prints or negatives which have low contrast.

Solarization. A term commonly applied to the production of a reversed or positive image by reexposure during processing. Properly known as the *Sabattier effect*.

Spotting. The process of removing spots or pinholes from a negative or print.

Squeegee. Either a rubber roller or strip of rubber held firmly in place for removing excess water from prints or negatives prior to drying.

Stock solution. A photographic solution in concentrated form, intended to be diluted before use.

Stop. As used in photography, a term expressing exposure. To reduce exposure by one "stop" would involve using the next fastest shutter speed or the next smaller *f*-number, causing half as much light to strike the film. "One stop over" means doubling the exposure.

Stop bath. A solution containing an acid which neutralizes the developer remaining in a negative or print before it is transferred to the fixing bath.

Subtractive color process. A process in color photography using the colors magenta, cyan, and yellow.

Superproportional reducer. A reducing solution which affects the highlight densities faster than the shadow densities.

Supplementary lens. A detachable lens by which the focal length of a camera objective may be increased or decreased.

Swinging back. A camera back which can be swung through a small arc so that the divergence or convergence of parallel lines in the subject can be minimized or eliminated.

Synchronizer. A device for synchronizing a flash unit with the shutter of a camera so that the subject will be fully illuminated at the instant the shutter is open.

Telephoto lens. A long-focus lens used to obtain enlarged images of distant objects.

Time-temperature chart. A chart indicating the development time for a specific developer within a certain temperature range.

Tone. In photography, this usually refers to the color of a photographic image.

Toning. A method of changing the color or tone of photographic image by chemical action.

Translucent. A term applied to a medium that passes light but diffuses it so that the source cannot be clearly distinguished.

Transmission. The ratio of the light passing through an object to the light falling upon it.

Transparency. A photographic image on a transparent base which must be viewed by transmitted light. A color slide is an example.

Tripod. A three-legged support for a camera, usually with adjustments allowing the camera to be tilted, turned, raised, and lowered.

Tungsten. In photography, a term referring to artificial illumination as opposed to daylight. For example, film emulsion speeds are given for both tungsten and daylight.

Ultraviolet light. Invisible wavelengths of light beyond the blue end of the spectrum.

Vernier scale. A device used on a camera to indicate object distance.

Viewfinder. A viewing instrument, attached to or built into a camera, used to obtain desired framing.

Vignetting. Ordinarily, a dodging method used in projection printing. A process regulating the distribution of light which reaches the print in such a way that the image fades out toward the edges.

Wide-angle lens. A lens possessing a shorter focal length than the standard lens, and used to include a wider angle of view.

Working solution. A photographic solution which is ready for use.

Yellow. A red-green (minus blue) color.

BIBLIOGRAPHY

General

ADAMS, ANSEL, *Artificial Light Photography*, Morgan and Morgan, Hastings-on-Hudson, N.Y., 1968.

————, *Camera and Lens: The Creative Approach*, Morgan and Morgan, Hastings-on-Hudson, N.Y., 1970.

————, *Natural Light Photography*, Morgan and Morgan, Hastings-on-Hudson, N.Y., 1965.

————, *The Negative: Exposure and Development*, Morgan and Morgan, Hastings-on-Hudson, N.Y., 1968.

————, *Polaroid Land Photography Manual*, Morgan and Morgan, Hastings-on-Hudson, N.Y., 1963.

————, *The Print*, Morgan and Morgan, Hastings-on-Hudson, N.Y., 1968.

Adventures in Existing-Light Photography, Eastman Kodak Co., Rochester, N.Y., 1969.

ARNOLD, EDMUND C., *Feature Photos That Sell*, Morgan and Morgan, Hastings-on-Hudson, N.Y., 1960.

BAINES, H., *The Science of Photography*, revised by E. S. Bomback, John Wiley and Sons, N.Y., 1967.

BEGBIE, G. HUGH, *Seeing and the Eye*, Natural History Press, Garden City, N.Y., 1969.

BERGIN, DAVID P., *Photojournalism Manual*, Morgan and Morgan, Hastings-on-Hudson, N.Y., 1967.

BETHERS, RAY, *Composition in Pictures*, Pitman Publishing Corp., N.Y., 1956.

BRAIVE, MICHAEL F., *The Photograph: A Social History*, McGraw-Hill Book Co., N.Y., 1966.

CHERNOFF, GEORGE, and SARBIN, HERSHEL, *Photography and the Law*, Chilton Book Co., Philadelphia, 1965.

CORY, O. R., *The Complete Art of Printing and Enlarging*, Amphoto, N.Y., 1969.

COX, ARTHUR, *Photographic Optics*, Amphoto, N.Y., 1966.

DE MARE, ERIC, *Colour Photography*, Penguin Books, Baltimore, 1968.

————, *Photography*, Penguin Books, Baltimore, 1964.

DESCHIN, JACOB, *Say It With Your Camera: An Approach to Creative Photography*, Ziff-Davis Publishing Co., N.Y., 1960.

EATON, GEORGE T., *Photo Chemistry in Black-and-White and Color Photography*, Eastman Kodak Co., Rochester, N.Y., 1957.

————, *Photographic Chemistry*, Morgan and Morgan, Hastings-on-Hudson, N.Y., 1965.

EDGERTON, HAROLD E., and KILLIAN, JAMES, JR., *Flash! Seeing the Unseen by Ultra-High Speed Photography*, Charles T. Branford, Newton Centre, Mass., 1954.

ENGDAHL, DAVID, *Color Printing: Materials, Processes, and Color Controls*, Amphoto, New York, 1971.

EVANS, RALPH M., *Eye, Film, and Camera in Color Photography*, John Wiley and Sons, N.Y., 1959.

————, *An Introduction to Color*, John Wiley and Sons, N.Y., 1948.

FEININGER, ANDREAS, *The Color Photo Book*, Prentice-Hall, Englewood Cliffs, N.J., 1969.

————, *The Complete Photographer*, Prentice-Hall, Englewood Cliffs, N.J., 1966.

————, *The Creative Photographer*, Prentice-Hall, Englewood Cliffs, N.J., 1955.

————, *Successful Color Photography*, Prentice-Hall, Englewood Cliffs, N.J., 1969.

The Focal Encyclopedia of Photography, McGraw-Hill Book Co., N.Y., 1969.

FOX, RODNEY, and KERNS, ROBERT, *Creative News Photography*, Iowa State University Press, Ames, Iowa, 1961.

HEIST, GRANT, *Monobath Manual*, Morgan and Morgan, Hastings-on-Hudson, N.Y., 1966.

HERTZBERG, ROBERT, *Photo Darkroom Guide*, Amphoto, N.Y., 1967.

HICKS, WILSON, *Words and Pictures: An Introduction to Photojournalism*, Harper, N.Y., 1952.

HORNSBY, K. M., *Basic Photo Chemistry*, Ziff-Davis Publishing Co., N.Y., 1956.

HORREL, C. WILLIAM, and STEFFES, ROBERT A., *Introductory and Publications Photography*, Kenilworth Press, Glen Ellyn, Ill., 1969.

JACOBS, LOU, JR., *Electronic Flash*, Amphoto, N.Y., 1962.

JACOBSON, C. I., *Developing: The Technique of the Negative*, Amphoto, N.Y., 1966.

————, and MANNHEIM, L. A., *Enlarging*, Amphoto, N.Y., 1969.

JONAS, PAUL, *Manual of Darkroom Procedures and Techniques*, Amphoto, N.Y., 1967.

KINGSLAKE, RUDOLF, *Lenses in Photography*, A. S. Barnes and Co., South Brunswick, N.J., 1963.

LARMORE, LEWIS, *Introduction to Photographic Principles*, Prentice-Hall, Englewood Cliffs, N.J., 1958.

LE GRAND, YVES, *Light, Colour, and Vision*, John Wiley and Sons, N.Y., 1957.

Life Library of Photography, Time-Life Books, N.Y., 1970.

LLOYD, IRVIN, *Creative School Photography*, American Yearbook Co., Cambridge, Md., 1962.

LOOTENS, J. GHISLAIN, *Lootens on Photographic Enlarging and Print Quality*, edited and revised by L. H. Bogen, Chilton Book Co., Philadelphia, 1967.

MEES, C. E., and JAMES, T. H., *The Theory of the Photographic Process*, Macmillan Co., N.Y., 1966.

MORGAN, WILLARD D., and LESTER, HENRY M., eds., *The Leica Manual*, Morgan and Lester, N.Y., 1944.

MUELLER, CONRAD G., and RUDOLPH, MAE, et al., *Light and Vision*, Time-Life Books, N.Y., 1969.

NEBLETTE, C. B., *Fundamentals of Photography*, Van Nostrand Reinhold Co., N.Y., 1970.

————, *Photographic Principles and Practices*, D. Van Nostrand Co., N.Y., 1946.

————, et al., *Photography: Its Materials and Processes*, D. Van Nostrand Co., N.Y., 1962.

PAYNE, LEE, *Getting Started in Photojournalism*, Chilton Book Co., Philadelphia, 1967.

Pocket Darkroom Data Book No. 2, Morgan and Morgan, Hastings-on-Hudson, N.Y.

RHODE, ROBERT B., and MCCALL, FLOYD H., *Introduction to Photography*, Macmillan Co., N.Y., 1971.

————, *Press Photography: Reporting with a Camera*, Macmillan Co., N.Y., 1961.

ROTHSTEIN, ARTHUR, *Creative Color in Photography*, Chilton Book Co., Philadelphia, 1963.

———, *Photojournalism: Pictures for Magazines and Newspapers*, Amphoto, N.Y., 1969.

SATOW, Y. ERNEST, *35 mm Negs & Prints*, Amphoto, N.Y., 1969.

SCHARF, AARON, *Art and Photography*, Penguin Books, Baltimore, 1968.

———, *Creative Photography*, Reinhold, N.Y., 1965.

SIDEY, HUGH, and FOX, RODNEY, *1000 Ideas for Better News Pictures*, Iowa State College Press, Ames, Iowa, 1956.

SNELLING, HENRY H., *Art of Photography*, facsimile edition, Morgan and Morgan, Hastings-on-Hudson, N.Y., 1970.

SPENCER, D. A., *Color Photography in Practice*, Focal Press, N.Y., 1966.

SPENCER, OTHA C., *Better Pictures for a Better Yearbook*, Henington, Wolfe City, Tex., 1959.

SPINA, TONY, *Press Photographer*, A. S. Barnes and Co., South Brunswick, N.J., 1968.

STROEBEL, LESLIE, *View Camera Techniques*, Hastings House, N.Y., 1967.

SUSSMAN, AARON, *The Amateur Photographer's Handbook*, Thomas Y. Crowell Co., N.Y., 1965.

SWEET, OZZIE, *My Camera Pays Off*, Amphoto, N.Y., 1958.

THOMPSON, C. LESLIE, *Colour Films*, Chilton Book Co., Philadelphia, 1969.

WALLS, H. J., *How Photography Works*, Macmillan Co., N.Y., 1959.

WHITE, MINOR, *The Zone System Manual*, Morgan and Morgan, Hastings-on-Hudson, N.Y., 1968.

WOLCHONOK, LOUIS, *The Art of Pictorial Composition*, Harper and Row, N.Y., 1961.

WOOLLEY, A. E., *Camera Journalism*, A. S. Barnes and Co., South Brunswick, N.J., 1966.

History

COBURN, ALVIN LANGDON, *Alvin Langdon Coburn: Photographer*, edited by Helmut and Alison Gernsheim, Frederick A. Praeger, N.Y., 1966.

DARRAH, WILLIAM CULP, *Stereo Views: A History of Stereographs in America and Their Collection*, Times and News Publishing, 1964.

DOTY, ROBERT, *Photo Secession: Photography as a Fine Art*, George Eastman House, Rochester, N.Y., 1960.

EDER, JOSEF M., *History of Photography*, Columbia University Press, N.Y., 1945.

FOX TALBOT, WILLIAM HENRY, *The Pencil of Nature*, a facsimile of the 1844–1846 edition, with an introduction by Beaumont Newhall, Da Capo Press, N.Y., 1969.

FRANK, WALDO, *America and Alfred Stieglitz: A Collective Portrait*, Doubleday, N.Y., 1934.

French Primitive Photography, introduction by Minor White, Aperture, Inc., N.Y., 1970.

FRIEDMAN, JOSEPH S., *History of Color Photography*, Focal Press, N.Y., 1968.

GARDNER, ALEXANDER, *Gardner's Photographic Sketch Book of the Civil War*, Dover Publications, N.Y., 1959.

GERNSHEIM, HELMUT, *Creative Photography: Aesthetic Trends, 1839–1960*, Boston Book and Art Shop, Boston, 1962.

GERNSHEIM, HELMUT, and GERNSHEIM, ALISON, *The History of Photography, 1685–1914*, McGraw-Hill Book Co., N.Y., 1969.

———, *L. J. M. Daguerre: The History of the Diorama and the Daguerreotype*, World Publishing Co., Cleveland, 1956.

———, *Roger Fenton: Photographer of the Crimean War*, London, 1954.

HORAN, JAMES, D., *Mathew Brady: Historian with a Camera*, Bonanza, N.Y., 1960.

———, *Timothy O'Sullivan: America's Forgotten Photographer*, Doubleday, N.Y., 1966.

JACKSON, CLARENCE S., *Picture Maker of the Old West: William H. Jackson*, Scribner's, N.Y., 1947.

MEES, CHARLES E. K., *From Dry Plates to Ektachrome Film: A Story of Photographic Research*, Ziff-Davis Publishing Co., N.Y., 1961.

NEWHALL, BEAUMONT, *The Daguerreotype in America*, Duell, Sloan and Pearce, N.Y., 1961.

———, *The History of Photography from 1839 to the Present Day*, Museum of Modern Art, N.Y., 1964.

———, *Latent Image: The Discovery of Photography*, Doubleday, N.Y., 1967.

NORMAN, DOROTHY, *Alfred Stieglitz: Introduction to an American Seer*, Duell, Sloan and Pearce, N.Y., 1960.

POLLACK, PETER, *Picture History of Photography*, Harry N. Abrams, N.Y., 1969.

RINHART, FLOYD, and RINHART, MARION, *American Daguerreian Art*, Clarkson N. Potter, N.Y., 1967.

SELIGMANN, HERBERT J., *Alfred Stieglitz Talking*, Yale University Press, New Haven, Conn., 1966.

SIPLEY, LOUIS WALTON, *A Half Century of Color*, Macmillan Co., N.Y., 1951.

———, *Photography's Great Inventors*, American Museum of Photography, Philadelphia, 1965.

TAFT, ROBERT, *Photography and the American Scene*, Dover Publications, N.Y., 1964.

THOMAS, D. B., *The Origins of the Motion Picture*, Her Majesty's Stationery Office, London, 1964.

THOMPSON, JOHN, and SMITH, ADOLPHE, *Street Life in London*, Benjamin Blom, N.Y., 1969.

TOWLER, J., *The Silver Sunbeam*, a facsimile of the 1864 edition, with an introduction by Beaumont Newhall, Morgan and Morgan, Hastings-on-Hudson, N.Y., 1969.

WALL, E. J., *The History of Three-Color Photography*, Amphoto, Boston, 1925.

Periodicals and Booklets

Aperture, Aperture, Inc., N.Y.

Applied Infrared Photography, Eastman Kodak Co., Rochester, N.Y., 1968.

Basic Developing, Printing, Enlarging, Eastman Kodak Co., Rochester, N.Y., 1962.

British Journal of Photography, Henry Greenwood and Co., London.

BURNHAM, ROBERT W., et al., *Color: A Guide to Basic Facts and Concepts*, John Wiley and Sons, N.Y., 1969.

Camera, C. J. Bucher Ltd., Lucerne.

Camera 35, U.S. Camera Publishing Co., N.Y.

Color As Seen and Photographed, Eastman Kodak Co., Rochester, N.Y., 1966.

Color Photography Annual, Ziff-Davis Publishing Co., N.Y.

Creative Camera, International Federation of Amateur Photographers, London.

Evaluating Color Negatives, booklet 2, Eastman Kodak Co., Rochester, N.Y., 1968.

Filter Data for Kodak Color Films, booklet, Eastman Kodak Co., Rochester, N.Y., 1962.

Filters for Black and White and Color Pictures, Eastman Kodak Co., Rochester, N.Y., 1969.

Flash Pictures, Eastman Kodak Co., Rochester, N.Y., 1967.

Infinity, American Society of Magazine Photographers, N.Y.

Kodak Black-and-White Films in Rolls, Eastman Kodak Co., Rochester, N.Y., 1967.

Kodak Color Dataguide, booklet, Eastman Kodak Co., Rochester, N.Y., 1968.

Kodak Color Films, Color Data Book, Eastman Kodak Co., Rochester, N.Y., 1968.

Kodak Master Darkroom Dataguide, Eastman Kodak Co., Rochester, N.Y., 1970.

Kodak Photographic Papers, Eastman Kodak Co., Rochester, N.Y., 1967.

Modern Photography, Billboard Publishing Co., N.Y.

Photo-Lab-Index, Morgan and Morgan, Hastings-on-Hudson, N.Y., 1970.

Popular Photography, Ziff-Davis Publishing Co., N.Y.

Printing Color Negatives, Data Book, Eastman Kodak Co., Rochester, N.Y., 1969.

Processing Chemicals and Formulas for Black-and-White Photography, Eastman Kodak Co., Rochester, N.Y., 1963.

Travel & Camera, U.S. Camera Publishing Corp., N.Y.

U.S. Camera World Annual, U.S. Camera Publishing Corp., N.Y.

Books of Photographs and Books About Photographers

ABBOTT, BERENICE, *The World of Atget*, Horizon Press, N.Y., 1964.

ADAMS, ANSEL, *Born Free and Equal*, U.S. Camera, N.Y., 1944.

———, *This is the American Earth*, text by Nancy Newhall, Sierra Club Books, San Francisco, 1960.

ANDREWS, RALPH W., *Picture Gallery Pioneers*, Bonanza Books, N.Y., 1964.

AVEDON, RICHARD, *Observations*, text by Truman Capote, Simon and Schuster, N.Y., 1959.

BISCHOF, WERNER, *Japan*, text by Robert Guillain, Simon and Schuster, N.Y., 1954.

———, *The World of Werner Bischof*, text by Manuel Gasser, Dutton, N.Y., 1959.

BOURKE-WHITE, MARGARET, *Portrait of Myself*, Simon and Schuster, N.Y., 1963.

———, *Say, Is This the U.S.A.?*, with Erskine Caldwell, Duell, Sloan and Pearce, N.Y., 1941.

———, *You Have Seen Their Faces*, with Erskine Caldwell, Modern Age Books, N.Y., 1934.

BRANDT, BILL, *Shadow of Light*, Viking Press, N.Y., 1966.

Brassai, introduction by Lawrence Durrell, Museum of Modern Art, N.Y., 1968.

BRY, DORIS, *Alfred Stieglitz: Photographer*, Boston Museum of Fine Arts, Boston, 1965.

CALLAHAN, HARRY, *Harry Callahan*, introduction by Sherman Paul, Museum of Modern Art, N.Y., 1967.

Camera Work, a Photographic Quarterly, Alfred Stieglitz, N.Y., 1903–1917.

CAPA, CORNELL, ed., *The Concerned Photographer*, Grossman Publishers, N.Y., 1968.

CAPA, ROBERT, *Images of War*, Grossman Publishers, N.Y., 1964.

———, *Slightly Out of Focus*, Holt, Rinehart and Winston, N.Y., 1947.

CAPONIGRO, PAUL, *Paul Caponigro*, An Aperture Monograph, Aperture, Inc., N.Y., 1967.

CARTIER-BRESSON, HENRI, *The Decisive Moment*, Simon and Schuster, N.Y., 1952.

———, *Photographs by Cartier-Bresson*, Grossman Publishers, N.Y., 1963.

———, *The World of Henri Cartier-Bresson*, Viking Press, N.Y., 1968.

Contemporary Photographs, UCLA Art Galleries, Los Angeles, 1968.

DAVIDSON, BRUCE, *East 100th Street*, Harvard University Press, Cambridge, Mass., 1970.

DUNCAN, DAVID DOUGLAS, *The Private World of Pablo Picasso*, Ridge Press, N.Y., 1958.

———, *Self Portrait: U.S.A.*, Harry N. Abrams, N.Y., 1969.

———, *Yankee Nomad*, Holt, Rinehart and Winston, N.Y., 1966.

EISENSTAEDT, ALFRED, *The Eye of Eisenstaedt*, edited by Alfred Eisenstaedt and Arthur Goldsmith, Viking Press, N.Y., 1969.

———, *Witness to Our Time*, Viking Press, N.Y., 1966.

EVANS, WALKER, *American Photographs*, Museum of Modern Art, N.Y., 1938.

———, *Message From the Interior*, Eakins Press, N.Y., 1966.

FABER, JOHN, *Great Moments in News Photography*, Thomas Nelson and Sons, N.Y., 1960.

The Family of Man, introduction by Edward Steichen, Museum of Modern Art, N.Y., 1955.

FRANK, ROBERT, *The Americans*, Aperture, Inc., N.Y., 1969.

The Hampton Album, introduction by Lincoln Kirstein, Museum of Modern Art, N.Y., 1966.

HEARTFIELD, JOHN, *John Heartfield*, Institute of Contemporary Arts, London, 1969.

KARSH, YOUSUF, *Faces of Destiny*, Ziff-Davis Publishing Co., N.Y., 1946.

———, *In Search of Greatness*, Alfred A. Knopf, N.Y., 1962.

KEPES, GYORGY, *Language of Vision*, Paul Theobald, Chicago, 1951.

KERTÉSZ, ANDRÉ, Photographer, introduction by John Szarkowski, Museum of Modern Art, N.Y., 1964.

LANGE, DOROTHEA, *An American Exodus*, with Paul Taylor, Reynal Hitchcock, N.Y., 1939.

———, *Dorothea Lange*, introduction by George P. Elliott, Museum of Modern Art, N.Y., 1966.

LARTIGUE, J. H., *Boyhood Photos of J. H. Lartigue*, Ami Guichard, Lausanne, 1966.

LYONS, NATHAN, ed., *Contemporary Photographers: The Persistence of Vision*, Horizon Press, N.Y., 1967.

————, *Photography in the Twentieth Century*, George Eastman House, Horizon Press, N.Y., 1967.

————, ed., *Photographers on Photography*, Prentice-Hall, Englewood Cliffs, N.J., 1966.

————, ed., *Vision and Expression*, George Eastman House, Horizon Press, N.Y., 1969.

MOHOLY-NAGY, LASZLO, *Laszlo Moholy-Nagy*, Museum of Contemporary Art, Chicago, 1969.

————, *Vision in Motion*, Paul Theobald, Chicago, 1947.

MOHOLY-NAGY, SIBYL, *Moholy-Nagy: Experiment in Totality*, MIT Press, Boston, 1969.

NEWHALL, BEAUMONT, and NEWHALL, NANCY, *Masters of Photography*, George Braziller, N.Y., 1958.

NEWHALL NANCY, *Paul Strand: Photographs, 1915–1945*, Museum of Modern Art, N.Y., 1945.

PENN, IRVING, *Moments Preserved*, Simon and Schuster, N.Y., 1960.

PORTER, ELIOT, *In Wildness Is the Preservation of the World*, Sierra Club–Ballantine, N.Y., 1967.

Photography, USA, DeCordova Museum, Lincoln, Mass., 1968.

RAY, MAN, *Man Ray*, Los Angeles County Museum of Art, Los Angeles, 1966.

————, *Photographs, 1920–1934: Paris*, Random House, N.Y., 1934.

————, *Self Portrait*, Little, Brown, Boston, 1963.

RUBIN, WILLIAM S., *Dada, Surrealism, and Their Heritage*, Museum of Modern Art, New York Graphic Society, N.Y., 1968.

SALOMON, ERICH, *Portrait of an Age*, Macmillan Co., N.Y., 1967.

SCHULTHESS, EMIL, *Africa*, Simon and Schuster, N.Y., 1959.

————, *China*, Viking Press, N.Y., 1966.

STEICHEN, EDWARD, *The Bitter Years: 1935–1941*, Museum of Modern Art, N.Y., 1962.

————, *A Life in Photography*, Doubleday, N.Y., 1963.

————, *Steichen the Photographer*, Museum of Modern Art, N.Y., 1961.

SZARKOWSKI, JOHN, *The Photographer's Eye*, Museum of Modern Art, Doubleday, N.Y., 1966.

WEEGEE (Arthur Fellig), *Naked City*, Essential Books, N.Y., 1945.

WESTON, EDWARD, *The Daybooks of Edward Weston*, vol. 2, edited by Nancy Newhall, George Eastman House, Horizon Press, N.Y., 1966.

————, *My Camera on Point Lobos*, Houghton Mifflin Co., Boston, 1950.

WINOGRAND, GARRY, *The Animals*, Museum of Modern Art, N.Y., 1969.

INDEX